DIGITAL

NATURE
PHOTOGRAPHY
CLOSEUP

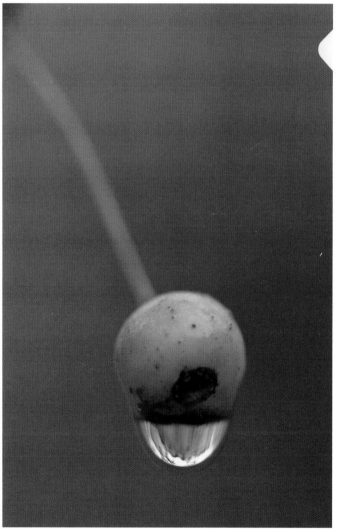

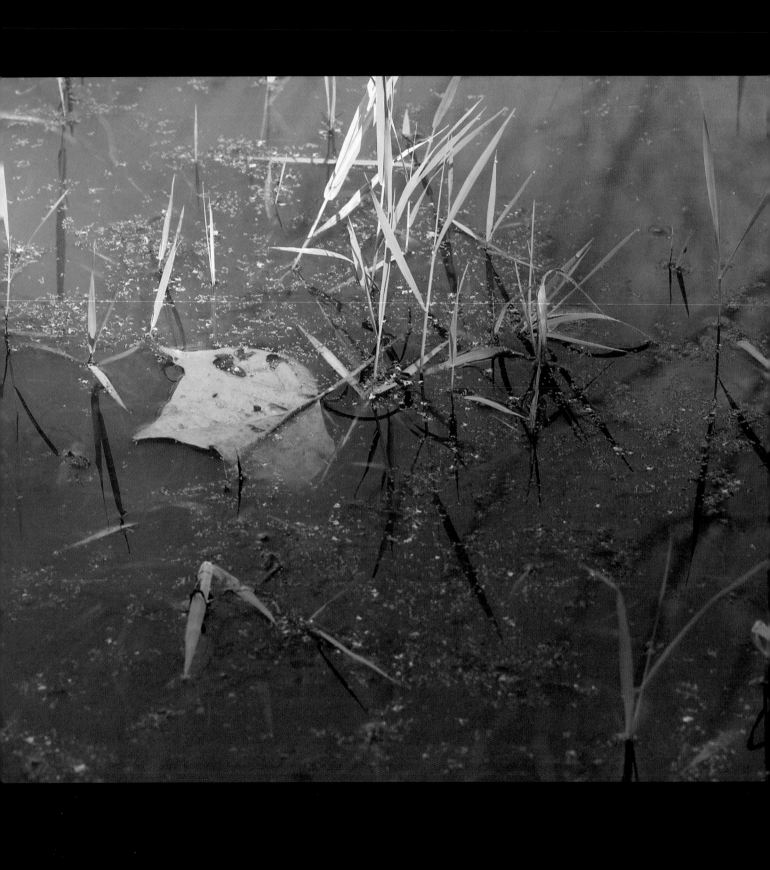

DIGITAL
NATURE
PHOTOGRAPHY
CLOSEUP

JON COX

AMPHOTO BOOKS

AN IMPRINT OF WATSON-GUPTILL PUBLICATIONS
NEW YORK

Page 1: Crab apple with raindrop, Unionville, Pennsylvania. Nikon D1X with Micro-Nikkor 105mm f/2.8D AF lens

Page 2: Wetland in fall, Unionville, Pennsylvania. Nikon D1X with Micro-Nikkor 105mm f/2.8D AF lens

Page 5: Straw flower, El Malpais National Conservation Area, New Mexico. Nikon D1X with Micro-Nikkor 105mm f/2.8D AF lens

Page 6: Lily, Unionville, Pennsylvania. Nikon D1X with Micro-Nikkor 105mm f/2.8D AF lens and Nikon Speedlight SB-800

Page 8: Penguin, Antarctica.

Text and photographs copyright © 2005 Jonathan Cox

First published in New York in 2005 by
Amphoto Books
an imprint of Watson-Guptill Publications
a division of VNU Business Media, Inc.
770 Broadway
New York, NY 10003
www.amphotobooks.com
www.wgpub.com

Library of Congress Cataloging-in-Publication Data

Cox, Jon, 1975–
 Digital nature photography closeup / Jon Cox.
 p. cm.
 Includes index.
 ISBN 0-8174-3674-X ((pbk.))
 1. Nature photography—Handbooks, manuals, etc. 2. Photography—Digital techniques—Handbooks, manuals, etc. 3. Photography, Close-up—Handbooks, manuals, etc. I. Title.
TR721.C69 2005
778.9'3—dc22

2004028827

Printed in Singapore

1 2 3 4 5 6 7 8 9 / 13 12 11 10 09 08 07 06 05

Senior Acquisitions Editor: Victoria Craven
Senior Development Editor: Alisa Palazzo
Designer: Jay Anning, Thumb Print
Production Manager: Hector Campbell

TO KELLY

I look forward to sharing a lifetime of memories

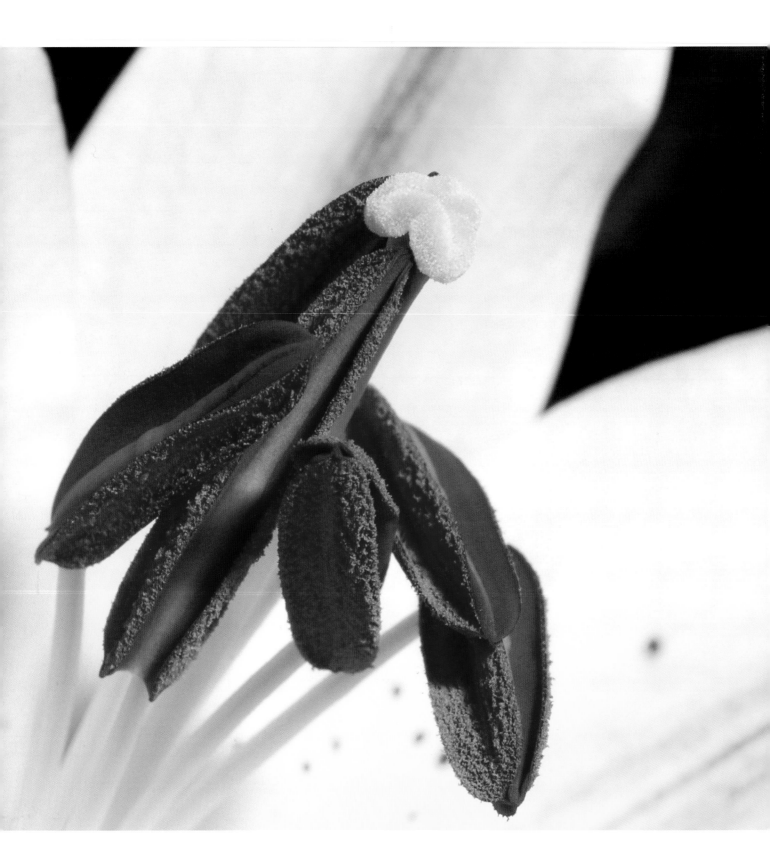

ARTIST'S STATEMENT

Practically from day one I collected insects, plants, and other intriguing elements of nature. As time passed, these trophies faded, broke apart, or were misplaced. Once I discovered the world of photography, my specimen-collecting stopped, and I started collecting images. Stalking a butterfly with a camera is more challenging than stalking it with a net, and the rewards are far greater. Better yet, my new collection doesn't fade or decay, and I can duplicate it as much as I want. At the end of the day, it's far more gratifying to see my subject living and not dead in a glass box!

My goal as a nature photographer remains consistent: I want to introduce as many people as possible to the natural world. The more that people learn about and understand nature, the more likely they are to help protect it. Get to know your subject, and the images will follow.

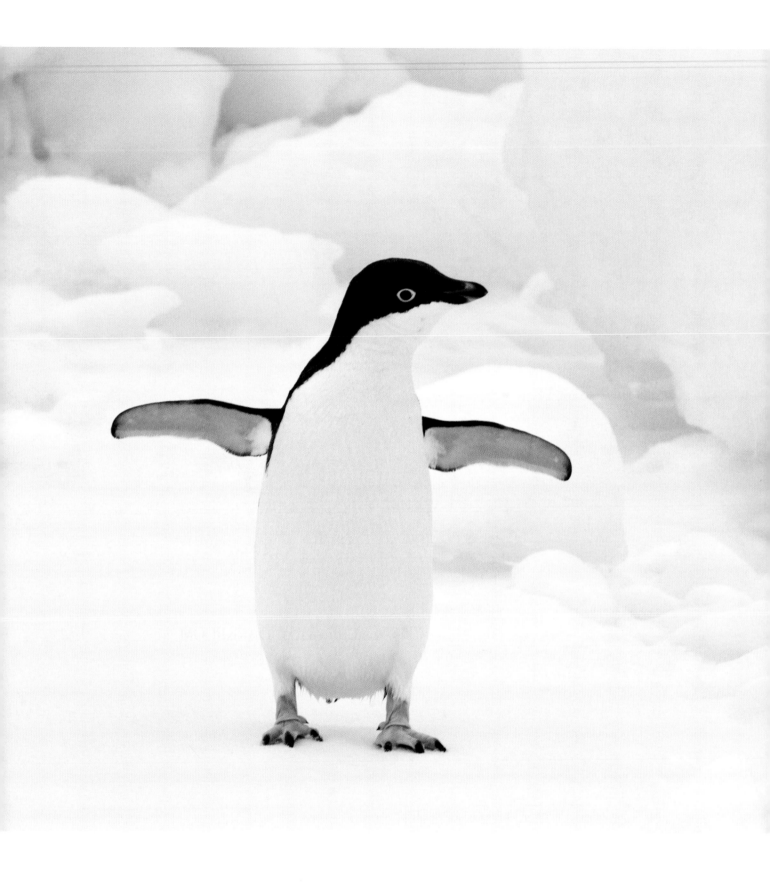

CONTENTS

PREFACE 10

CHAPTER ONE
EQUIPMENT 12

CHAPTER TWO
CAMERA FEATURES
& TECHNIQUES 46

CHAPTER THREE
LIGHT & COLOR 60

CHAPTER FOUR
COMPOSITION 84

CHAPTER FIVE
FLASH 112

CHAPTER SIX
WORKING WITH
HISTOGRAMS & RAW FILES 130

CHAPTER SEVEN
THE DIGITAL DARKROOM 144

GLOSSARY 157

RESOURCES 159

INDEX 160

PREFACE

What is a closeup?

The term *closeup* means different things to different people. A closeup shot of the planet Saturn could be one in which the rings are visible. Making a closeup of a skyscraper might involve cropping in on only the front door. One photographer may consider a clump of flowers in a meadow to be a closeup, while another's closeup may be a single flower portrait or just a single petal. A molecular biologist might consider a closeup shot to be one of a pollen grain taken under an electron microscope. This book will focus on a spectrum of closeup scenarios.

Throughout the text I use the term *closeup* loosely and give as many possible closeup shooting scenarios as a nature photographer may encounter. This includes a variety of shooting situations I believe to be vital for a photographer exploring the world of closeup digital nature photography. With the use of a variety of digital cameras, equipment, and photographic techniques, I will share the methods I use to continually capture closeup images in nature.

In my first Amphoto book, *Digital Nature Photography*, I scratched only the surface of closeup, or macro, digital nature photography. In this book, I show how to make a closeup using tested techniques and shooting situations.

To do this, it's crucial to give an overview of digital photography techniques, including composition, lighting, and digital photography basics. I touched on this in the first book, as well, but it never hurts to brush up.

Four bacterial mats, Yellowstone National Park, Wyoming. Nikon D1X with Micro-Nikkor 105mm f/2.8D AF lens

I was in one of the best-known national parks for wildlife photography where I spent the day looking down, breathing sulfur air. The bacterial mats of Yellowstone National Park are fascinating on many levels. The bacteria vary from location to location, producing what seems to be the entire spectrum of light. While I'll never grow tired of watching the park's buffalo, elk, and wolves, taking the time to focus my lens on the closeup world is just as rewarding.

Digital photography has opened up countless new possibilities in closeup nature photography. Gone are the days of painstaking exposure calculations. If you don't capture the exposure you want with your first shot, then make a few adjustments and reshoot.

Advances in digital photography occur at an alarming rate. It has been only two years since my last book, yet digital photography has grown by leaps and bounds. However, closeup techniques have remained consistent. My goal is to take you through the necessary steps to capture, print, and store macro images. I cover the fundamental photographic principles and also those aspects of photography specific to digital capture. I think we've reached the point at which people understand that photography is photography, regardless of whether it's digital or film. So, I won't discuss the difference between the two mediums, since as I always say, it's the final image that counts.

Shooting closeups requires patience and a desire to examine the rarely seen closeup world. Zooming in on the architecture of a subject will reveal many different shapes, colors, and textures. The right combination of lighting, equipment, and composition works to capture the fascinating world that lies beneath our feet. The number of possibilities in closeup photography can be quite overwhelming at times, and that's okay. A single petal becomes an intricate structure made of color, shape, and texture. Couple that with numerous camera angles and lighting situations and the image becomes like a chameleon, changing to fit the desired effect. It's exciting to explore our world's many levels with a digital camera.

In recent years, I've watched dozens of professional, amateur, and student photographers switch from shooting film to shooting digital. One of the biggest misconceptions is that you need to have the best camera on the market in order to capture the best shot. This mentality will build a nice camera inventory but can empty out your pockets! We live in a fast-paced society in which pretty much everything is at our fingertips. Digital photography allows you to see immediate results, which is one reason it has become so popular. But, while you can see your results immediately, don't expect perfect pictures on the first shot or two. Again, it's *patience* and strong closeup images that go hand in hand.

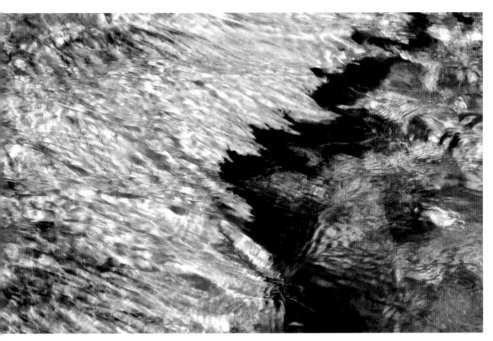

EQUIPMENT

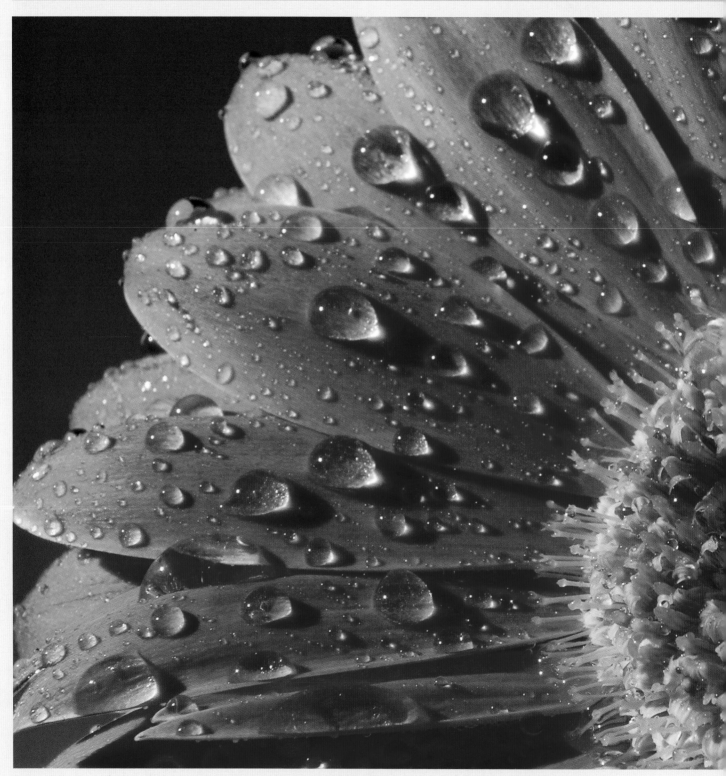

Gerbera Daisy, Unionville, Pennsylvania. Nikon D1X with Micro-Nikkor 105mm f/2.8D AF lens

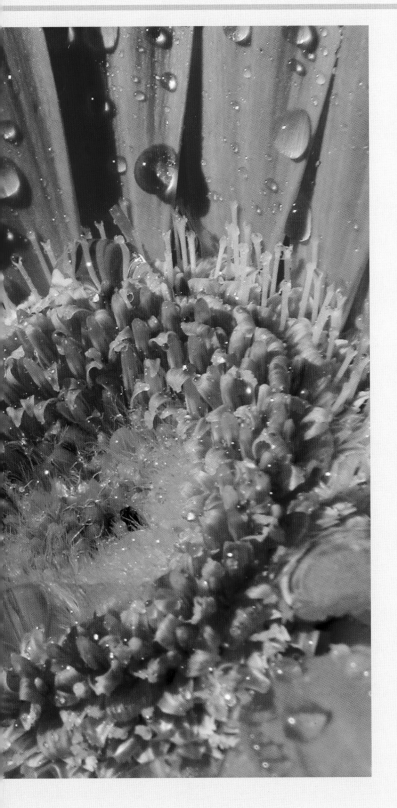

Today's digital cameras make shooting closeups easier than ever. Consumer models have built-in closeup modes and digital SLRs that are equipped to handle a variety of lenses and accessories, enabling you to dive into the macro (closeup) world with ease. The only question is, How close do you want to capture your subject?

Digital Point-and-Shoot Cameras

In 2003, Canon unveiled the Digital Rebel, the first digital SLR camera under $1,000 and it's shipped with a lens. At this price, it's easy for professionals, amateurs, and even students to start shooting digital. The question is no longer, Can you afford a digital camera? but rather, How do you want to use the digital camera?

In the past, the high cost of a digital SLR camera was the major factor in why people bought the less expensive pocket-sized point-and-shoot digital cameras. Since cost is no longer an issue, it's size that's the driving force behind buying a pocket-sized digital camera. My first point-and-shoot digital camera was over $900, and now digital SLRs are around the same price. Ask yourself what type of camera you will use the most.

Many people worry about buying a digital camera now, because the price keeps going down, and what they buy today will be outdated in six months. That statement was true up until around 2002. That year seemed to be a turning point for what I would consider to be cameras made to last at least a few years, if not more. When companies started making cameras in the 5MP (megapixel) range, a definite switch to digital photography occurred. People who had been on the fence, stating that film was better than digital, began to reassess what they were saying. The resolutions of these 5MP cameras enable a photographer to make 12 x 18-inch prints with ease, and much larger if the right interpolation techniques are employed. Kodak, during the writing of this book, discontinued making film cameras and started selling a 14MP digital SLR for the same price that I paid for my 5MP camera two years

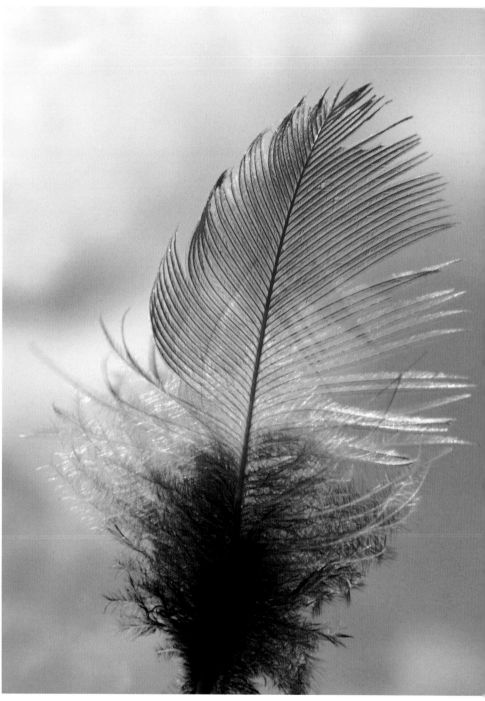

Cardinal feather, Unionville, Pennsylvania. Nikon Coolpix 4500

Using the point-and-shoot Nikon Coolpix 4500, I held the camera with one hand and the feather with the other. I set the camera on manual focus. I metered the blue sky and puffy white clouds, setting the f-stop and shutter speed manually. To take the shot, I pointed the camera toward an interesting area of the sky and then moved the feather back and forth until it was in focus on the LCD screen.

ago. That doesn't mean I don't like my 5MP images anymore, and I certainly don't regret buying my camera.

Consumer pocket-sized digital camera models are wonderful for shooting closeups. There are even times I prefer a point-and-shoot camera to a digital SLR, especially when working in precarious field situations. The compact size of the point-and-shoot camera enables you to maneuver around your subject. Some models even have a tilt LCD screen, which is indispensable for capturing unusual angles. Many of the pocket-sized digital cameras have the same manual adjustments as digital SLRs, including manual focus, shutter speed, *f*-stop, and various ISO settings. Point-and-shoot digital cameras can be attached to a microscope or telescope, can shoot video, and can even fit in your pocket.

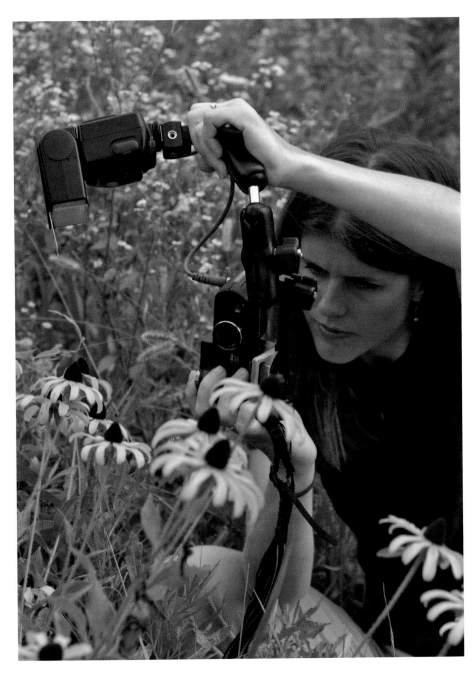

Kelly McConnell, Unionville, Pennsylvania. Nikon Coolpix 4500 with Wimberley external flash bracket and Nikon flash

I've finally stopped searching for flash brackets! This universal flash bracket from Wimberley fits both pocket-sized and digital SLR cameras. It allows infinite flash-to-subject positions, putting the creativity back in the hands of the photographer. If one flash doesn't provide the lighting you desire, you can add a second bracket and another flash. I have personally handcrafted brackets out of cast aluminum that work well but not nearly as well as the Wimberley bracket.

WHAT I LOVE AND DON'T LOVE ABOUT MY POCKET-SIZED POINT-AND-SHOOT DIGITAL CAMERA

WHAT I LOVE

I can take it everywhere.

It's totally manual if I want it to be.

There's a built-in closeup mode.

I can attach an external flash instead of, or in addition to, the internal one.

The tilt head allows for infinite shooting angles and often saves me from having to lie on the ground to capture a shot.

There's never any dust on my imaging sensor because the lens is fixed to the camera.

WHAT I DON'T LOVE

When you shoot closeups, the working distance is short.

I don't have the same variety of lenses as I do with my digital SLR.

I can't get the same magnification as I can achieve with a digital SLR.

Spider on Queen Anne's lace, Unionville, Pennsylvania. Nikon Coolpix 4500

With the Nikon Coolpix 4500 consumer model point-and-shoot digital camera, this was as close as I could get with the camera's built-in closeup mode using the camera's optical zoom. I could have zoomed in closer if I had used the digital zoom, but the image quality quickly degrades when using digital zoom. That's why I never use it; in fact, I'm not sure why digital cameras are even equipped with a digital zoom.

This may be as close as you ever want to photograph; if it is, you may want to consider sticking to a pocket-sized digital camera.

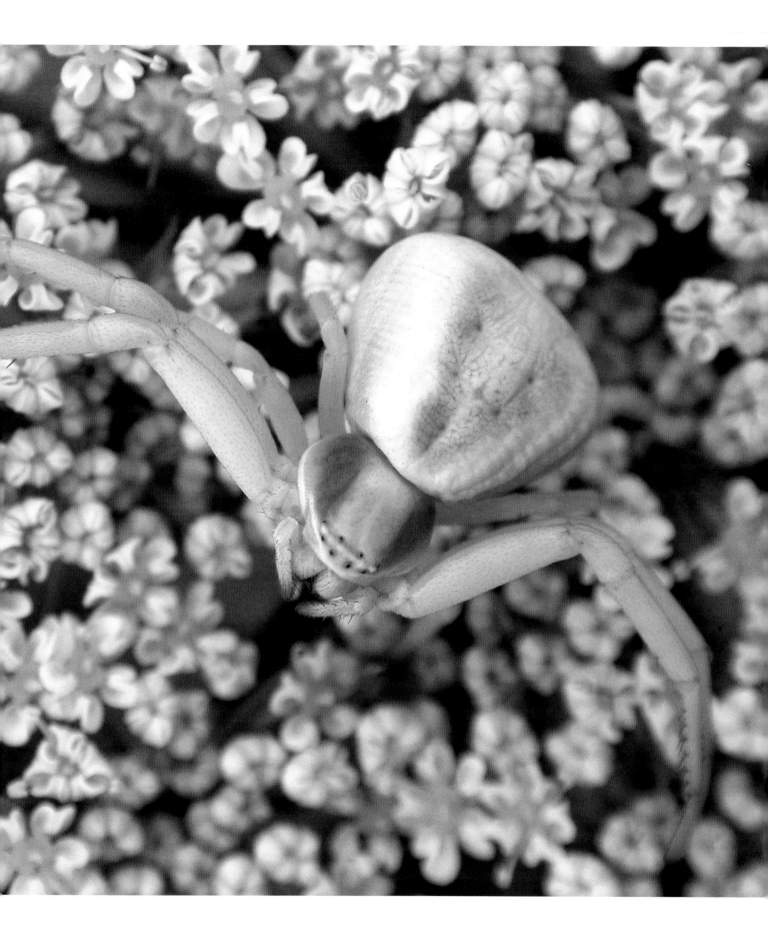

Digital SLR Cameras

If you find your pocket-sized point-and-shoot digital camera isn't doing what you need it to, consider a digital SLR (single-lens reflex) camera. For example, if you want to start photographing hornet's nests or rattlesnakes, I don't think a pocket-sized digital camera is the best way to go because of the small working distance—you're sure to be stung or bitten.

Personally, I don't care how close I am to my subject; i.e., I don't care how many times life size the image appears, I just want to capture the subject in the best light, making adjustments to achieve appropriate exposure and composition. I think a good image is a good image no matter how close or far it is.

There's a tendency in macro photography to concentrate on the technical aspects, forgetting about the creativity. You should have a good understanding of your equipment, but you don't necessarily need to know all the closeup magnification math equations to capture a good shot. How many images have you seen captioned as "Grand Canyon, 1/450 life size"? You haven't, which is my point. I think it's far more constructive to capture a good image and worry about how close you are after the fact. Scientists needing precise measurements should be far more concerned about magnification sizes than photographers. So, that being said, I'm not going to spend a great deal of time going over how to obtain the magnification rates.

With film, capturing closeups was more difficult, but determining the magnification rate was much less complicated. The reason being an image on 35mm film was always 1 x 1.5 inches. When you got your film back, you could look at a slide and say, Yes, that ant appears to be the exact same size as it did in life, meaning the image was shot at a magnification of 1:1 or life size. That's how manufacturers and photographers talk about closeup lenses and images. A lens able to capture an image 1:4 will be able to capture a scene 1/4 life size. A lens able to focus 2:1 will enable a photographer to capture a scene 2 times life size.

This is difficult to understand when using a digital camera because the magnification now relates to the size of the imaging sensor, which is not always the standard 1 x 1.5-inch format like 35mm film. To determine your magnification rate, you need to figure out your camera's "digital factor" to determine your lens's angle of view. My Nikon D1X has a digital factor of 1.5. This means that a lens that's able to focus 1:1 is actually now able to capture subjects at 1.5 times life size. When I use my 400mm lens on my Nikon D1X, it becomes a 600mm lens—excellent for zooming in closer. However, the downside to the "digital factor" becomes apparent when you use a wide-angle lens. My 12–24mm lens, when used with my Nikon D1X, becomes an 18–36mm lens, giving me a narrower angle of view.

Choosing and Changing Lenses

Every lens is different, and there are a variety of ways to use your lenses to capture closeups. As a closeup photographer, you are the master of your gear and decide how to use your equipment to capture stunning images. Feel free to combine gear in any arrangement. Try new combinations and experiment as much as possible. Learning how each piece of equipment can be used is a good foundation on which to build your skills as a closeup digital photographer, and using the equipment in the field is where the understanding occurs.

You should always be careful changing lenses when using a digital SLR camera. You want to keep foreign particles from landing on your camera's imaging sensor. Change your lens in an area that's out of the wind. Have your new lens in a handy location ready to attach to your camera. Point your camera toward the ground so that particles won't fall into the part where you attach the lens. Finally, attach your new lens to the camera as quickly as possible, with the camera still being pointed toward the ground. If you find gray or black spots in the sky or light areas of your images, it's time to clean your imaging sensor. (See page 39.)

DIGITAL FACTOR RESOURCES
The Web site www.steves-digicams.com has an online lens calculator to help you figure out your camera's digital factor and how it relates to your lens's angle of view.

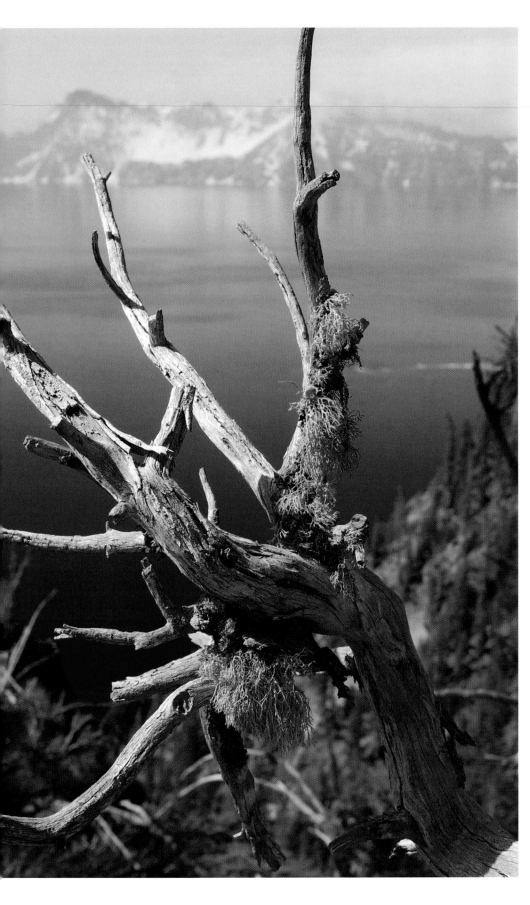

Lichen on a dead branch, Crater Lake National Park, Oregon. Nikon D1X with 28–70mm 1:4.5 macro lens

A wide-angle lens is probably the lens I use *least* when capturing closeups. However, shooting closeups with a wide-angle lens lets you capture your subject while including the surrounding environment. The fresh green lichen was an ideal subject for a nature closeup—I couldn't pass up the opportunity to include the crystal clear Crater Lake below. To capture both the lichen and the lake, I needed to use the highest f-stop to obtain good depth of field and a tripod to steady the camera.

Remember, the term *closeup* is relative. This may be as close as you ever want to go, or you may want to zoom in tight and capture the intricate detail for a more traditional closeup.

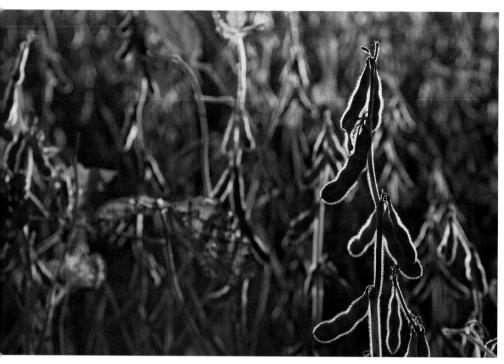

Soybean field in autumn, Unionville, Pennsylvania.
Nikon D1X with 28–70mm 1:4.5 macro lens

One fall, I would pass this soybean field at the same time every
evening. I knew it would make an interesting subject, but the light was
never appropriate when I drove by. As the days became shorter, my
subject became more attractive. At last, the sun was low enough in the
horizon to backlight the delicate hairs with beautiful golden light. I
didn't want to capture just one soybean pod, so I used my wide-angle
lens to incorporate many pods into the scene.

Leopard tortoise, Tanzania. Nikon D1X with
Nikon DX12–24mm 1:4 G ED wide-angle lens

The Nikon DX12–24mm 1:4 G ED wide-angle lens is my new
favorite landscape lens specially designed for Nikon digital
cameras. I didn't think I would use it for closeups, but seeing
this leopard tortoise changed my mind. Lying on the sand
gave me the exact angle needed to capture the tortoise in its
environment. Don't be afraid to get a little dirty—your
compositions will improve. To capture the essence of a
tortoise, ask yourself, How does a tortoise see the world?

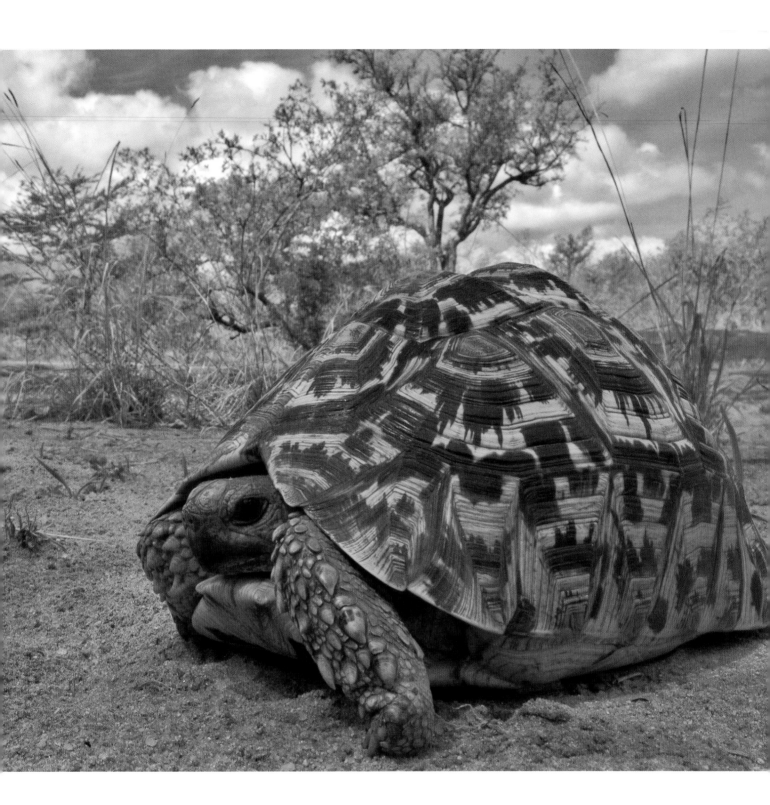

Using Long Zoom Lenses

A long zoom lens is good for those subjects requiring a long working distance. Long zooms aren't marketed as closeup lenses, but you can easily make them focus closer by adding extension tubes (see page 26) or a diopter (see page 28). When you're limited to how close you can approach your subject, a long zoom is an indispensable tool. If I'm trying to photograph a poisonous snake, a hornet's nest, or a skittish creature, a long zoom lens gives me the safe working distance I need. Adding space between you and your subject will also allow your subject to act more normal and enhance your chances of capturing a natural-looking shot.

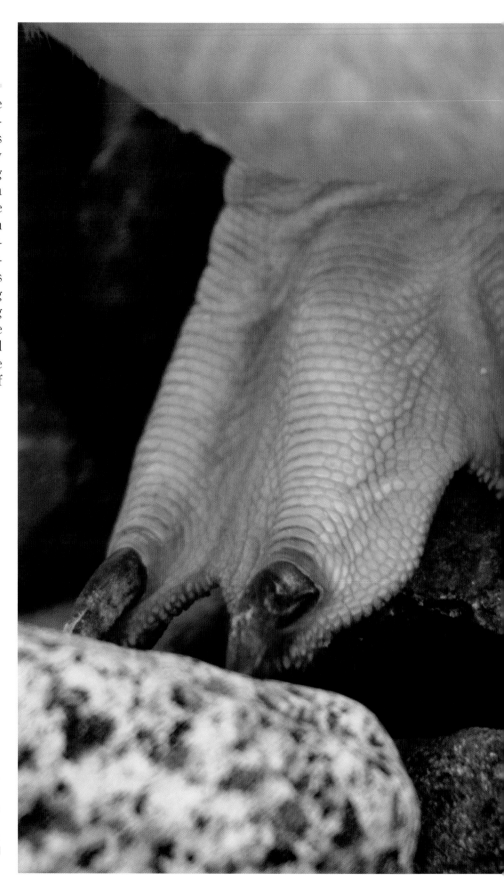

Gentoo penguin feet, Antarctica. Nikon D1X with Nikkor AF VR 80–400mm lens

In Antarctica, as in many national parks, it's against the rules to approach the wildlife. However, the wildlife can approach you, and they often do, especially the curious penguins. Using a long zoom was exactly what I needed to capture the orange feet of this gentoo penguin as it waddled past, giving me a quick once-over. For this shot, I did zoom my lens all the way to 400mm, giving me an effective 600mm lens, and I did use a tripod to avoid camera shake.

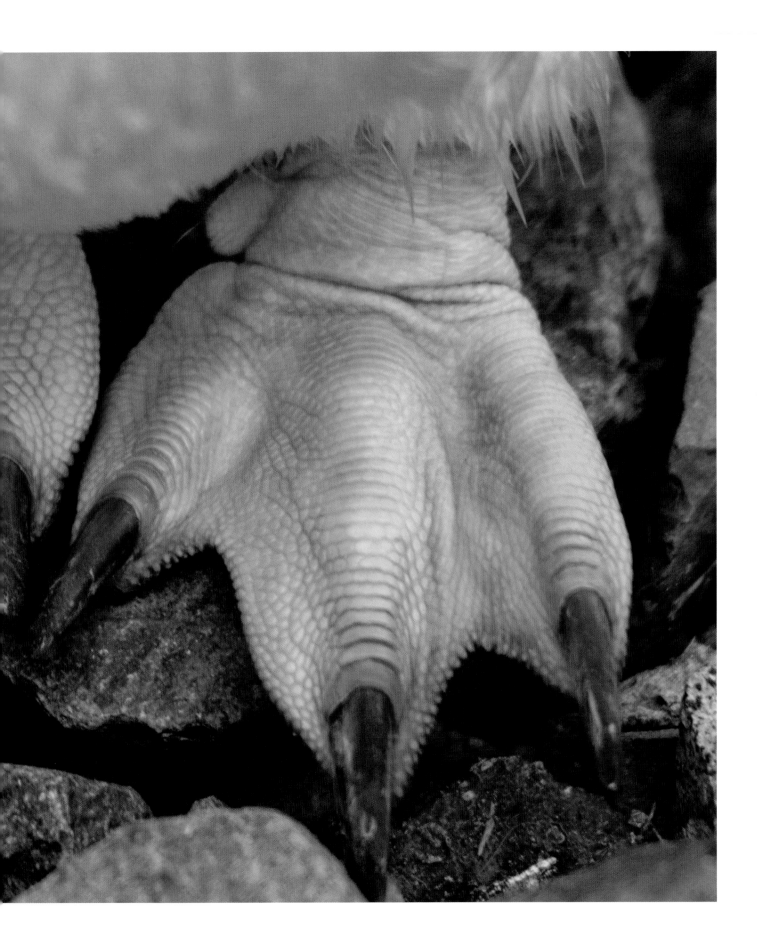

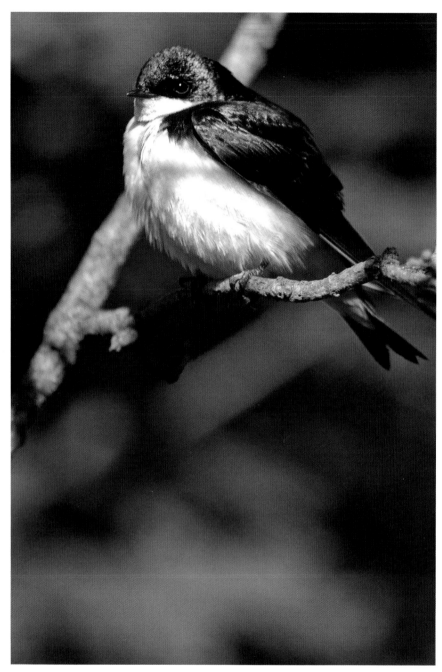

Tree swallow, Unionville, Pennsylvania. Nikon D1X with
Nikkor AF VR 80–400mm lens and 12mm extension tube

This was one tame tree swallow—I was able to approach within a few feet
(its home was a bluebird house in my backyard). Attaching a 12mm
extension tube to my 400mm lens increased the magnification; it didn't add
much, but it was just enough to fill the top of the frame with my subject.

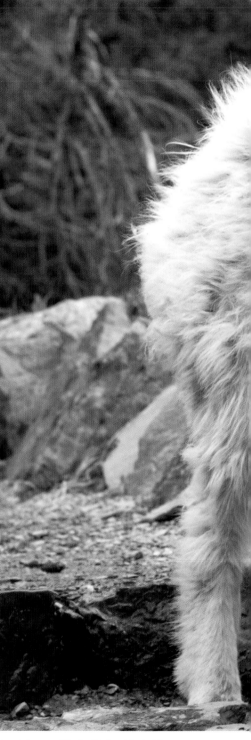

Mountain goat, Glacier National Park, Montana.
Nikon D1X with Nikkor AF VR 80–400mm lens

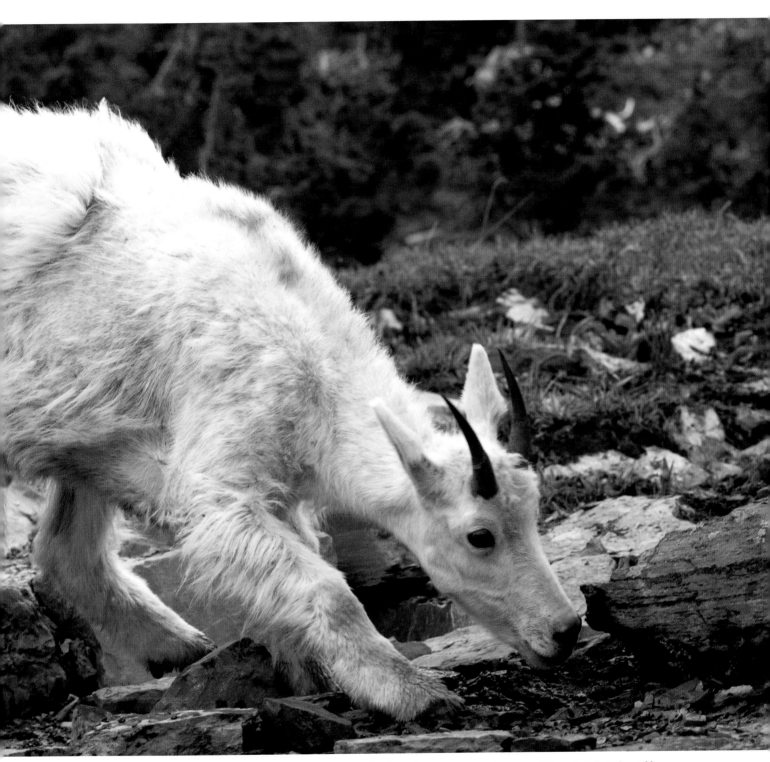

Catching my breath on top of a rock after about a mile hike across a snowfield, I heard a rustle behind me. Staying still, I slowly peaked over my shoulder. To my surprise, my first sight of a mountain goat in the wild was right next to me. I admit excitement overwhelmed me to the point where I fumbled with my camera controls until regaining my composure. Undisturbed by my presence, the mountain goat walked within a few feet of me to feed on whatever was growing under this rock. I shot about fifty images while the mountain goat was in range, making sure to check my exposure by looking at the histogram because of the white hair (see pages 132–137 for an explanation of histograms). Even though there was a long zoom on my camera, the best shot wasn't the closest. I did capture a few full-face portraits, but the goat's crouched position is what captured my interest.

Extension Tubes

Extension tubes are placed between the camera body and the lens. Using an extension tube is one of the best methods to gain additional magnification without compromising the quality of your image. It turns a regular lens into a macro lens by making it focus closer to your subject. The benefit of extension tubes is that they are hollow tubes—you aren't adding additional glass elements, which can adversely affect the quality of your image.

Extension tubes come in a variety of sizes and can be used singularly or stacked for additional magnification. If you're on a budget and want to turn an old lens into a macro lens, this is the way to go. They're also wonderful for use with new lenses and can be combined with other closeup accessories for additional magnification. In my opinion, no self-respecting closeup nature photographer would be caught without a set of extension tubes.

If you want to determine the magnification rate gained by using an extension tube, divide your total extension by the focal length of your lens and then multiply by the "digital factor" if necessary. If you're using a zoom lens, you would have to know the exact focal length to determine the exact magnification.

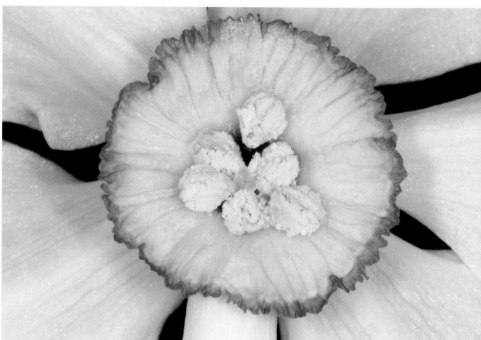

Daffodil, Unionville, Pennsylvania. Nikon D1X with Micro-Nikkor 105mm f/2.8D AF lens, Nikon ring flash, and 12mm extension tube

I wanted to fill the frame with the brilliant orange and yellow flower center. My lens wouldn't focus close enough, so I added a 12mm extension, which did the trick. By using a hollow tube instead of a diopter (see page 28), I was assured a sharp image because additional glass elements—which can lessen the quality of the image—were not introduced.

Crab apple blossom, White Clay Creek State Park, Delaware. Nikon D1X with 28–70mm 1:4.5 macro lens and medium-size extension tube

In the first shot (right), this was as close as my lens would focus. To increase the magnification, I used a 12mm extension tube (below). When I divided the extension tube length by the focal length I was using (12mm/28mm), I got a magnification rate of approximately .43 times life size; then, when I multiplied that number by my "digital factor" of 1.5, I got a total magnification rate of approximately .65 times life size. Fortunately, I didn't need to do any of these calculations in the field. All I needed to do was look through the lens and see that the lens by itself didn't provide enough magnification to capture the shot I wanted. So, I added an extension tube to capture the desired magnification.

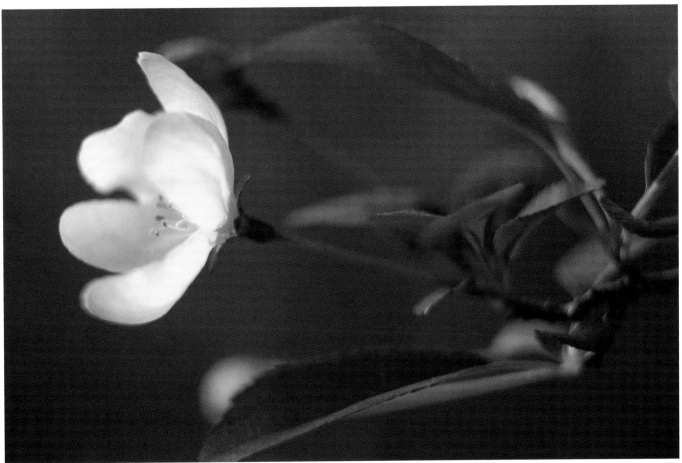

Diopters

A *plus lens*, a *closeup lens*, and a *diopter* are the same things—a piece of glass that looks like a filter fitting to the end of your lens—they just go by different names. Using a diopter is the cheapest and easiest way to begin taking close-ups. You need only to screw the close-up accessory onto your existing lens.

If your lens won't fit your diopter, you can purchase a step-up ring, as long as the diopter is larger than the front of your lens. Adding these lenses won't cost you any light, and you can use them with any combination of other closeup accessories. They're usually sold in +1, +2, and +3 strengths, with the highest number giving the most magnification. You can stack them together, but be forewarned that using more than two will result in poor image quality. The biggest downside is that when you add additional glass elements to a lens, you decrease the quality of the final image. I never use single-element diopters; the quality is never as good as I envision. When, in a pinch, I do need something, I have a high-quality two-element diopter made by Nikon that yields good results.

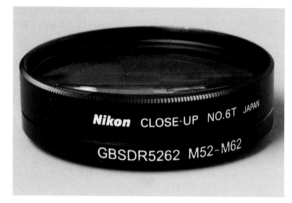

Nikon 6T diopter with 52–62mm step-up ring

This is my favorite diopter—it's a multi-element lens that attaches to the end of my camera's lens. I especially like using it with my Micro-Nikkor 105mm f/2.8D AF lens. When I need just a little more magnification, this is the perfect solution. It doesn't cost me any light, and all of the auto functions on the lens still work. I can attach it to any lens as long as the lens diameter is smaller than 62mm. If the diameter of your lens is larger than the diameter of your diopter, vignetting will occur in your image. My Micro-Nikkor 105mm f/2.8D AF lens has a diameter of 52mm, so I only needed a 52–62mm step-up ring (which I purchased for $6) to make the diopter work. I've been using the same diopter for over seven years; it has seen me go through the transition of shooting film to shooting digital. Canon also makes two-element diopters. The good news is you can use any brand of diopter on any camera model as long as the filter sizes match.

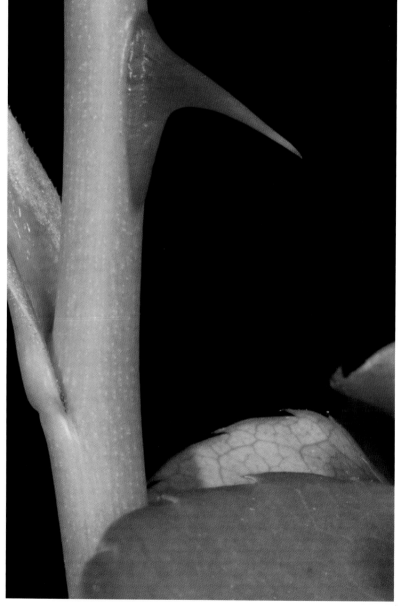

Rose thorn, Unionville, Pennsylvania. Nikon D1X with Micro-Nikkor 105mm f/2.8D AF lens, Nikon 6T diopter, and ring flash

Crocus, Unionville, Pennsylvania. Nikon D1X with Micro-Nikkor 105mm f/2.8D AF lens, Nikon 6T diopter, and ring flash

The first crocus of the year is rejuvenating, signaling that spring is right around the corner. Wanting to hone in on the beautiful contrasting colors of the crocus, I used my Nikon Micro-Nikkor 105mm f/2.8D AF lens; the problem was, it didn't allow me to focus close enough to fill the frame with the petals. My extension tubes were at home, leaving that option out; but I did have my Nikon 6T diopter handy. Adding the diopter gave me the added magnification needed to capture an intimate frame-filling view of the crocus.

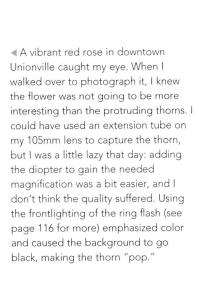

◄ A vibrant red rose in downtown Unionville caught my eye. When I walked over to photograph it, I knew the flower was not going to be more interesting than the protruding thorns. I could have used an extension tube on my 105mm lens to capture the thorn, but I was a little lazy that day: adding the diopter to gain the needed magnification was a bit easier, and I don't think the quality suffered. Using the frontlighting of the ring flash (see page 116 for more) emphasized color and caused the background to go black, making the thorn "pop."

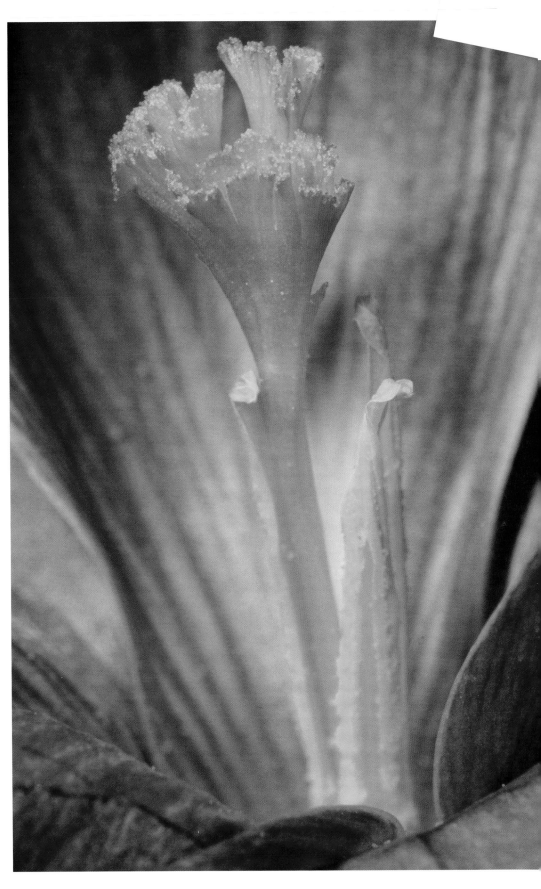

Filters

I'm not a big fan of using filters, but they can be good additions to your camera gear when conditions warrant their use. My best piece of advice is: if you don't need a filter, don't use one. Adding an additional glass element to the front of your lens can cause more harm than good. Filters can introduce unwanted flare and cause vignetting in your images. Knowing how and when to use them will result in better images.

The most common filter is the *UV filter*, sold as an accessory with most new cameras. A UV filter absorbs ultraviolet rays and is best used for decreasing atmospheric haze in an image. Since haze isn't a problem when shooting closeups, you should only use a UV filter like an insurance policy for your expensive lens—protecting it from nature's harsh elements. If you're photographing in dusty, sandy, rainy, or salty conditions, always use a UV filter to protect your lens. The most important consideration is keeping the filter glass as clean as you would keep the glass of your lens. If Mother Nature is cooperating and the weather is good, take the UV filter off. There's no reason to decrease the quality of your image when environmental conditions don't require lens protection.

Polarizing filters increase color saturation, reduce reflections, and darken blue skies, and are available as linear and circular models. My preference is a circular polarizer. It allows the photographer to turn the filter, thereby either increasing or decreasing the amount of polarization until the desired effect is achieved. Since polarizers remove glare, they're wonderful

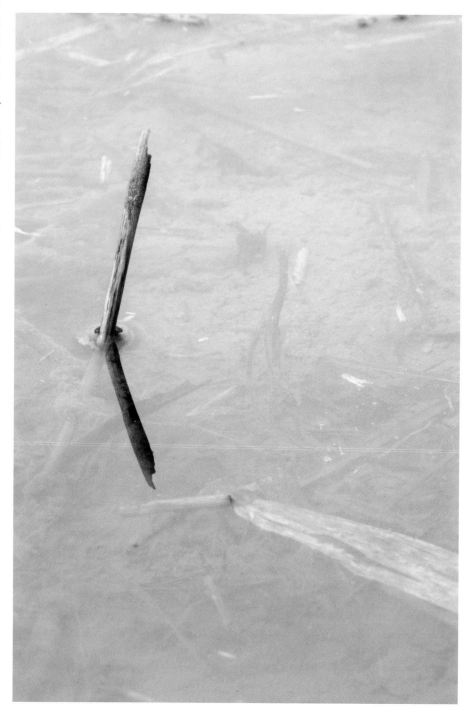

Wetland, Unionville, Pennsylvania. Nikon D1X with Micro-Nikkor 105mm f/2.8D AF lens and Nikon 52mm circular polarizer

The first image (near right) was taken without the polarizer; you can see, even on a cloudy day, a reflection from the sky. Using the circular polarizer (opposite), I adjusted the amount of polarization until I was able to see into the water.

for capturing shiny leaves and also for shooting through glass. The time to use a polarizer is when your subject is perpendicular to your light source. Point your left arm at the light source and your right arm at the subject; when your arms form a right angle, you're in the best position to use a polarizing filter.

Neutral-density filters reduce the amount of ambient light entering your camera without changing the color rendition. There are two basic types of neutral-density filters: solid ones and graduated ones. A solid [...] density filter lowers the amount of light in the entire frame by a given number of stops. Graduated-neutral density filters fade from clear to dark and vary in intensity.

The only time I use a solid neutral-density filter is if I'm photographing running water and want to add a blur effect but there's too much available light to show the motion of the water. Adding the neutral-density filter in this situation cuts down on the available light, enabling me to use a longer shutter speed to blur the water. You can use a graduated neutral-density filter to darken a sky while leaving the foreground untouched. You might need to do this when your foreground is going to be underexposed when compared to a brighter sky. If you don't already have a graduated neutral-density filter, see page 151 to learn a comparable digital darkroom corrective technique; you'll obtain the same result without having to purchase and carry around extra gear.

If you were once a film photographer, you are probably familiar with warming and cooling filters. These are added to the front of the lens to remove color casts in difficult lighting situations. I don't even own a warming or cooling filter—there's no reason for me to own them. I'm a firm believer that it is much better to capture your shot in the field, but if there's a better, faster way to achieve the same result in the digital darkroom, then use the digital darkroom. If you want to remove a color cast you can do so in Photoshop with much more control than you would have with a filter on the end of your lens. Photoshop CS software even includes popular filters used by film photographers to remove color casts in digital images. (See page 152 for more on this.)

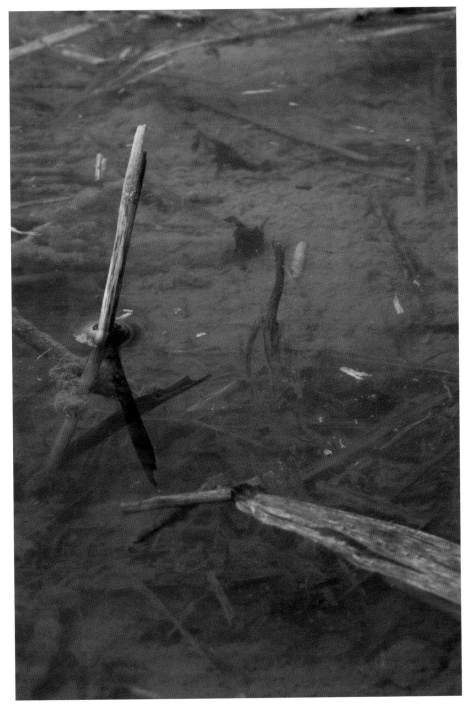

Stacked Lenses

This is more a technique than a special piece of equipment, but since it involves your gear, I've included it in the Equipment chapter. Stacking lenses is an old trick that can work even with today's digital cameras, but it is not the best solution for digital closeup photography. In fact, I never take closeups using stacked lenses, but you may have better luck than I do using this method.

The benefit of stacking lenses is that you retain the automatic controls of the lens that's closest to your camera body. Your best scenario is to stack lenses with the same size filter to avoid vignetting (darkening toward the edges of an image). For example, you may stack a manual-focus 50mm lens on the front of an AF lens, allowing you to use all the features of the automatic lens. To combine the two lenses, the only adapter needed is a 52–52mm one (this allows the lenses to be connected in a front-to-front fashion). Adapters are cheap; pick one up and you may bring life to an old lens stored in the back of your closet. But, a word of caution: use this technique only if you don't want to spend any money on a multi-element diopter, which is a much better choice to obtain greater magnification and retain the automatic features of your lens.

Vignetted poinsettia. Nikon D1X with 35–70mm AF lens, 50mm lens reversed, and Nikon ring flash

Using multiple lenses increases distortion due to the additional glass elements, and the blatant drawback of stacking lenses is the dark ring, called a *vignette*, that often appears in your images. While vignetting can be a compositional technique, it should only be used intentionally. If you want to include a vignette after the fact, you can do so in Photoshop. In this image, I purposefully stacked two lenses I knew would cause an atrocious vignette to illustrate what can happen. If you do want to stack your lenses, make sure you try them out—before taking them into the field—to ensure they won't vignette.

Bellows

Using a bellows allows you to capture extreme closeups many times life size but is also the most cumbersome way of working in the field. Except for using a microscope, a bellows will produce the highest magnification obtainable with 35mm digital SLR photography. A bellows is basically a superlong expanding and retracting extension tube. It's impossible to handhold a bellows—you will always need a tripod to steady the big rig. Read your lens specs and bellows specs to see what *f*-stop is recommended—also known as the "sweet spot" of your lens.

As digital photographers, we have become accustomed to instant results; we want everything to work immediately. When using a bellows, don't expect to capture your image in the first shoot. Finding your subject in the viewfinder may require a few minutes, and composing your image may take even longer. Budget at least thirty minutes per each final image. Patience is of the utmost importance when photographing at high magnifications. I bought a bellows for when I was shooting 35mm film, thinking I would use it all the time for closeups. It didn't happen—the fact that I had to wait a day or two to see the results drove me mad. It was rare that I ever captured a good shot, causing me to retire my bellows to my camera gear graveyard. But digital photography resuscitated my old bellows. Since results are immediately visible on my digital camera's LCD, making slight adjustments is easy, and this enables me to almost always capture my intended shot.

The bellows I once used for 35mm film photography just required one adjustment to suit my Nikon D1X

digital SLR camera: I added a 20mm extension tube between the bellows and the camera body to make them work together. I can attach any one of my lenses to the front of the bellows and even reverse lenses if preferred. Like an extension tube, a bellows will produce a clean and clear image because you're not adding any additional pieces of glass to capture your image. If you're thinking about buying a new bellows, though, you may want to try all other methods of magnification first. You may never need or want to photograph subjects at this high a magnification. The size of the rig makes photographing difficult, but

still, for extreme closeups, it may be your only way.

Be creative in your lens arrangements. There's no right or wrong way to use a lens—it's how you want the lens to work for you. Your bellows will most likely have a lever on the front to close down the aperture of your lens. It may also be equipped with a spot for a release cable. If it is, use the release cable to avoid camera shake and also use the anti-mirror-shake on your digital camera to minimize vibrations. If you're photographing in the field, make sure there's no wind—even the slightest breeze will blur your image at high magnifications.

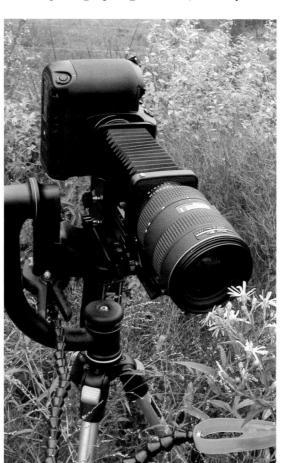

Nikon D1X with 28–70mm 1:4.5 macro lens, bellows, tripod head, and plamp from Wimberley

You can see by its size, using a bellows makes photography in the field difficult—but not impossible. The plamp, a device used to steady subjects, is excellent for combating a pesky breeze. I attach the plamp to the head of my tripod, then to the base of my subject for support; it's much better than trying to hold your subject still.

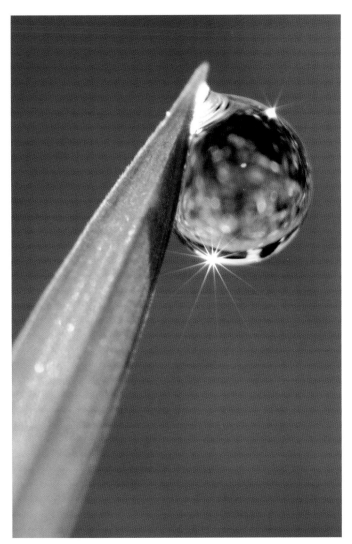

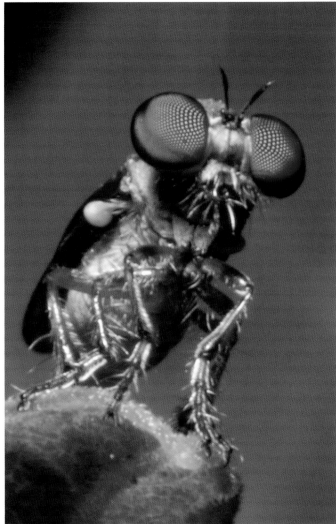

Dewdrop on a blade of grass, Unionville, Pennsylvania. Nikon D1X with Micro-Nikkor 105mm f/2.8D AF lens attached to bellows

Bubble-eye fly, Unionville, Pennsylvania. Nikon D1X with Nikkor 105mm lens, bellows, tripod, and one external flash on Wimberley flash bracket

This image of a simple blade of grass and dewdrop was one of the most difficult closeup shots I have ever taken. I visualized this image before seeing it in the field. Imagining it was the easy part. Finding the scene was a different story. Using natural light increased the technical difficulty involved because I needed a 2-second shutter speed to capture the correct exposure. One still August morning, the conditions were ideal: no wind, a dew-laden landscape, and the sun peaking up over the horizon. I attached my favorite closeup lens to my fully extended bellows for maximum magnification. The result: an image about twelve times life size. The bellows's focusing rail enabled minute focusing adjustments, whereas moving my tripod for focusing would have been impossible.

Succession is a series of changes that create a full-fledged plant and animal community in a natural environment—for example, from the colonization of bare rock to the establishment of a forest. I'm allowing succession to occur in my backyard; native plants flourish, and I remove exotic species. Mowing a small path through my naturalized backyard facilitates photographing wild creatures in their native habitat. My morning ritual is a cup of coffee and a short walk down the path in search of new subjects. On this day, an unusually chilly summer morning kept insects on their nightly perches, creating the perfect photographic situation. Once an insect's temperature warms to a certain point, it is once again able to fly. Paying attention to your environmental surroundings is vital to consistently capturing usable images. Know your subject, and the images will follow.

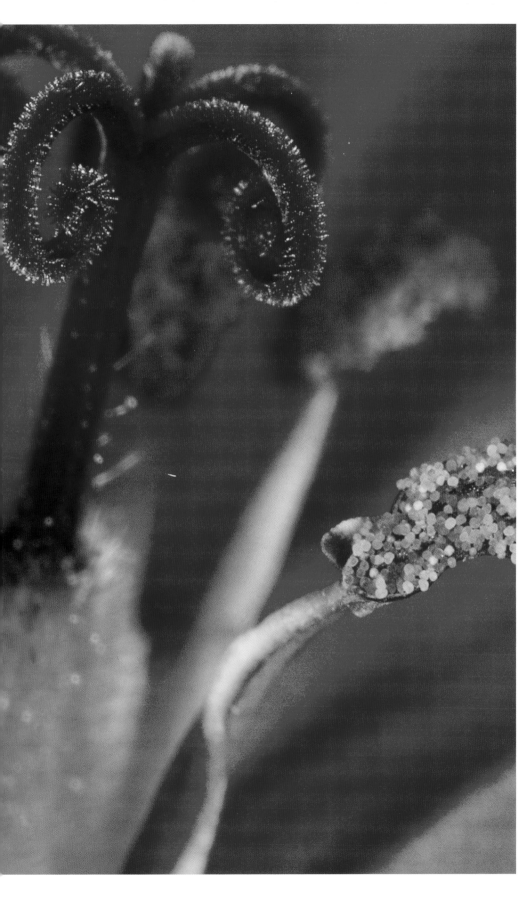

Geranium pistil and anther with pollen grains, Unionville, Pennsylvania. Nikon D1X with Nikkor 105mm lens, fully extended bellows, tripod, and Nikon ring flash

A clump of geranium flowers is beautiful. Move closer and a different form takes shape. I was visually blown away when photographing this minute scene. At this high magnification, you can see individual pollen grains. Incorporating the ring flash into my rig enabled me to capture the flower's reproductive parts using a high depth of field, which was essential if I wanted to show the pollen grains and pistil in sharp focus.

Automatic Closeup Lenses

There is no doubt—specially designed automatic closeup lenses are my favorite lenses for closeup digital nature photography. They do exactly what they're designed to do: shoot closeups with ease. Nikkor's line of micro lenses, ranging from 60mm to 105mm and 200mm, enables a photographer to shoot up to life size without adding any additional equipment. Remember to add the "digital factor" if your digital camera isn't 35mm equivalent. When used on my Nikon D1X, this 1:1 Nikkor 105mm lens focuses to an effective 1.5 times life size—nice bonus. Canon manufactures a lens that lets photographers shoot at a whooping 5 times life size. Chances are you'll never need a bellows or diopter if you own a Canon 5x macro lens—wish I had one in my camera bag.

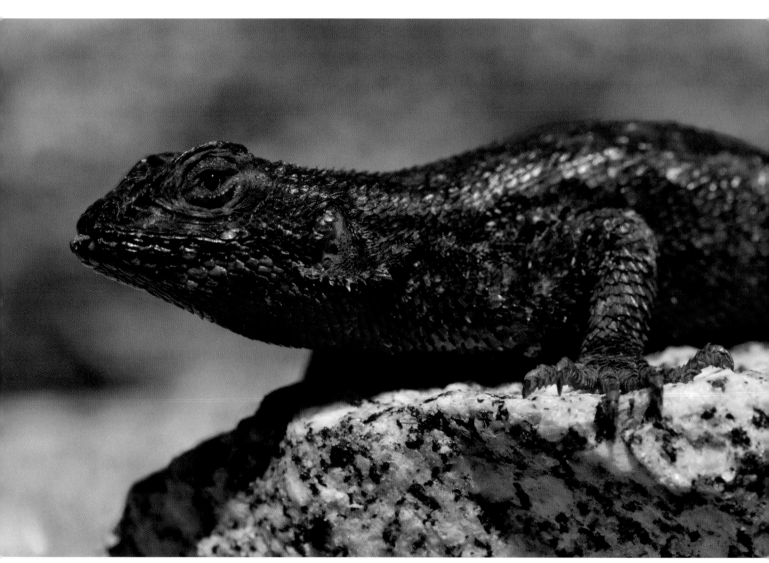

Blue-bellied lizard, Sequoia National Park, California. Nikon D1X with Micro-Nikkor 105mm f/2.8D AF lens

If you're hiking in Sequoia National Park near rocky cliffs during summer, you will surely catch a glimpse of the vibrant blue-bellied lizard. This is an occasion I wished I'd had a 200mm lens instead of the 105mm lens in my bag. Of the ten or so lizards I photographed, this is the only one that let me really get up close and personal. Unfortunately, when you're backpacking you need to make decisions on what type of gear you're going to carry. You definitely don't want to carry all of your gear on a thirty-plus mile hike; at least I don't want to! If you find yourself in this situation, be patient, keep shooting—and, once again, be patient. If you sit for just a few minutes, you'll be surprised how many creatures come to you. I've never captured a great shot by chasing my subject.

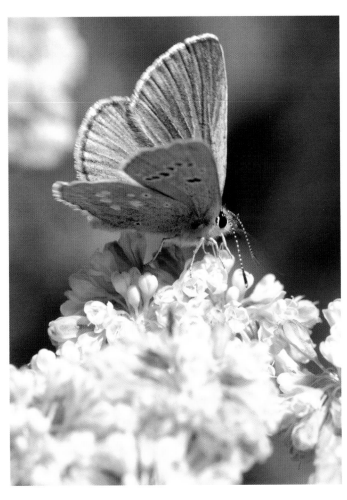

Blue butterfly on yarrow, Grand Teton National Park, Wyoming. Nikon D1X with Micro-Nikkor 105mm f/2.8D AF lens

When I'm handholding the camera, my favorite lens for closeups is the 105mm. It provides more working distance than a 60mm lens, but doesn't force me to use as high a shutter speed as if I were using a 200mm lens. By handholding the camera, I was able to change camera angles as the butterfly moved from flower to flower in search of nectar.

This was the first time I had ever been to a butterfly house. As a butterfly fanatic, I couldn't pass up the chance to view and photograph countless butterflies in a controlled situation. Butterfly houses are great places for aspiring photographers to practice their moves, and you are bound to come out with a few good shots. The natural available light in this butterfly house was well suited to using a 105mm lens and no tripod. I used a low *f*-stop to blur out any traces of man-made structures. Using a low *f*-stop got me a shallow depth of field and this blurred the background out. Using a low *f*-stop also gave me enough light to use a fast shutter speed for handholding the camera.

African monarch butterfly (captive), British Columbia, Canada. Nikon D1X with Micro-Nikkor 105mm f/2.8D AF lens

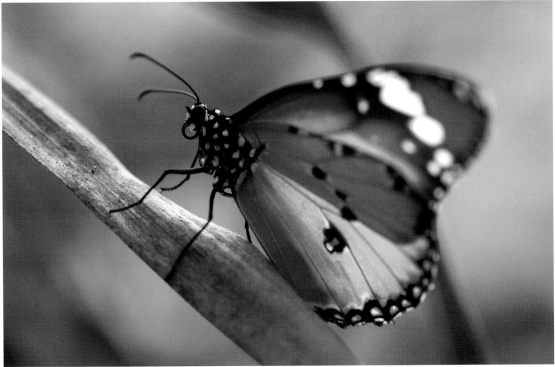

Teleconverters, Tripods, and Tripod Heads

Teleconverters

Teleconverters are placed between the camera body and the lens to magnify your subject. They differ from extension tubes in that they are equipped with a glass lens. These aren't made just for closeups; they can also be used with any lens to obtain greater magnification. Teleconverters are usually sold in two sizes: 1.4X and 2X power. A 2X teleconverter will change a 100mm lens into a 200mm lens. It will also turn a lens that focuses to life size into a lens that focuses to twice life size.

Don't get too excited, though—there are drawbacks. Teleconverters cut down on the light entering a lens. If you're using a 2X teleconverter, then you're losing two stops of light—fine for flash photography but a nightmare if you're using natural light. The other drawback is that you're adding additional glass elements to your lens, degrading the image quality. Today's teleconverters are much better than older models, but I prefer other methods of magnifying my subjects.

Tripods and Tripod Heads

Before buying a tripod, decide how you're going to use it. If you're shooting with a consumer model digital camera, I don't suggest buying a heavy tripod. However, if you're using both a digital SLR camera and a pocket-sized camera you may want to buy a tripod that will work for all of your equipment instead of buying multiple tripods.

The number one aspect of a tripod is that it has to be easy to use. If setting it up and taking it down is a struggle, you won't use it and your images will suffer. There are a variety of tripod designs, and one that's easy for me to use may not be easy for you to use. A tripod's design is a personal preference; once again, try it out before you buy.

A tripod for closeups must be able to go close to the ground. Many of your subjects will be near the ground, and a good tripod will get you there with the support you need. A tripod with a fixed center column won't allow you the flexibility of getting close to the ground. However, a tripod with a removable center column will give you a variety of shooting options.

If you're backpacking or hiking any distance, you should consider a carbon-fiber tripod, which is lightweight yet sturdy enough to support heavy loads of camera gear. Carbon fiber is also a wonderful material for working in freezing temperatures, because carbon won't get as cold as a metal tripod will. If you're shooting in the cold with a metal tripod, try taping some foam pipe insulators onto the legs; this will keep your hands from freezing when you touch the tripod.

Once you decide on a tripod, you'll need a way to attach your camera to the base: a tripod head. Every year there are more and more tripod head designs from which to choose. When I'm using my pocket-sized digital camera, I like a small ball head made by Manfrotto. My new favorite head when shooting with my digital SLR camera is made by Wimberley. Just as with your tripod, make sure the head is easy for you to use. Camera shops often have models available for you to try. Bring your camera and attach it to the different designs to see which one you like best. If you're shooting with more than one camera, consider buying a tripod head with a quick release. This allows you to switch quickly between different cameras without having to change your setup.

GENERAL CAMERA CARE

HOW TO CLEAN YOUR CAMERA

Use a can of air to blow dust out of the cracks and crevices of your camera. Prior to aiming the air can at your camera, always clear the passage of the air can tube with two or three short bursts. Make sure you never shake the can, because the next burst of air will blow residue all over your equipment.

Wipe down your camera with an old lens cloth.

Consider sending your camera to the manufacturer for professional cleaning once a year or after shooting in particularly harsh environmental conditions.

HOW TO CLEAN YOUR LENS

Use a can of air to blow dust off the surface of the lens.

When wiping the lens, always use a clean microfiber cloth, *never* your T-shirt or anything else for that matter. Start in the center of the lens using a circular rubbing motion until you reach the edge of the lens.

If there are still smudges on your lens, use a single drop of lens-cleaning solution on the cloth and repeat the circular motion starting in the middle of the lens.

CLEANING YOUR CAMERA'S IMAGING SENSOR

Never touch the imaging sensor!

Use a blower brush to blow specks off the imaging sensor. Don't set the camera to a long shutter speed when blowing off the sensor. Instead, switch the camera's cleaning setting to On. This cuts off the electricity to the sensor (when the sensor is activated, it's statically charged, causing particles to stick to it).

If your images still contain dark or gray spots, you'll have to take slightly more drastic cleaning measures. I don't suggest doing this yourself; send your camera to the manufacturer for a thorough cleaning.

If you do decide to take the risk of cleaning the imaging sensor yourself, you can find supplies and directions on how to do it from Photographic Solutions, Inc. (See Resources on page 159.)

Microscopes

The microscope lens brings a fascinating world of subjects into focus. Like an abstract painting, images shot at superhigh magnifications remove a subject from context, allowing the viewer to concentrate on form and color.

Using a microscope in conjunction with a digital camera revolutionized the highly specialized world of microscope photography. Like other closeup images, it's the ability to see your microscope image results immediately that makes this genre of photography possible for the patient photographer. If you have the right setup, using a microscope can be easier than using a bellows, and your magnification rates will be much higher.

Microscope photography is a specialized—yet diverse—field. Images can be shot using anything from low-power dissecting scopes up to high-power electron-scanning scopes. Each type of scope has its own type of light source, enabling a photographer to illuminate a subject with different methods. An entire book could be dedicate to the topic of digital microscope photography; this section just serves as an introduction to entice you to try something new.

Getting Started

Attaching a digital camera to a microscope sounds more complicated than it is. I use a set of adapters made by ScopeTronix to attach both my Nikon Coolpix 4500 and Nikon D1X to a variety of microscopes. You may be able to attach the camera directly to the eyepiece or on a back-mounted center column.

When you use a point-and-shoot digital camera with a microscope, the benefit comes from using a tilt LCD screen. You can use this screen to focus instead of using the microscope

Swallowtail butterfly, University of Delaware (captive). Nikon 4500 on a dissecting microscope

An ideal subject for photographing under a microscope, a butterfly wing is relatively flat, allowing for a crisp shot even with a limited depth of field. Since the plane of focus is minute, a flat subject when positioned correctly exhibits edge-to-edge sharpness. The hardest part of taking this shot was making sure the wing was tilted to encompass the plane of focus—a millimeter off-kilter would have blurred part of the wing. I used two bendable dissecting lights to illuminate the 100+ scales in this frame. An amazing trait of this butterfly is the way the wing scales appear to change color as the angle of illumination changes, going from deep turquoise to an almost fluorescent blue.

eyepiece. In fact, this is a much better method. I've found that subjects that appear to be in focus in the eyepiece are not in focus in the camera, so I always use the camera's LCD screen. Use the manual setting to adjust your shutter speed, *f*-stop, and focus.

Just as it is with an SLR, vignetting—the unwanted side-effect of stacking lenses (see page 32)—is also an issue when using a microscope with your point-and-shoot digital camera because you're stacking lenses. To avoid a vignette, use a low *f*-stop as your aperture setting. I set the *f*-stop to the lowest setting, increase it until a vignette appears, then I back off one stop. You can also use the zoom feature to increase or decrease the size of the image. Be careful not to extend into the digital-zoom, as your image quality will degrade. A digital zoom magnifies the center of an image; it creates an image that is less sharp, because the image has been cropped and interpolated by the camera's processor. An optical zoom uses the camera's real multifocal length lens to capture the image; the image has not been interpolated and is, therefore, a higher quality than an image taken with a digital zoom. Using only the optical zoom will ensure the highest possible quality image. Once in focus, use the timer on your digital camera to avoid camera shake.

ScopeTronix microscope adaptors.

Weevil scales. Nikon 4500 on a dissecting microscope

This weevil was curved with ridges on its hard scale-covered modified wings (known as *elytra*). Using a dissecting microscope gave me only one choice: use the low depth of field creatively to capture an interesting form. If you're using a microscope to illustrate subjects for scientific purposes, this may not be your best choice, especially if your subject is curved like this weevil. However, if you're using a microscope to capture interesting subjects, use the low depth of field creatively to your advantage. There's nothing wrong with a low depth of field, as long as you use it properly.

Additional Equipment

Batteries and Charging

Camera batteries are getting lighter, smaller, and longer-lasting. This does not mean you won't need backups. I always carry at least two backup batteries in case I find myself in a fantastic shooting situation. Most of today's cameras use the manufacturer's proprietary batteries and chargers. Whenever possible, always use rechargeable batteries—these will save you money and help our environment.

If you travel, you'll need to charge your batteries on the road. Some camera companies sell car chargers for their proprietary batteries in addition to the AC chargers used in the home. One of the best purchases I've made for traveling is an AC adapter that plugs into my car's cigarette lighter. With this, you can bring all of your electronics: cell phone, laptop, cameras, flashes, walkie-talkies, and even an electric toothbrush if you want,

AC adapter

I plug this adapter into the cigarette lighters of my Volkswagen Golf. I have one AC adapter for the front lighter and one for the back lighter in my car. Even if you don't own a digital camera, these are wonderful little inventions. I've even hardwired them to a vehicle's battery while on safari in Tanzania. It was just enough to keep me digitally powered up for three weeks. They're available from Radio Shack.

although this is a bit excessive. The money you spend (about $50 on the AC adapter) is nothing compared to what you can spend on car adapters for each electronic device. When traveling, I keep all of my battery chargers in a hard-sided Pelican case when not in use. This keeps the cords from tangling and driving me crazy.

If traveling abroad, I always carry two multi-AC power adapters that cover almost all types of power sources. You never know when one is going to burn out; they're only about $25 and an extra one can keep you shooting. When traveling abroad, make sure you check the power source of the country to which you'll be traveling so that you are electronically prepared.

When you aren't using your camera or flash for more than a few days, make sure you remove the batteries. This will eliminate the possibility of the batteries corroding and ruining your equipment. Have you ever seen what happens to a flashlight when the batteries corrode? It's not a pretty sight.

If you're shooting in cold climates, keep your batteries in an inside pocket; this will keep them warm, thus increasing their shooting life. When you're ready to shoot, put them in the camera and take them out when you're finished. While this technique usually works, it's not a guarantee. As I hiked up Mt. Kilimanjaro "pole, pole" (Swahili for *slowly, slowly*), there was plenty of time for closeup shots! I was hoping to capture a shot of the glaciers before they melt completely by the predicted year of 2020. Unfortunately, when I reached the roof of Africa's Uhuru point, it was so cold my shutter froze. My camera did turn on—the batteries were working because I kept

them in my pocket—however, the shutter had seized up. Like a good fishing tale, every photographer has a story of the one that got away! Next time, I'll be sure to keep my camera inside my jacket no matter how difficult it may be.

Camera Bags

A good camera bag is just as important as a good camera. I'm guilty of having a lot of camera bags, but each one has a specific purpose. Hard-sided watertight camera bags made by Pelican are great if you're traveling in a canoe or storing gear in your car. However, try taking one of those hard-sided cases on a multiday backpacking trip, and you'll regret every step of the way because of the added weight. Besides my hard-sided Pelican cases, I use a variety of camera bags made by RoadWired. They're durable, have lots of compartments, and are comfortable to carry. I also carry a photographer's backpack designed by Promaster for those long day hikes. It holds loads of gear and lunch, and has two side pockets: one for water and one for my tripod. My best suggestion is to try before you buy! Bring your equipment to your local camera store, and make sure your gear fits, the bag is easy and comfortable to use, and the construction is sturdy.

When traveling, you may want to consider concealing your nice new camera bag under an old dirty knapsack. A camera bag sends out a signal to thieves: Look at me, I'm carrying something you want and all you have to do is take it off my shoulder!

Camera Rain Gear

Inclement weather yields some wonderful shooting conditions. But ask yourself: Are you ambitious enough

to gear up for the challenge of shooting in less-than-perfect conditions? And, is your camera equipped for the inclement weather? Don't allow your camera to get wet—electronic devices and water are not good combinations. There are ways to take advantage of shooting in rainy and snowy conditions, and the easiest is to make a raincoat for your digital camera. I like to use a see-through plastic bag to cover the entire camera except for the lens. By using a see-through plastic bag, I can still use all of my camera's settings and see through the viewfinder. If you have a lens hood, this is a perfect application. You can

mount your camera to a tripod—and you may have to, with the decreased light falling on a rainy or snowy day.

Don't get me wrong; if it's really pouring, be smart and put your camera away. I always tell my students that if you don't think you can pay for your gear with the shot that you are risking your camera for, then put it away! I've been stupid and lost a camera because I didn't protect it when shooting in the rain. Don't let it happen to you. This technique also works well in dusty environments. If you don't want to make your own camera raincoat, you can purchase one. (See Resources on page 159.)

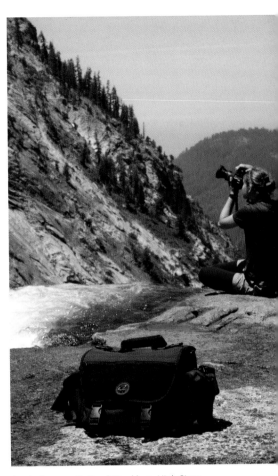

Josyln Berger with RoadWired bag, High Sierra Trail, Sequoia National Park, California. Nikon D1X with 28–70mm 1:4.5 macro lens

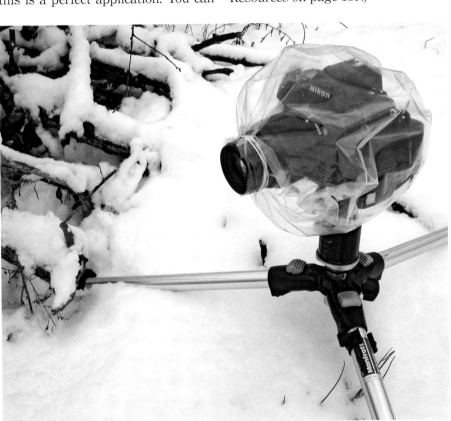

Nikon D1X camera under a homemade raincoat, Nikon 4500

A cheap see-through plastic bag enabled me to keep shooting even in these snowy conditions. I used two rubber bands: one to close the end of the bag and another to secure the bag around the end of my lens. To secure the camera to my tripod, I fastened my quick-release clip over the plastic bag. I started the hole in the bag with the tip of a pen, then screwed the clip to the bottom of my camera. Using the rubber bands and the clip on the outside of the bag creates a tight seal, keeping water away from my camera. The only part not covered is the glass on the camera's lens. I also suggest using a UV filter to protect your camera's lens when shooting in wet weather.

Downloading and Storing Digital Files

Equipment for Downloading

If I'm trekking into the backcountry or traveling to places where a laptop is too bulky to carry, portable hard drives are my preferred choice for downloading images. My older 20-gigabyte minds@work drive is still working fine after three years of intense use. I also use a 40-gig iPod as a traveling companion, which also plays MP3 and stores my address book and calendar. While the iPod download time is not as fast as my minds@work drive, it does hold more images and play music. The biggest problem I have with the iPod is that I can only download about 2 gigs in images before the battery runs out. This is fine if you're going to be near a power source every couple of days, but if you're going to be away from power for a few weeks, it simply won't hold up.

Portable hard drives are small and light, they store a lot of data, and as of this printing, they start at about $300. On some newer models, like the Jobo Digital Giga Vu PRO and Flash-Trax, you can view the images in color like you can on a laptop.

Battery-operated CD burners are another good option for downloading your digital images. I bought one of these to try out when hiking Mt. Kilimanjaro. Portable hard drives won't work above 10,000 feet elevation because the air expands inside the drive, thus freezing it up. Taking them to these heights won't destroy them; it will only render them unusable at high elevations. I used a portable CD burner at 15,500 feet, and it worked fine. The only problem that can occur at heights like this is the low temperature. If this is the case, you can burn your CD in your sleeping bag, which will hopefully be above 32 degrees Fahrenheit.

I also found that a portable CD burner was useful for burning CDs while on safari with my students in Tanzania. The burner accepts most digital media, allowing students to burn a CD, reformat their card, and keep shooting. Everyone was able to use my portable CD burner, which also kept costs down. The drawback, however, is that they're larger than portable hard drives, and you can only fit 780 MB of data onto a CD. I suspect a battery operated DVD burner is in the works, enabling you to store a full 4-gig card onto a 4.7-gig DVD.

Battery-operated CD burner

Digital Storage Devices

Digital storage devices come in a variety of shapes and sizes. The first storage device you'll need is one for your digital camera. At the writing of my first book in 2003, the largest "digital media" available for a digital camera was 1 gigabyte. As of 2004, Lexar sells a compact flash card smaller than a matchbook that holds an incredible 8 gigs of data. That's almost as much as the hard drive of the laptop I purchased in 2002. Compact flash cards, either type I or type II, are still the industry standard for digital media; their sturdiness and large data capacity make them my preferred choice.

Instead of buying the largest single item of digital media you can afford, I suggest spending that amount of money on two pieces of digital media. By doing so, you back up your system of capturing digital images. Photography in the field is like rock climbing: you always want a backup! Once you have filled up your digital media, you need to save the images somewhere else so that you can keep shooting.

A laptop is my preferred choice for downloading images, especially if I'm spending my nights in hotels or places that have access to electricity and the Internet. You can view and edit your images, and can access any other applications you may need to use. If I need to show examples to students in the field during one of my backpacking/photography trips, my 12-inch laptop is small and light enough to fit into my backpack. You can store images on the hard drive and also back them up to a CD or DVD. A laptop is the most expensive and largest storage device to house your images, but it also gives you the most freedom.

EQUIPMENT INSURANCE

You should think seriously about insuring your digital camera equipment. You wouldn't buy a brand new car or diamond ring without getting insurance, so why would you buy a camera—something that you continually put in harm's way—without getting insurance? A homeowner's insurance policy may cover only $1,000 in camera gear—a drop in the bucket if you have loads of digital SLR camera equipment. Joining an organization like NANPA (North American Nature Photography Association) or a local camera club may give you an opportunity to purchase equipment insurance where your homeowner's policy may turn you down. I asked my homeowner's insurance company to add all of my equipment to my policy. They agreed, but when I asked if my equipment would be insured if, let's say, I happened to drop it off the side of a Zodiac (a small inflatable raft used to get from ship to shore) in Antarctica, they quickly declined my request and wouldn't even give me a quote.

Almost every camera I've ever owned has ended up broken. Is it the manufacturer's fault or mine? It's mostly my fault. Can you think of any electronic device made to fall off a cliff or survive a sandstorm? I'm careful, but I'm not overly protective. I'm a firm believer that camera gear is made to use. A banged up camera says a lot about the photographer.

CAMERA FEATURES & TECHNIQUES

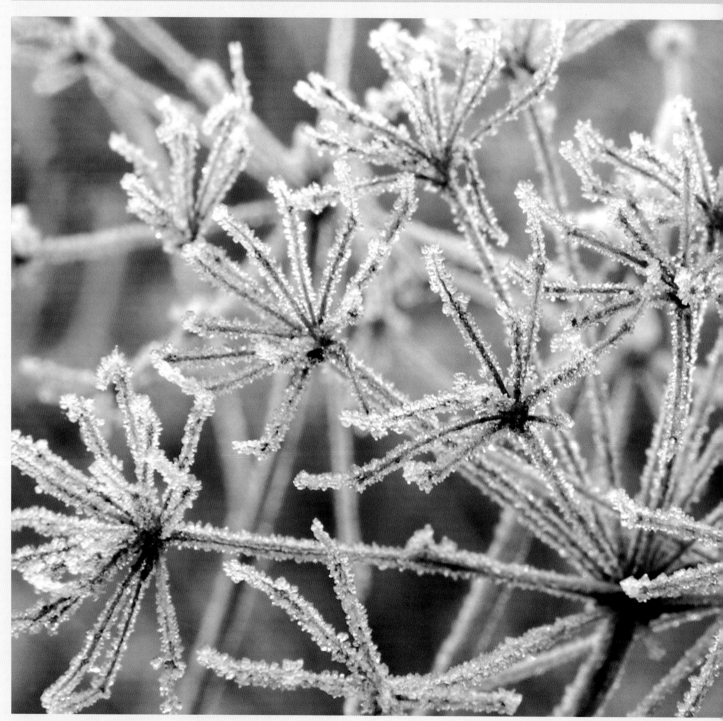

Frost-covered Queen Anne's lace, Unionville, Pennsylvania. Nikon D1X with 28–70mm 1:4.5 macro lens

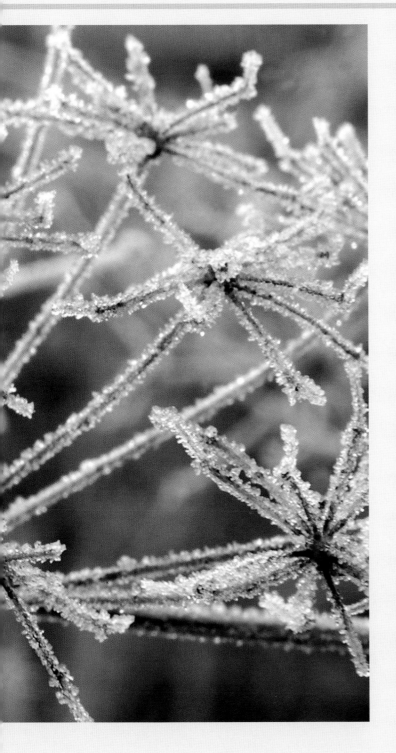

"My automatic mode takes great pictures! Why should I bother learning how to use the manual camera settings?" I've heard this question from many people, and it always baffles me. You paid for all the sophisticated options on your digital camera—learn how to use them. If you're content to paint by the numbers or bake a cake using a mix, then this chapter isn't for you. However, if you want total control over the creative shooting process, then switch your camera to manual mode and keep reading. Control the camera. Don't let the camera control you!

Basic Camera Mechanics and Settings

You're probably familiar with the basics of photography. Most people don't start off their journey into the closeup realm without prior knowledge of photography skills. Taking this into consideration, I'll review how camera settings affect the outcome of an image. I'll also include various settings that I use that are found only on digital cameras.

To start, you should have a basic understanding of the mechanics behind a digital camera. When your camera's shutter opens, light is captured by an imaging sensor called either a CMOS (complementary metal oxide semiconductor) or a CCD (charged coupled device). The imaging sensor is composed of millions of photosites, each one relating to an individual pixel in the final image. More photosites on an imaging sensor correlates to a camera with a higher megapixel rating, known as *camera resolution*. *Image resolution* is different than *camera resolution* and *print resolution,* which are discussed on page 148. The photosites on the imaging sensor capture individual colors. The camera's built-in computer then adjusts the image for the individual settings you have selected. Once the data is interpolated, the camera saves the image onto your digital media as a compressed JPEG file or uncompressed TIFF file. If you're shooting RAW files, the camera uses minimal processing. (See pages 138–143 for more on RAW files.)

Photography is a give and take process. The three factors controlling light in your image are: shutter speed, *f*-stop, and ISO setting. Since these are all measured in stops of light, they can be shifted around in any order that you see fit. It always amazes me that when I take fifteen students to the same place and we all shoot the same scene, we end up with fifteen different images. Each student uses different camera setting combinations. The result—a photographers voice shines through.

Shutter speeds, *f*-stops, and ISOs aren't new to photography. Whether you're shooting with a digital camera or film camera, adjustments to these settings are the necessary building blocks to creating an image. Understanding how these settings affect your images permits you to tap into the more advanced features of your digital camera and show your creativity as a photographer.

Shutter Speed

The shutter speed controls the length of time that your camera's aperture stays open. Shutter speed affects how action is rendered in an image; in other words, it is responsible for either stopping or blurring action. A fast shutter speed will stop action, whereas a slow shutter speed will blur action. The longer the shutter speed, the more light is captured by your camera's imaging sensor.

Shutter speeds are measured in stops—a halving or doubling of the shutter speed is equal to a change of one stop of light. For example, 1/30 sec. will allow one more stop of light than 1/60 sec. The reverse is true, as well: 1/30 sec. will allow one stop less light than 1/15 sec. Cameras display shutter speeds in full-stop, half-stop, and even third-stop increments. Full stops are: 1 second, 1/2 sec., 1/4 sec., 1/8 sec., 1/15 sec., 1/30 sec., 1/60 sec., 1/125 sec., 1/250 sec., 1/500 sec., and 1/1000 sec. Many digital cameras include faster shutter speeds of up to 1/4000 sec. and some have shutter speeds as long as 30 seconds.

If 30 seconds isn't long enough, you may be able to set your camera on the Bulb setting and use a cable release to capture even longer exposures. The Bulb setting allows you to use a shutter speed that's as long as you please. I don't recommend using a shutter speed over 30 seconds, however, because of the "digital noise" that occurs as a side effect of long exposures. Taking long exposures is where a digital camera fails in comparison to a film camera. Improvements are being made, but not as fast as I would like.

Shutter speed is also a key component of avoiding *camera shake*, which is also known as *photographer shake*. When the shutter speed for your camera is too slow for the lens you're using, the entire image will look blurry because you moved the camera during the exposure. This occurs when you're handholding the camera, not when the camera is on a tripod. To avoid camera shake, use the Handheld Rule, which states that your shutter speed must be at least 1/the focal length of your lens (if you're handholding your camera). It's as simple as that! If you're shooting with a 50mm lens, your shutter speed must be at least 1/50 sec. to capture a sharp shot. This rule is especially important when shooting closeups, as the slightest movement can blur your shot.

If you're using a digital SLR that's not equivalent to a 35mm camera, make sure you calculate the digital magnification rate. The magnification rate is typically 1:1.5, meaning a 50mm lens, when used on a digital SLR with a digital factor of 1.5, is equivalent to using 75mm lens. A

Hot spring mud volcano, Yellowstone National Park, Wyoming.
Nikon D1X with Nikkor AF VR 80–400mm lens

200mm lens, when used on a digital SLR with a 1.5 digital factor, is equivalent to a 300mm lens, and so on. How does this change the Handheld Rule? If your digital SLR isn't equivalent to a 35mm camera, you'll need to use a faster shutter speed to capture a sharp shot. If you're using a 100mm lens, your shutter speed needs to be set 50 percent faster than the handheld rule states in order to capture your scene in sharp focus. When I'm using my favorite lens for closeups (the Micro-Nikkor 105mm f/2.8D AF), I must set my shutter speed to 1/160 sec. or faster to ensure a crisp image.

Even though the bubbling hot spring was rank with the natural sulfur smell, it was a good subject for stopping action. A park-constructed boardwalk surrounding the spring keeps people off the dangerous acidic land, and I did watch a buffalo in the distance, but the gurgling spring commanded my attention. To freeze the gurgling action, I used a tripod and a shutter speed of 1/500 sec., focused on a particularly active spot, and waited for large bubbles to emerge.

HANDHELD RULE

$$\text{Shutter Speed} = \frac{1}{\text{Focal Length of Lens}}$$

Waterfall, Grand Teton National Park, Wyoming. Nikon D1X with Micro-Nikkor 105mm f/2.8D AF lens

After backpacking all day with a warm water bottle, I was ready for a cool refreshing drink. This snow-fed mountain stream, just above the freezing point, was the perfect spot to filter some water. A few sips later, I was ready to set up my tripod and capture the 3-inch waterfall cascading into a small pool. In the first image (top), I stopped the action by using a fast shutter speed of 1/500 sec. and an f-stop of f/4. In the second shot (bottom), I blurred the action by using a slow shutter speed of 1/15 sec. and an f-stop of f/22. To capture the same exposure in the second scene, I decreased the shutter speed by five stops, permitting the water to blur during that length of time. Let's count: 1/500 sec., 1/250 sec., 1/125 sec., 1/60 sec., 1/30 sec., 1/15 sec. That's five stops. To capture the same exposure in the second image, I also needed to close down the aperture by five stops, to f/22.

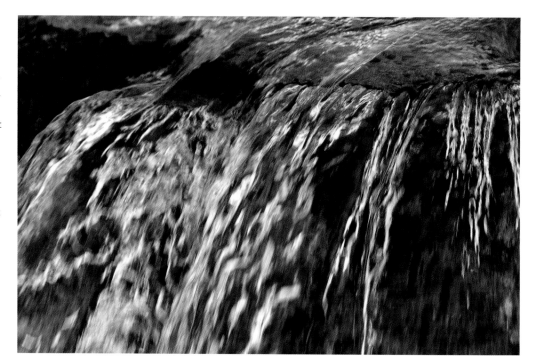

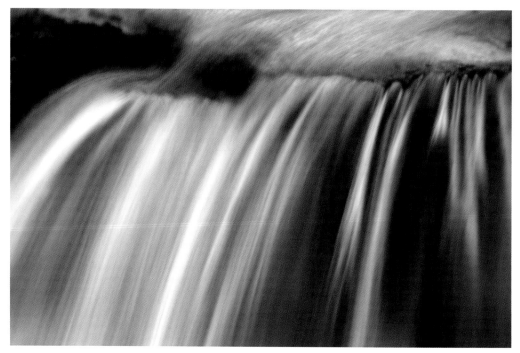

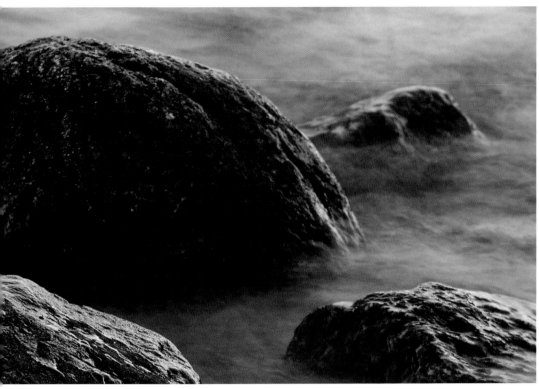

There isn't much light for photographers to work with before sunrise when you can barely see—but that doesn't mean you give up. Using a tripod to steady the camera, I knew a high f-stop was crucial to capturing the rocks in sharp focus. That left me but one choice—use a long shutter speed. For this shot, my shutter speed was 30 seconds to capture the exposure I wanted. The other benefit of using a long shutter speed is shown by the lapping waves that form a soft blur, adding mystery to the scene. In addition to using a tripod, I used the timer and the anti-mirror-lock setting to avoid photographer shake.

Rocky shore, Jenny Lake, Grand Teton National Park, Wyoming. Nikon D1X with Nikkor AF VR 80–400mm lens

I handheld the camera for both these shots. For the first image, I broke the handheld rule, using a shutter speed of 1/60 sec. The entire shot is blurry because I moved the camera during the exposure. In the second image, I followed the handheld rule, using a shutter speed of 1/250 sec. This was fast enough with the lens I was using to capture a sharper image. I had to use a shutter speed of 1/250 sec. and not 1/125 sec. because my Nikon D1X has a magnification rate of 1.5.

Dew-coated asters, Unionville, Pennsylvania. Nikon D1X with Micro-Nikkor 105mm f/2.8D AF lens

f-Stop

The *f*-stop is the aperture setting on your camera. Like shutter speed, it uses stops to measure the amount of light hitting your digital camera's imaging sensor. An aperture that's small in size will have a high number, such as *f*/22, whereas an aperture that's large in size, will have a small number, such as *f*/1.4.

These are actually fractions, which explains why the higher number equals a smaller-sized opening. A larger-sized aperture allows for more light to be captured by your camera's imaging sensor.

The *f*-stop is also responsible for the depth of field in an image. The depth of field is the plane that appears to be in sharp focus. This plane can either be very large or deep from front to back in an image, or very small or shallow. A smaller-sized aperture (an *f*-stop of *f*/22, for example) will have a large plane that appears to be sharp, whereas a larger-sized aperture (*f*/1.4, for example) will have a small plane that appears to be sharp. This effect is even more dramatic when shooting closeups.

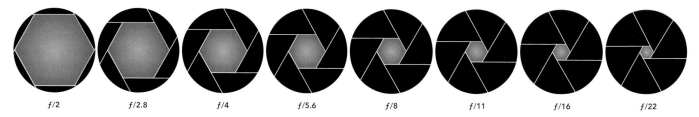

| *f*/2 | *f*/2.8 | *f*/4 | *f*/5.6 | *f*/8 | *f*/11 | *f*/16 | *f*/22 |

This diagram shows the different aperture sizes of a lens. The lower the *f*-stop, the larger the opening in the lens and the shallower the depth of field. (Low *f*-stop = Less depth of field.) The higher the *f*-stop number, the smaller the opening in the lens and the greater the depth of field. (High *f*-stop = More depth of field.) Remember, since the *f*-stop is really a fraction, as your *f*-stop number increases, the size of your aperture decreases.

Capturing this shot in sharp focus and handholding my camera, even in the shade, was a cinch. My subject wasn't going anywhere—it hadn't moved for hundreds of years. Since the petroglyphs were carved on a flat surface, I used my lowest *f*-stop— *f*/2.8. This was sufficient to capture all of the carvings in sharp focus, because my camera's focal plane covered the entire surface. Using a low (larger-sized) *f*-stop let in a lot of light, which enabled me to use a high shutter speed and handhold the camera.

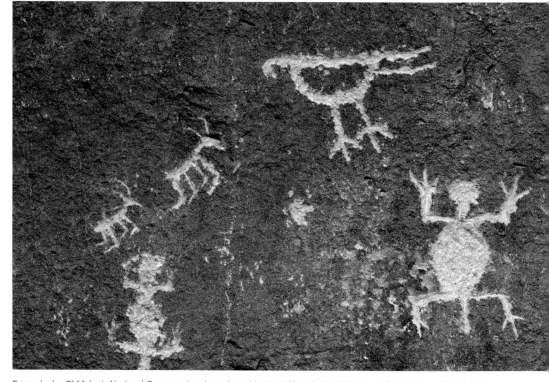

Petroglyphs, El Malpais National Conservation Area, New Mexico. Nikon D1X with Micro-Nikkor 105mm f/2.8D AF lens

Prickly pear cactus, El Malpais National Conservation Area, New Mexico. Nikon D1X with Micro-Nikkor 105mm f/2.8D AF lens

I found a spectacular clump of cacti while hiking through the lava formations of El Malpais National Conservation Area. I positioned my tripod directly over the cacti, making sure my arms and legs weren't touching the sharp spines. In the first image (left), I used my lens's lowest f-stop of f/2.8, which resulted in a shallow plane of sharp focus and, thus, a blurry background. I then switched my f-stop to f/32 to get greater depth of field to capture some of the spines in the background, while adjusting my shutter speed accordingly (right). Even with my highest f-stop, I wasn't able to capture all the spines in sharp focus because depth of field is very shallow when shooting closeups. If you don't want to take both a low depth-of-field shot and a high depth-of-field shot, you can use the depth-of-field preview button (if your camera has one); this allows you to see what will be in focus in your image. It's a toss up as to which of these two images I like best. I'm happy I shot both, because I can always decide later which one to use.

ISO

On digital cameras, the ISO (International Standards Organization) setting is used to describe the imaging sensor's sensitivity to light. A lower ISO setting of 100 causes the imaging sensor to be less sensitive to light. This means that more light is needed to capture a properly exposed image. A higher ISO setting of 800 causes the imaging sensor to be more sensitive to light. This means that less light is needed to capture a proper exposure.

Why don't photographers always use a high ISO setting? A higher ISO setting causes "noise" or "grain" to appear in an image. On a digital camera, a high ISO setting will cause an image to have a grainy texture. Think of a low ISO as a satin cloth and a high ISO setting as a piece of sandpaper.

I always try to use the lowest possible ISO setting to capture the smoothest possible image. If I want to add noise after the fact in an imaging program, it's an easy step—taking away noise is not. You won't be able to see the difference on your camera's LCD screen, and you may not be able to see the difference on your monitor until you blow the image up to 100 percent. Printing images 5 x 7 inches or larger is when I see the benefits of shooting at a low ISO setting rather than at a high ISO setting.

How do you know what ISO setting to use? This depends on the subject, the ambient light, and how you want the image to appear. If you're handholding the camera, you must set your shutter speed to at least 1/the focal length of the lens. Then, you must decide if the depth of field is more important or the graininess? Like shutter speed and f-stops, ISO settings also work in stops. A halving or a doubling of the ISO number equals one stop of light. The lowest ISO setting available on a digital camera at the writing of this book is 6, and ISO settings can reach up to 3200. Your camera may include full, 1/2, and even 1/3 ISO settings. What's great about using a digital camera is that you can change ISO settings between shots (rather than having to wait until you reach the end of a roll of film). You might have five or six different ISO settings on the same digital media and that's okay. If you were shooting film, the best you could hope for is two cameras, each with different ISO speed films.

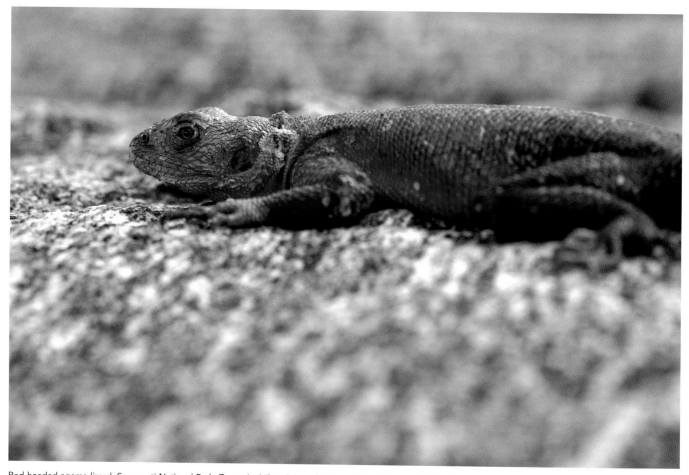

Red-headed agama lizard, Serengeti National Park, Tanzania. Nikon D1X with Micro-Nikkor 105mm f/2.8D AF lens

Metering

Many digital cameras come equipped with three different metering settings. Depending on your subject, you may wish to switch between the various available meter settings. Before you shoot, decide which metering choice is most appropriate for your subject.

The *spot metering* setting reads the amount of light falling on your subject from a narrow area within the scene. You may be able to select the spot from which your camera meters the scene. This is the best metering option to use when your subject has high contrast and you want either the light areas or the dark areas to have detail. You can't always have both.

Center-weighted metering places an emphasis on reading light that falls in the center of the frame. You can point your subject in the dead center of the frame, take a meter reading, then recompose your image for a more interesting composition. *Matrix metering* takes an average reading of the light falling on the entire scene and is most suited for everyday use.

Since I started shooting digital, I don't spend a lot of time worrying about taking a meter reading. I take a meter reading and test shot, look at my camera's LCD screen to view the histogram, and make exposure adjustments as needed. It's one way in which

I have modified my shooting style to adjust to the instant feedback that a digital camera offers. Some may say my method is cheating. Is it cheating to use a calculator instead of a slide rule? No. Is it cheating to bake bread in an electric oven instead of a wood-burning hearth? No. The image is what matters, not the process. Use the technology to find a metering system that works for you and stick with it. I also never use a handheld meter. In fact, I sold mine a few years ago and have never regretted that choice. I know some photographers can't live without a handheld meter, but to me it's an added piece of gear that I don't need.

METERING TIPS

- Remember, the correct exposure is the exposure *you want*, not what the camera wants.

- Don't spend too much time metering a scene—take a shot and check your camera's histogram (see pages 132–137).

- Overexpose from your meter reading when shooting light subjects, such as snow or white sand.

- Underexpose from your meter reading when shooting dark subjects, such as volcanic rock.

- Trust your camera's histogram and learn how to use it; the histogram is today's handheld light meter.

◄ While approaching this lizard, I made sure not to make any quick movements and scare it. My patience paid off as I was able to position my camera close. I was handholding my camera, and I didn't have a flash handy. My shutter speed had to be at least 1/160 sec. because of the 1.5 digital factor. I also wanted a crisp image, so I set my ISO to 125. This left me with only one option for my aperture: I needed to use a low f-stop of f/4, producing a shallow depth of field. You can see that centering the lizard in the frame resulted in only a shallow, centrally located area of sharpness. Everything in front of and behind the lizard is blurry. You decide where to place your focal plane—it doesn't always have to be in the foreground. Move it around, and add a little diversity to your images.

File Format

Over the past few years, a great deal of attention has been paid to the shooting format that digital photographers choose for their images. There are two basic types of digital photographers: those who shoot RAW, or uncompressed files, and those who shoot JPEG files.

A JPEG file is like shooting slide film—what you see is what you get. A JPEG file is a *lossy* compressed file, allows faster download times, and stores more images per megabyte than RAW or TIFF files. JPEGs are called *lossy* because some data is lost when the file is compressed, depending on the level of compression selected. You may be able to see the degradation of the image. The level of compression correlates to the quality of the image. A JPEG image compressed at 1:4 times the original will have a higher quality and use more memory on your digital media than an image compressed at 1:16 times the original file size.

In addition, a JPEG file imbeds all of your camera's settings into the image. Your digital camera processes settings—such as white balance, contrast, and sharpening—then compresses the data and saves it onto your digital media as a JPEG file. JPEGs are ideal for emailing and sharing images because most computers read them easily.

A RAW file is more like a film negative, giving the photographer ample leeway in the digital darkroom for color and tonal adjustment. A RAW file is a *lossless* compressed file, consuming more memory on your digital media than a JPEG file but less memory than an uncompressed TIFF file. On the plus side, you have an original file with minimal processing by your digital camera. In Photoshop, you can choose your settings (like Temperature and Sharpening) after the image is shot, or you can use your camera's proprietary software to work with the RAW file.

The question is, What type of file should you shoot? Most amateurs choose to shoot JPEG files, while professionals tend to shoot RAW files. This doesn't mean that shooting JPEGs makes you an amateur; there are plenty of situations in which pros are content shooting high-quality JPEG files. If your forte is in the digital darkroom, I suggest shooting RAW files. A RAW file will allow you more freedom to adjust for color balance and contrast without some of the side effects arising from rendering JPEG files. To use the RAW file format, you'll need to download your images using your camera's proprietary software or, my preferred method, the Adobe Photoshop RAW plug-in. Adobe Photoshop CS ships with the RAW plug-in, or you can purchase the RAW plug-in for Photoshop 7 separately.

Before the RAW plug-in was available in Photoshop, I didn't bother shooting RAW files because I wasn't happy with the digital workflow available from the proprietary RAW file software. I was happy with high-quality JPEG files. However, since the RAW Photoshop plug-in became available, I've become hooked on shooting RAW files. The creative control in the digital darkroom is spectacular, and I far prefer it to shooting JPEG files.

If shooting is your specialty, I suggest shooting at the highest quality JPEG your camera allows. This lets you take and store more images in less time with the same megabyte size digital media. The only downside is that you won't have as much flexibility in rendering your image in the digital darkroom. When I'm on extended trips and the situation warrants, I still shoot JPEG files. An example would be when I am trying to capture action and am running low on digital memory, I switch to a high-quality JPEG file. Like I said before, photography is a give-and-take process. I give up a little freedom in the digital darkroom by shooting JPEG files instead of shooting RAW files.

No matter what file format you choose, after downloading you should always save the image as an uncompressed file, like a TIFF or Photoshop file. If you save the image to your hard drive as a JPEG file, the image is being degraded each and every time you resave it. *One final note*: some of the helpful settings on your digital camera may be buried in one of the shooting menus; you may need to read your camera's instruction manual to find them. (For more information on working with RAW files, see pages 138–143.)

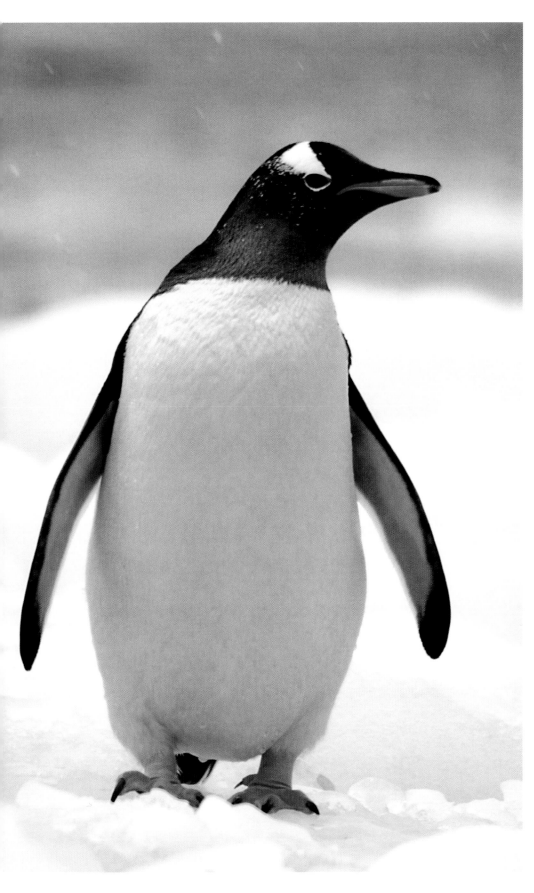

Gentoo penguin, Antarctica. Nikon D1X with Nikkor AF VR 80–400mm lens

Penguins, penguins, penguins everywhere you look. It's easy to fill up your digital media in this incredible location—and I did. By using the highest quality JPEG file format, I was able to capture a variety of penguin poses in a short amount of time. If I had chosen the RAW file format, I might have missed the shot, because I would have filled up my digital media faster with fewer shots. Since I had time to carefully meter the scene and adjust my white balance, I was content shooting high-quality JPEG files.

Additional Settings

Noise Reduction

This is a wonderful setting for those of you who shoot long exposures. It lessens the side effect of noise appearing in longer exposures that is common in many digital camera models. I've found that the highest shutter speed I can use without noise is about 30 seconds. Hopefully this side effect will improve with new technology.

Self-timer

The self-timer, available on many digital cameras, is a great way to avoid photographer shake. Even when your camera is on a tripod the slightest movement from the photographer can lower the crispness of an image. Unless I'm shooting action shots or handholding the camera, I use the self-timer for almost every shot taken. To save on battery power and the duration between shots you can set the self-timer to a variety of durations. When using a tripod, a

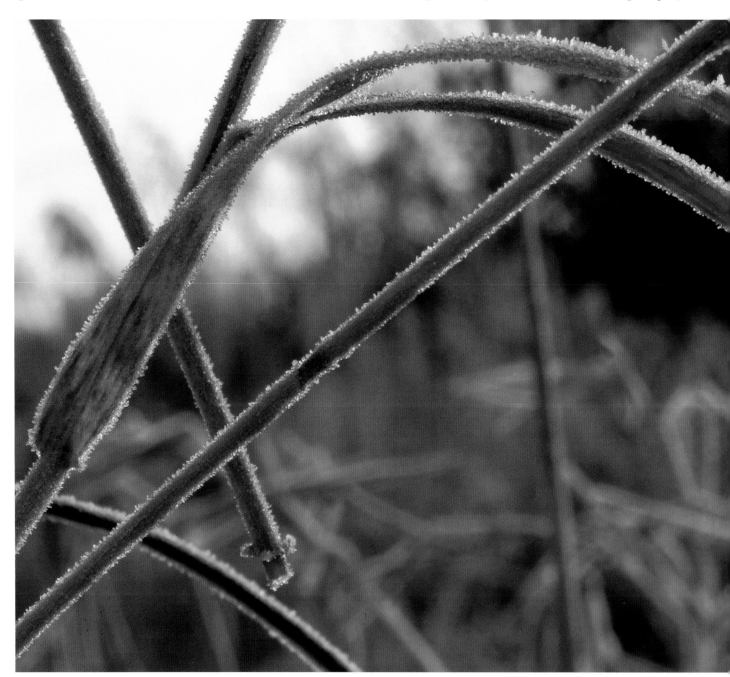

2-second duration gives me enough time to move my hand away from the camera after pressing the shutter. By adjusting the timer, I don't accidentally move the camera during the exposure and I avoid photographer shake.

Anti-mirror-shock

Why would you choose the anti-mirror-shock setting? Digital SLR cameras

record a scene at the same time the mirror is raised. Raising the mirror causes slight vibrations, which can create a blurring effect in your images. When you choose the anti-mirror-shock setting the mirror is raised and after a short period of time when the vibrations subside the image is recorded by the camera's imaging sensor. This setting is especially useful when shooting closeups from a tripod or when attaching your camera to a microscope when sharp focus is crucial.

You won't see the difference on the LCD screen of your camera, but you will see it when the image is enlarged on your computer monitor. Use this setting only when your camera is on a tripod or attached to a microscope; if you're handholding the camera and using natural light or flash, the anti-mirror-shock won't help you.

Image Sharpening

Once you've mastered capturing your subjects in *sharp focus*, you need to evaluate your images based on *image sharpness*. I know the two terms sound the same, but they aren't. *Sharp focus* refers to your subject being in focus. *Image sharpness* refers to how distinct the edges of the subjects appear in your images. Image sharpening can be done in the camera or in an imaging program. If you're shooting JPEG files and you find your images need a lot of sharpening in the computer, check to see if your camera allows you to adjust the sharpness level. Adjusting the

level of sharpness in the camera can save you some time on the computer. However, most images I take need some sharpening in Photoshop.

Tone Compensation

If the contrast in your images doesn't appear the way you envision, check to see if your camera is equipped with a tone compensation setting. This setting allows you to adjust a scene to add more contrast in diffused lighting situations or to reduce contrast on bright sunny days. If you're shooting high-quality JPEGs, use this setting to render the image as close to the way you want to print it. If you're shooting using a RAW file format, you'll be waiting to adjust the tone in your imaging program.

Card Formatting

Instead of erasing your digital media after downloading your images to your computer, reformat it for best results. Formatting will delete all of your images and set up the card at the same time. Using this process ensures that your card isn't corrupted, giving you a clean slate from which to start each and every time you shoot. If you can't retrieve data from your card, contact the card manufacturer to see if they have data retrieval services. I use the professional version of Lexar compact flash cards. On two occasions the card became corrupted, and Lexar retrieved my data and sent me a new card free of charge.

Frosty grass, Unionville, Pennsylvania. Nikon D1X with Nikkor AF 28–70 1:4.5 macro lens

To emphasize the frost crystals on the grass, I used the highest level of sharpening my camera offers. Camera sharpening still wasn't enough, so I used Photoshop to add a little more sharpening, which made the crystals stand out. (See page 155 for more information on sharpening using Photoshop.)

LIGHT & COLOR

Frost-coated raspberry leaves, Unionville, Pennsylvania. Nikon D1X with Nikkor AF 28–70mm 1:4.5 macro lens

A photographer's light is like a painter's palette. A painter starts with the primary colors, blending and mixing, bringing the canvas to life. Photographers use light like painters use paint, blending and mixing it. But, we first need to see before we capture. Knowing how the direction, type, and color temperature of light affects your subject is the key to mastering light and color in photography.

Types of Light

Being able to interpret the light falling on a scene will make your images visually sing. Snapping pictures to learn about *f*-stops and shutter speeds is fine for understanding the technical aspects of photography, but to study light, put your camera down and observe how a subject responds to available illumination.

Light originates from two sources: from the sun or the moon (natural light), and from a flash or studio light (artificial light). The subtle nuances found in natural light make it my preferred illumination choice. You will never find the exact same ambient light falling on a subject from day-to-day or even minute-to-minute; that's what makes photography with natural light so dynamic. In this chapter, I'll cover how natural ambient light affects a subject; for specific information on using an electronic flash see pages 114–129.

Before you begin to use electronic flash or studio lights, you must first understand natural lighting. Once you understand the properties of natural light, you can then use electronic flash to mimic those results. We can describe light in two categories: hard and soft. You see hard light on a bright sunny day or from a direct flash and studio light. Dark shadows and bright highlights that create texture and dimension are characteristics of hard light. Soft light is light produced by diffusing a light source (either you diffuse the light, or it is diffused naturally). The light you see on a cloudy day or a diffused artificial light source is considered soft light. Shadows and highlights are minimized or even eliminated in soft light, thus, emphasizing color and subtle detail. By studying different textures and subjects, you'll be able to determine which type of light is appropriate for your subject.

Birch tree bark, Unionville, Pennsylvania. Nikon D1X with Micro-Nikkor 105mm f/2.8D AF lens

You can find good subjects in the most obscure places. This birch tree was on the edge of a parking lot; even though the setting wasn't the best place for nature photography, the light was still good. The natural light falling on the birch bark was intense. Dark shadows enhance the curvature of the papery bark peeling away from the trunk and add a dramatic effect.

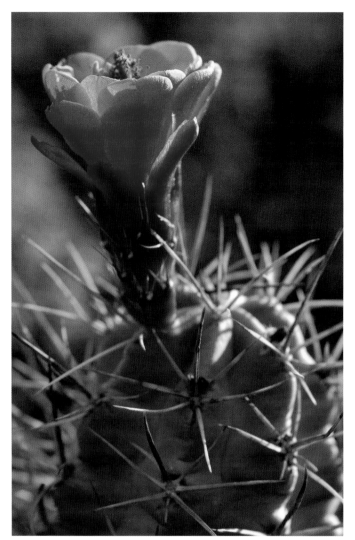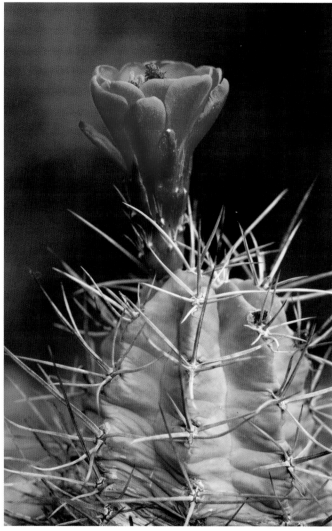

Claret-cup cactus, New Mexico. Nikon D1X with Micro-Nikkor 105mm f/2.8D AF lens

If the light is not exactly right for your subject, stick around a bit—it may change before your eyes. Early morning in the desert lands of New Mexico is a photographer's paradise, but you have to act fast before the sun drains the life out of you. In the summer, you need at least a gallon of water per day in this hostile environment. As I trekked across lava fields, a hard light hit the cacti, which intrigued me to walk over for a closer inspection. The hard light emphasized the sharp spikes and the texture in the vibrant red petals (left). Taking a few shots—and looking down at the histogram to make sure I'd captured the correct exposure—was enough time for the light to change. When I looked back at my subject, clouds had blown over the sun, diffusing the sunlight and eliminating shadows, therefore, emphasizing the flower's color (right). I could have achieved the same soft lighting effect if I had used a light disc diffuser when the sun was bright.

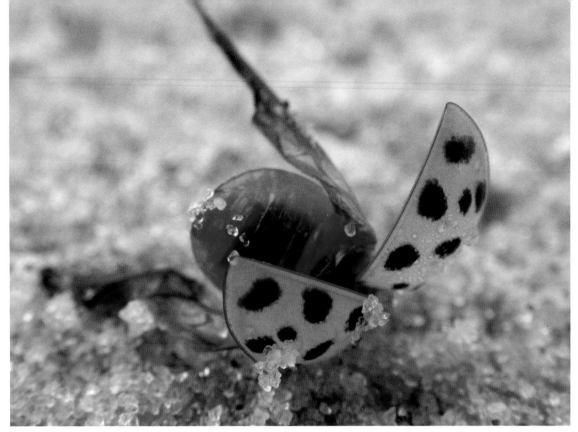

Ladybug washed ashore, Stone Harbor, New Jersey. Nikon Coolpix 995

A cloudy day at the shore keeps the sun worshipers indoors and leaves paradise to birdwatchers, artists, beachcombers, and photographers. There were no umbrellas or chairs. A few lifeguard boats and gulls were the only beach inhabitants. Strolling along the coast, a dapple of color amidst the monochromatic sand appeared. The soft light falling on this ladybug made the orange elytra "pop." When shooting subjects on the ground, the adaptability of a smaller point-and-shoot camera allows numerous camera angles. There was no need for a tripod. Instead, I positioned the point-and-shoot camera on my sandal using the timer to avoid photographer shake.

A fierce wind blowing across the plains made this shot almost impossible to capture. Depth of field is always an issue with closeup photography, and of the thirty-plus images I took, only this one of one grass seed head was in sharp focus. I loved the grass seed's dark shadow against the red and yellow petrified wood, but the conditions were not ideal for closeup photography. This is not because of the motion; I was using a fast shutter speed (1/1000 sec.) to freeze the motion of the blowing grass. It was because the grass seed was moving out of my camera's focal plane. But persistence and patience paid off.

Grass seed head, Petrified Forest National Park, Arizona. Nikon D1X with Micro-Nikkor 105mm f/2.8D AF lens

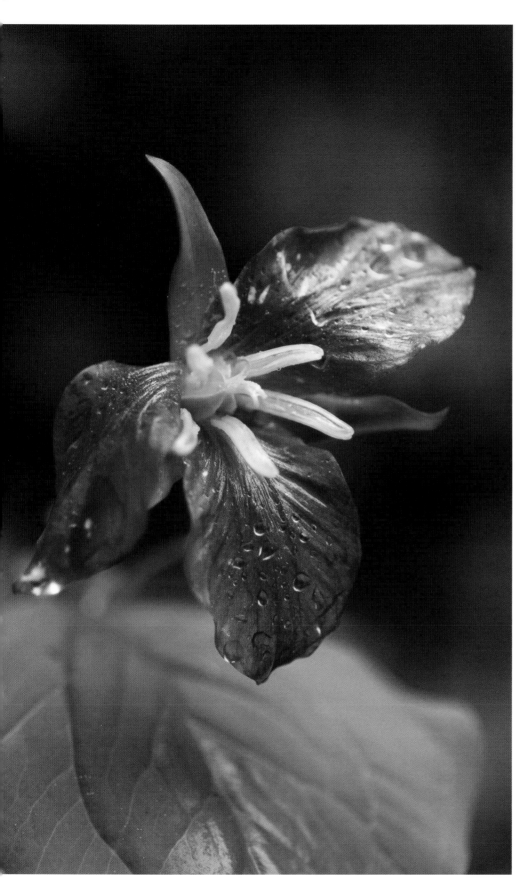

Trillium, Mt. Rainier National Park, Washington. Nikon D1X with Micro-Nikkor 105mm f/2.8D AF lens

It was June 21st, the first day of summer, and I was hiking through three inches of fresh snow. It was also the last day of a twenty-two-day trek across the national parks of the United States. The previous night, I had been raving to my students about a wildflower meadow I had photographed the previous July, about three weeks later than our arrival this particular year. I know that summers in the higher elevations of Mt. Rainier National Park are short, but wow, I couldn't believe my eyes! When we reached the supposed wildflower meadow, we gazed at a winter wonderland—a meadow covered with about ten feet of snow. So much for those wildflower shots! By the time we were ready to head back to camp, the summer snow at lower elevations had melted, leaving behind the first flowers of the new season. As we traveled down in elevation, the numbers of flowers increased, giving us unlimited photo-ops. Frozen the night before, this trillium's petals took on a wonderful translucent quality. The melting snow formed a foggy haze perfect for a diffused-lighting shot to capture the vibrant color and subtle detail in the trillium. A tripod, a long shutter speed, and the cloudy setting were essential components to shooting the trillium.

Direction of Light

We know hard light and soft light have different effects on the appearance of a subject. Let's now look at how the direction of light affects a subject. To capture different directions of light, you can do one of two things: move your camera around the subject if you're using natural light;

This diagram shows basic light source locations and the types of light they each generate, along with their positions relative to the subject. A change in the position of a light source in relation to your camera and subject will drastically change the look of your image. Understanding this simple concept allows you to best emphasize the physical character of your subject.

or move your artificial light source around your subject, keeping your camera stationary. Using various lighting positions enables you to highlight specific aspects of your subject. Determining the physical makeup of your subject allows you to decide the best lighting position to accentuate the physical characteristics that drew you to the subject.

Frontlight

Frontlight occurs when the light source is directly in front of the subject (so that the light hits the front of the subject). If you are using an internal flash or an external flash on top of your camera, or if the sun is positioned to *your* back, you are using frontlighting. Shadows and texture are eliminated when you use frontlighting. As a result, the color of your subject is accentuated. If color is what draws your eye to a subject, this may be the best lighting to use. Frontlight is probably the most popular type of light for closeups because it's the easiest to capture using your camera's internal flash. However, it isn't always the best choice for your subject. You must also consider how your subject reacts to light.

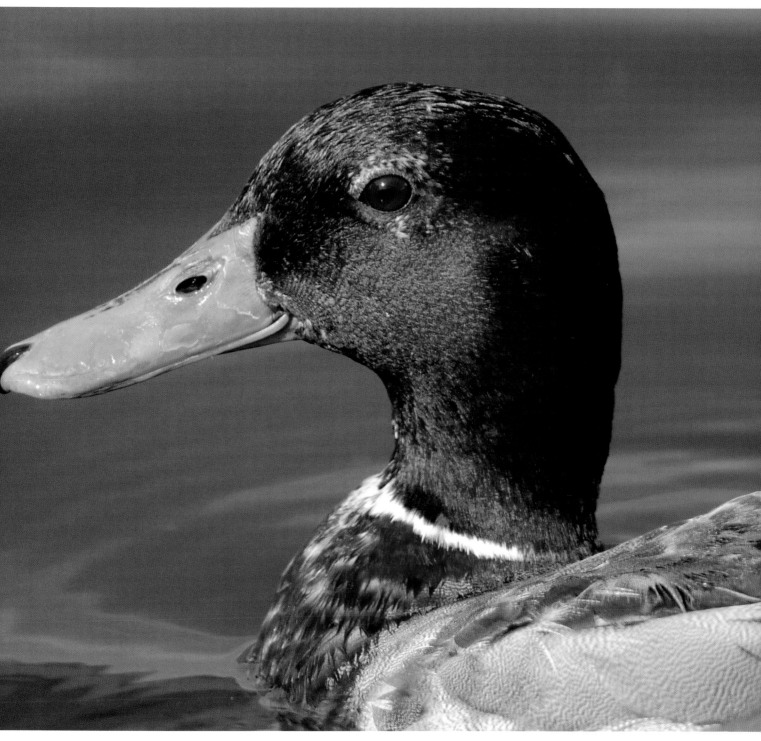

I was on a photo shoot in Annapolis Harbor doing some shots for a brochure, when this handsome male mallard caught my eye. I worked as quickly as I could to finish the headshots, which gave me enough time to capture the mallard before it swam out of range. The sun was behind me—creating a classic frontlighting scenario and also an ideal situation to highlight the male mallard's iridescent plumage. If you have the chance, watch a male mallard swim around and observe how the color of the plumage changes as the direction of light changes.

Mallard, Annapolis, Maryland.
Nikon D1X with Nikkor AF VR
80–400mm lens

Backlight

The opposite of frontlight is backlight, which occurs when a light source is directly behind the subject. Backlight is spectacular light for closeups of subjects that are translucent—it gives rise to a glowing effect. It may also produce an overexposed rim around a subject's edge or it may silhouette the subject. If you're drawn only to the shape of your subject, then a silhouette is an ideal treatment for it.

Staghorn cholla, El Malpais National Conservation Area, New Mexico.
Nikon D1X with Micro-Nikkor 105mm f/2.8D AF lens

I was hiking a section of the Continental Divide Trail that ran through an area of dark exposed lava rock when I saw this staghorn cholla—an excellent subject to demonstrate backlighting. I moved around the subject until the background was a shaded area of black lava rock. The thorns on the staghorn cholla stood out because of the overexposed rim against the dark background. Before setting up my tripod, I walked around, looking through my camera's lens, to find the perfect location.

Mammoth Hot Springs in Yellowstone National Park is known worldwide for its spectacular mineral formations. There's a short road, about half a mile, that you can drive on to get a closer look at the formations. You can also walk the path and leave the car in the lot—a much-preferred method if you're taking pictures. Even though my intent was to photograph the hot springs, this brush-foot butterfly sidetracked my plan. If you move slowly and are careful not to cast a shadow on the subject, some butterflies will allow you to get close enough for a portrait. This butterfly let me shoot about fifteen images before it flew to the next nectar-filled flower. By studying how light affects different subjects, I knew that certain butterfly wings are translucent. To capture this glowing effect, the light source had to be located behind my subject. Not only did the direction of the light capture a translucent wing, it also formed an overexposed rim on the butterfly, which carried into the flower petals.

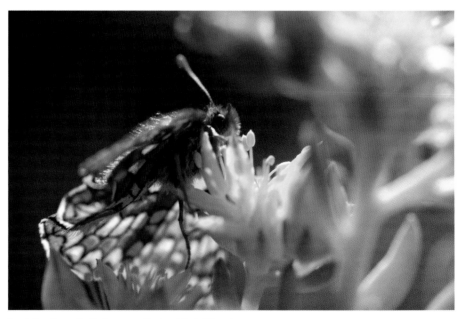

Brush-foot butterfly, Yellowstone National Park, Wyoming.
Nikon D1X with Micro-Nikkor 105mm f/2.8D AF lens

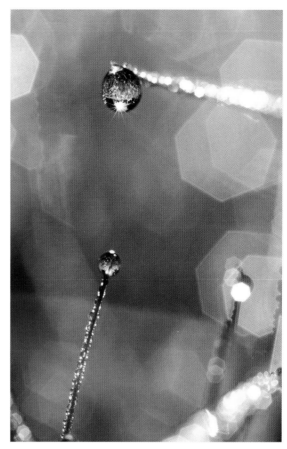

Dewdrops with flare, Unionville, Pennsylvania.
Nikon D1X with Micro-Nikkor 105mm f/2.8D AF lens
attached to bellows

A common side effect of backlighting is lens flare (overexposed spots or color casts). Lens flare occurs when direct light hits the lens. If you want to avoid flare, use a lens hood to block direct rays of light. If you want to use lens flare as a creative design element, leave the lens hood off. Lens flare in this image includes many seven-sided shapes related to the reflected shape of my lens aperture. It's a bit too much for my taste. You can heighten or lessen this effect by adjusting the angle of your lens to your subject.

Maple trees, Bridal Veil Falls, Yosemite National Park, California.
Nikon D1X with Micro-Nikkor 105mm f/2.8D AF lens

Just because a lens is specially designed for closeups doesn't mean you can't use it for larger subjects. My 105mm Micro lens does a wonderful job of capturing a variety of images. No wonder Ansel Adams loved shooting in Yosemite National Park! The magical light echoes off the granite rock faces, pulling at any photographer's camera to take a shot. Planning on shooting Bridal Veil Falls, I was to be drawn to an entirely different subject: the backlit maple leaves producing a warm feeling that contrasted with the cool mist shaded by the granite rock in the background. For dramatic lighting effects, try combining different types of light, as in this image.

Sidelight

Sidelight occurs when a light source is 45 to 135 degrees from your camera and subject (hitting the side of your subject). This type of lighting shows a combination of both texture and color in your subject. If you're not exactly sure how to light your subject, try using sidelight first. It's a great starting point, allowing you to determine if you want to accentuate the color or the texture of a subject. And, don't be afraid to experiment: changing the position of your light sources just a few degrees can mean the difference between a good shot and a great shot.

Sand dune, Oregon Dunes National Recreational Area, Oregon. Nikon D1X with Micro-Nikkor 105mm f/2.8D AF lens

Once in a great while, a photographer is blessed with indescribable light. The afternoon I took this dune hike to catch the sunset over the Pacific Ocean provided one of those times. It was one of those days that the sunset could have been great or a total flop, depending on where the clouds decided to settle. As luck would have it, the clouds stayed just above the horizon, producing about five minutes of some of the best light I've ever laid eyes on. When I see light like this I think, That's what photography is all about. And beautiful sunset images are not the only result: during the day—when the sun's angle is high—the sand dunes mold together, forming a monochromatic mass; but, when the angle of the sun drops toward the horizon, the sand dunes take on countless geometric shapes, enticing a viewer with shaded acute angles and diagonal lines.

Gull, Ushuaia, Argentina. Nikon D1X
with Nikkor AF VR 80–400mm lens

Taking my camera out for a warm-up before boarding a ship to Antarctica proved to be a superb idea. The gulls along the shore in Ushuaia are like gulls all over the world; they're easily approachable and colorful subjects to photograph. The low angle of the sun this far below the equator and the extended length of daylight made photographing in sidelighting a breeze. Unlike at the equator, where a sunset drops quickly toward the end of the earth, the magical afternoon light lasts longer below the equator.

Diffusers and Reflectors

If the natural light falling on the scene doesn't produce your desired result, take matters into your own hands and control your illumination. Diffusers and reflectors are ideal for directing both natural and artificial light.

If you're photographing under the hard light of a bright, sunny day and you would rather photograph under the soft light of a cloudy day, no problem—hold a light diffuser over your subject. A diffuser spreads light over the scene. Instead of getting dark shadows and bright highlights, you can achieve subtle detail emphasizing the color of your subject. If you want soft shadows to appear in your subject, hold the diffuser farther away from the subject. Holding the diffuser closer will lessen and even eliminate shadows, depending on how close you hold it to your subject. You can make your own diffuser out of a white cotton or silk sheet. You can also purchase diffusers that fold up easily for use in the field. You can also use these as reflectors.

Another option for controlling light is to use a reflector. A reflector will bounce light back toward your light source, filling in dark shadows. The closer you place your reflector to your subject, the brighter the reflection and the lighter the shadows will appear. Reflectors can be as simple as a candy bar wrapper or a piece of paper, or as advanced as a round disk covered with a gold, silver, or white material. Using a gold reflector will add a warming effect to your scene, while using a silver reflector will add a cooling effect. The best position for the reflector is on the opposite side of your light source—meaning your subject will be in between the reflector and the light source.

Since I didn't have anyone to help me, I used two sticks to prop up this diffuser.

Tulip leaf, Unionville, Pennsylvania. Nikon D1X
with Micro-Nikkor 105mm f/2.8D AF lens

Tulip leaves are a study of shape and form. The direct
bright morning sun cast dark shadows on this tulip leaf
(above), so to soften the shadows, I positioned a diffuser
between my subject and the sun. The shadows were
softened (right) because the diffuser spread the light
over the scene instead of leaving it to come from the
sun's direct path.

Color

The direction and type of light affect the appearance of a subject. Just as important is the influence that color has on the subject. Color is also often responsible for creating the mood of a scene. The basic color wheel is a valuable tool showing the relationships of colors to one another. There are the three *primary colors*: red, blue, and yellow. When two primary colors are mixed together, the *secondary colors* result: red + blue = violet, blue + yellow = green, and red + yellow = orange. Pairs of colors that fall opposite each other on the wheel are called *complementary colors* or *complements*, so called because they intensify each other when they appear close together.

In addition, colors are often categorized by temperature, with the *cool* colors (associated with shadows) in general being the green, blue, and violet families and the *warm* colors (associated with sunlight) in general being the reds, oranges, and yellows. Color temperature is relative: a color that is usually thought of as warm may look cool next to a warmer color.

And, while red may usually be thought of as a warm color, there are cool reds (which have more blue in them) and warm reds (which have more yellow). See pages 78–83 for more on color temperature.

For a subtle effect in your images, use colors of similar value in either the warm or cool hues. For a dramatic effect, use complementary colors, located opposite each other on the color wheel: red and green, blue and orange, and yellow and violet. These are the color pairings with maximum contrast.

A color wheel is a valuable tool, showing the relationships between the different colors and how colors interact with one another. A basic color wheel consists of the three *primary* colors (red, blue, and yellow), so called because they cannot be made by combining any other colors together, and the three *secondary* colors (orange, green, and violet), each made by combining two primaries (red + yellow = orange, blue + yellow = green, and red + blue = violet). Colors that fall directly opposite each other on the wheel are called *complementary* colors, or *complements*, so called because these colors tend to intensify each other when they occur close together in a composition. The basic complementary pairs are red and green, blue and orange, and yellow and violet. Complementary pairs consist of one primary and one secondary color. In addition, one color in a complementary pair is warm, while the other is cool. Take some time to familiarize yourself with the color wheel and to explore the relationships between the colors. You can also purchase (at any art store) a color wheel with twelve colors, which would include the *tertiary* colors (those that are a combination of a primary and a secondary color) and let you explore color relationships in more detail.

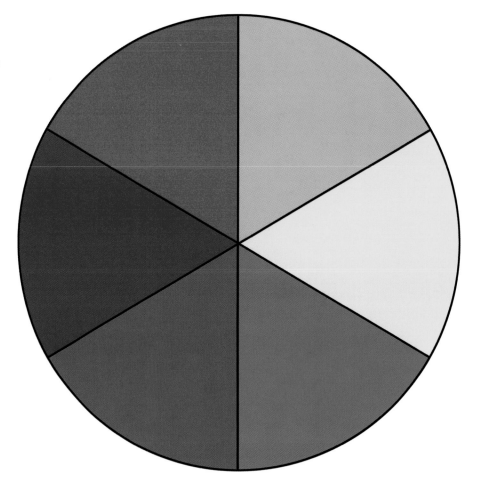

Honeysuckle leaf with berry, Unionville, Pennsylvania. Nikon D1X with Micro-Nikkor 105mm f/2.8D AF lens

A blast of color results from this pairing of complementary red berry and green leaf. Backlighting enabled me to take advantage of the translucent physical makeup, causing my subject to glow. Studying how light affects different textures and structures will give rise to new images. Try bringing a closeup subject into a dark room with a flashlight. Turn the flashlight on and see how your subject reacts to different lighting positions as you move the flashlight around your subject.

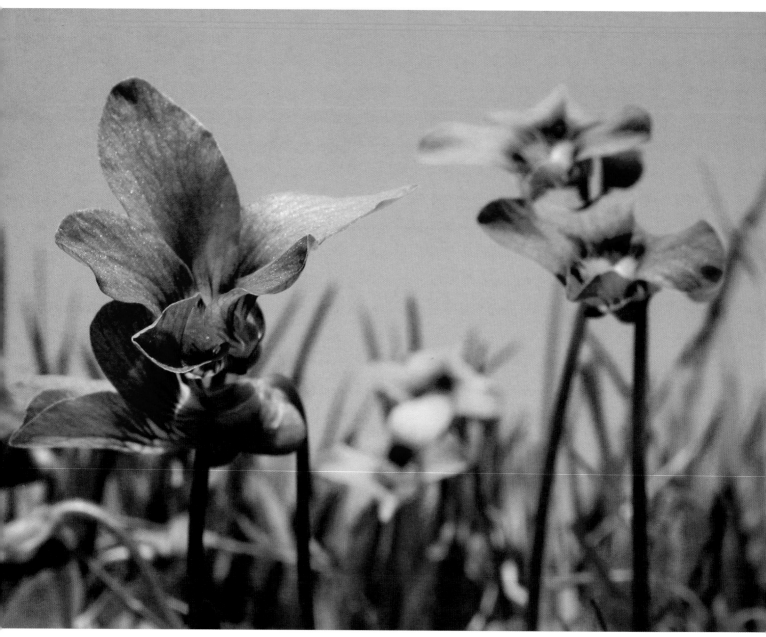

Violets, Unionville, Pennsylvania. Nikon Coolpix 4500

To make the violets appear much larger than life, I first had to find the precise location, which happened to be a hill outside my kitchen window. To make a subject look big, try shooting from below so that the lens is looking up. In the case of these violets, the hill allowed me to get below the violets and shoot up into the blue sky. I didn't need a tripod to steady the camera. All I needed to do was position the camera on the ground and use the self-timer to avoid camera shake. The colors in this scene fall on the cool side of the color wheel, and the image is peaceful to look at because of the subtle color variations.

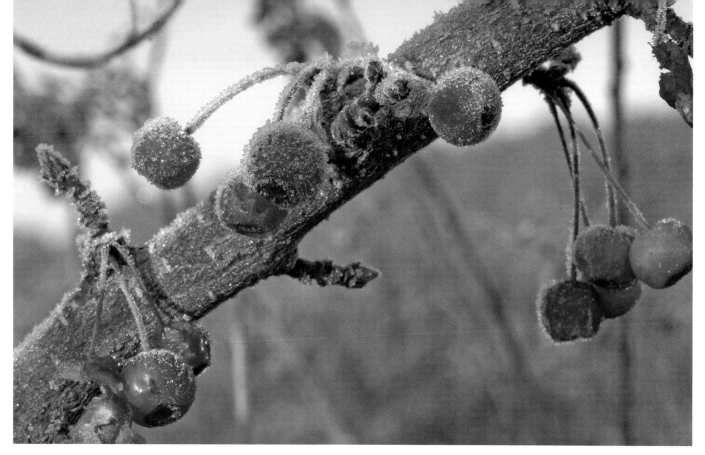

Frost-covered hawthorn berries, Unionville, Pennsylvania.
Nikon D1X with Nikkor AF 28–70mm 1:4.5 macro lens

A frosty fall morning is one of my favorite times of the year to photograph closeups in nature. These orange hawthorn berries, while beautiful in their own right, needed a little punch of color. Instead of focusing closer to add punch, I used my wide-angle lens to show my subject in its environment. Including the blue sky combined the complementary colors of blue and orange, making the scene's subtle colors pop. Composing the branch on a diagonal through the frame forms acute angles and increases the tension. The image is also enhanced by the contrasting warm and cool color temperatures.

Bottlebrush flower, Tanzania. Nikon D1X
with Micro-Nikkor 105mm f/2.8D AF lens

A brief glance over the African savannah reveals a monochromatic landscape. A closer examination, however, reveals vivid hues like the complementary colors of violet and yellow that show up in this bottlebrush flower. The diffused light of a cloudy day was ideal for accentuating the flower's color.

Color Temperature and the White Balance Setting

The aspect of light responsible for controlling the hue of an image is called color temperature, and it is measured in degrees Kelvin. A burning candle will emit a light measuring about 1,500 degrees Kelvin, while a crisp clear bright sunny day can emit a light as bright as 12,000 degrees Kelvin. The temperature is often related to the mood of an image. The warm colors of red, yellow, and orange tend to make people feel "warm" and are inviting, while the cool colors of violet, blue, and green feel "cool" and are soothing.

Film photographers are often plagued with the task of interpreting a scene's color temperature. To correct for different color casts, film photographers apply filters to either add a warming or cooling effect. Fortunately, digital photographers don't need any additional filters in their camera bags to correct for color—we have ours built into our camera's white balance setting.

White balance measures the color temperature of the scene. Camera manufacturers have made this easy to understand by giving photographers white balance settings of Cloudy, Flash, or Fluorescent instead of using the exact degrees in Kelvin to describe the temperature of light falling on a subject.

As I mentioned previously, the white balance is something that seems to be neglected by many digital photographers. They seem to set the white balance on automatic, letting the camera choose the color temperature falling on the scene. While this may work some of the time, I don't recommend giving an electronic device total creative control over your images. If you're shooting RAW files, you don't need to worry about the color temperature of a scene until you download the image and choose your image's color temperature in Photoshop or your camera's proprietary imaging software. If you're shooting JPEG files, you should become well acquainted with the white balance settings on your digital camera.

You can change color temperature in an imaging program. In fact, Photoshop CS ships with filters corresponding to the films photographers commonly use. When shooting JPEG files, I change between different white balance settings in my camera to capture scenes the way I envision. For a warming effect, try using the Shade or Cloudy white balance settings. For a cooling effect, try using the Fluorescent or Incandescent white balance settings. The best way to learn about your equipment is to try the different white balance settings and see which ones work best for you. You may not be able to capture the exact color temperature of a scene using the white balance setting, and if this is the case, then your best option is to use Photoshop.

As an exercise, set your camera on a tripod, focus on your subject, then run through the different white balance settings to see how each one affects the image. Check to see if your camera lets you manually set the white balance. Setting the white balance manually can come in particularly handy when shooting in snow or white sandy conditions. (If you're shooting RAW files, turn to pages 140–142 for information on adjusting color temperature.)

LIGHT AND COLOR TEMPERATURE		
TYPE OF LIGHT	COLOR	DEGREES KELVIN
TUNGSTEN		2,850
SUNRISE/SUNSET		3,000
1 HOUR AFTER SUNRISE 1 HOUR BEFORE SUNSET		3,500
2 HOURS AFTER SUNRISE 2 HOURS BEFORE SUNSET		4,000
NOON DAYLIGHT		5,500
CLOUDY		6,500
SHADE		7,500
BLUE SKY		10,000

This color temperature chart shows the different types of light, and their corresponding colors and temperatures in degrees Kelvin.

Frosty leaves,
Unionville, Pennsylvania.
Nikon D1X with Micro-
Nikkor 105mm f/2.8D
AF lens

At first sight, these two images may look like the same branch, but they're not. They are actually two branches on different sides of a choke cherry tree in my backyard. I took the first image in the early morning sunlight, resulting in a warm-toned scene with a color temperature of about 3,500 degrees Kelvin. For the second image, I walked to the back of the tree where another frosted branch was in total shade, resulting in a cool-toned color temperature of about 7,500 degrees Kelvin.

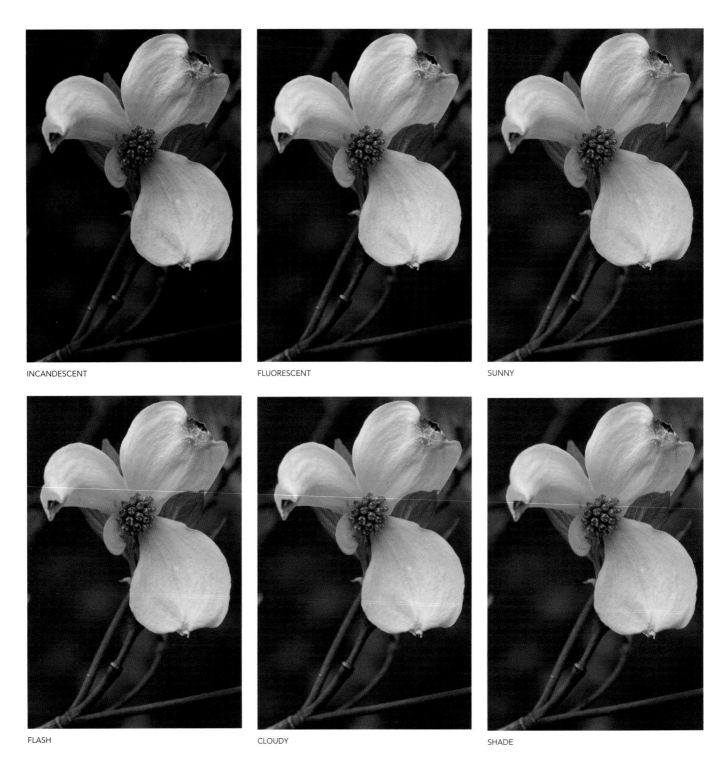

INCANDESCENT

FLUORESCENT

SUNNY

FLASH

CLOUDY

SHADE

Dogwood flower, Unionville, Pennsylvania. Nikon D1X with Micro-Nikkor 105mm f/2.8D AF lens

A tripod enabled me to photograph this flower as a JPEG file using all of the preset white balance settings my camera offers: Incandescent, Fluorescent, Sunny, Flash, Cloudy, and Shade. Since I was shooting a high-quality JPEG, the camera processed the color temperature. The natural light falling on the scene was the diffused light of a cloudy day. Notice what happens when I use the wrong white balance setting for the available light, in the case of the Incandescent setting. The same thing would happen to a film photographer using the wrong color-correcting filter.

Garden spider, Unionville, Pennsylvania. Nikon D1X with Micro-Nikkor 105mm f/2.8D AF lens

Late August is ideal for photographing spiders. Their bodies are plump, and their webs are sprawling and often coated with dew in the early morning hours. This morning was misty, and the sun was just starting to peak through the mist. The color temperature was in between a Cloudy white balance setting and a Sunny setting. If I had selected the Cloudy setting, the scene would have been a bit too warm for my taste. Selecting the Sunny setting made the web take on a slightly cool white tint that separated it from the yellow/green foliage in the background. It's the same effect I would have gotten using a cooling filter.

Katydid, Unionville, Pennsylvania. Nikon D1X with Micro-Nikkor 105mm f/2.8D AF lens

I stopped mowing over three-quarters of my yard, permitting nature to reclaim the area even though there is a constant battle with invasive species. In the first summer, I noticed a drastic difference in the amount of wildlife inhabiting the area. At night you can see a defined line of lightning bugs where the mowed grass ends and the natural habitat begins. Another benefit of bringing nature back is a plethora of creatures to photograph. I photographed this katydid on pokeweed in the middle of the day handholding my digital camera. Since I was shooting a high-quality JPEG file, the digital camera needed to capture the correct color temperature of about 5,500 Kelvin, so I set the white balance to Sunny.

The Pacific coastline is notorious for hiding under a blanket of clouds. Don't let a gloomy day get you down. Pack a raincoat for yourself and one for your equipment. Cloudy days offer wonderful diffused lighting situations that let you capture the intricate detail and color of your subject. I stumbled, and I do mean stumbled, over kelp-covered rocks to find this splendid entangled pair of ochre starfish. I used my tripod and the highest f-stop on my lens to obtain sharp focus throughout the image. To capture the correct color temperature, I selected the Cloudy white balance setting with a color temperature of about 6,500 degrees Kelvin. Along with a raincoat, make sure you pack a tide chart so that you don't end up stranded!

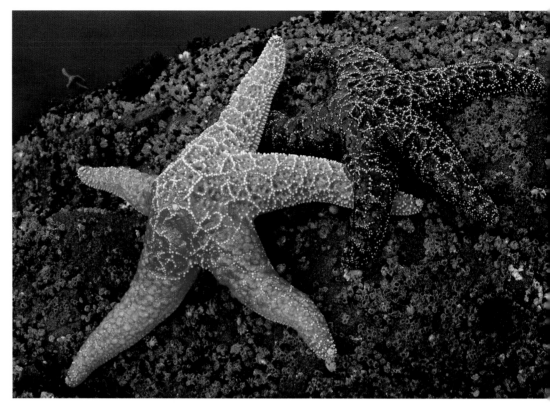

Ochre starfish, Olympic National Park, Washington. Nikon D1X with Nikkor AF 28–70mm 1:4.5 macro lens

After a ten-mile hike to Bear Paw Meadow, I was ready to drop the heavy pack, stretch my legs, and take a few shots before the day's light faded. I passed a few mule deer hunkered down in the grass, but what caught my attention was this striking patch of wildflowers. I had decided to carry my tripod on this three-day trek, vowing to put it to good use. A lightweight tripod that goes close to the ground is essential if you're specializing in closeups and if you're hiking long distances. If a lightweight carbon-fiber tripod isn't sturdy enough, you can always add a few rocks to a pouch that you attach to the tripod's center for extra support. I needed to use the Shade white balance setting and a 10-second shutter speed to photograph this subject.

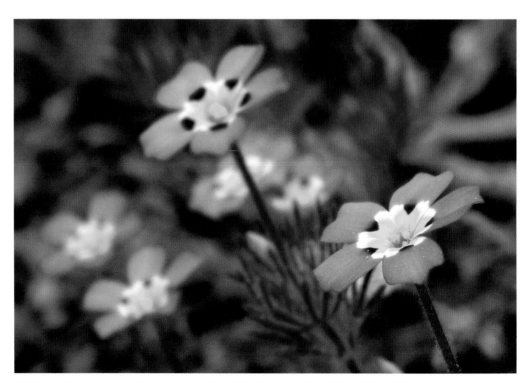

Wildflowers, Sequoia National Park, California. Nikon D1X with Micro-Nikkor 105mm f/2.8D AF lens

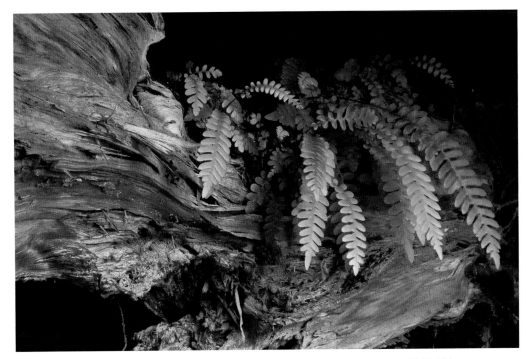

As I was hiking over a hill on the Pacific Crest Trail, an uprooted spruce tree appeared with ferns growing off the back side. The enormous roots blocked the wind—the fern was still. The only problem was that it was in total shade. Luckily, my tripod enabled me to set up using a shutter speed of 20 seconds and the highest f-stop to capture the highest depth of field. I used the Shade setting in the white balance mode to capture the most accurate color temperature.

Fern on the Pacific Crest Trail, British Columbia, Canada. Nikon D1X with Micro-Nikkor 105mm f/2.8D AF lens

Time is not on your side on frosty mornings. As soon as the sun hits, the frost begins to melt, turning the crystallized gems into a thin film of water. If you wake up early, you may be able to catch a mixed lighting situation as I did here. The backlit portions of the leaf produced a warm red and orange color. Since the angle of the sun was low to the horizon, segments of the leaf were still shaded in a cool light. Combining these two drastically different lighting temperatures causes a visual and emotional tension in the image. In the field, the backlighting drew me to the scene; but when I downloaded the image to my computer, it was the contrasting color temperatures that captured my attention. I have used this lighting setup in landscapes many times before, but in closeups this was the first time. I now seek out this unusual and exciting light.

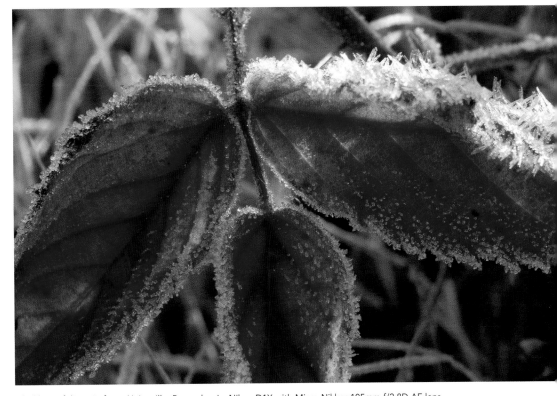

Blackberry foliage in frost, Unionville, Pennsylvania. Nikon D1X with Micro-Nikkor 105mm f/2.8D AF lens

COMPOSITION

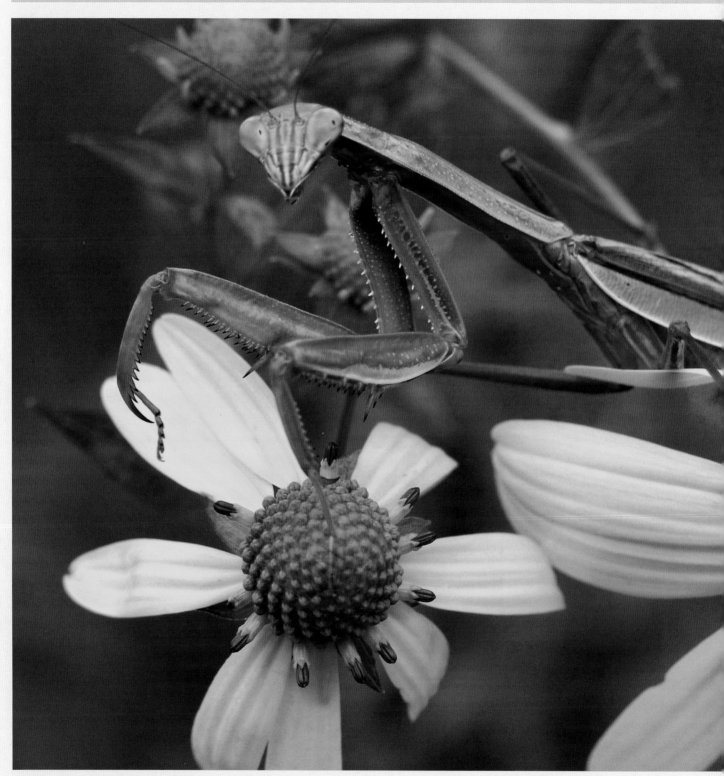

Praying mantis, Unionville, Pennsylvania. Nikon D1X with 28–70mm 1:4.5 macro lens

When I pull the camera away from my eye, I'm out of breath, I'm sweating, and I've lost all track of time. Experiencing a transcendental moment, becoming part of the scene instead of a voyeur, occurs only when the camera seems to be an extension of my arm. A runner's high describes the feeling of capturing a compelling composition.

The Importance of Composition

What aspect of an image stops viewers dead in their tracks? Lighting, depth of field, and shutter speed are integral parts to the structure of a closeup photograph. However, a good composition entices a viewer to look deeper into your image. Technical aspects of closeup digital nature photography are simple to comprehend; it's the arrangement of subjects in an image that takes mastering. Intersecting lines, repeating shapes, and varied focus are just a few elements leading viewers through the frame.

As a photographer, you want viewers to transcend to another place when gazing into your images. The best way to achieve this is to lose yourself in your photography. Losing yourself in your photography never happens when it's forced. These special moments only occur when you are comfortable with your equipment, and your technique is second nature. This won't happen the first time you take out your camera—it comes with practice. Think of a professional ice skater or a master carpenter. They make it look so easy. The reason it looks easy is because they're comfortable with their equipment, allowing their creative side to shine through.

How do you develop better compositional skills? Many people think they need more lenses. Instead of increasing your choices of lenses, try taking out only one of your lenses. On my last trip, one of my students broke her 200mm lens and was very upset because she could not capture what she wanted. I said, Don't worry about it; now you can master your 50mm lens. She left the trip with some marvelous images, all shot with her 50mm lens. Limiting your choices forces you to look at subjects under a different light. For example, restrict yourself to shooting subjects only at life size, and don't allow yourself any other choices. If you're photographing a tiger swallowtail or a hibiscus, you'll have to come up with some creative cropping techniques because these subjects won't fit into a life-size image.

Horizontal or Vertical?

The first aspect of a composition to consider is whether the subject will look best as a vertical or horizontal image. If you're not sure, shoot both and decide later. Look at the physical elements making up your subject. Horizontal subjects, like a crawling slug, look best in a horizontal format, whereas vertical subjects, like a single blade of grass, look best in a vertical format. Of course, you don't have to stick to this rule—but it does help for guidance.

Ferns, Pacific Crest Trail, British Columbia, Canada. Nikon D1X with Micro-Nikkor 105mm f/2.8D AF lens

Fern fronds growing in all directions made choosing a composition a bit difficult. I positioned my camera vertically and horizontally until I settled on the position with the strongest composition. I let the bottom fern dictate my horizontal format, using the center vein as a way to guide the viewer through the frame.

Hybrid lily, Unionville, Pennsylvania. Nikon D1X with Micro-Nikkor 105mm f/2.8D AF lens

The luminescent filaments bearing pollen-filled anthers caught my eye. Flower reproductive parts are fascinating structures. As you move in closer, they take on different shapes, becoming even more interesting. This is a straightforward composition: to emphasize the reaching stalks, I used a vertical format to frame the subject.

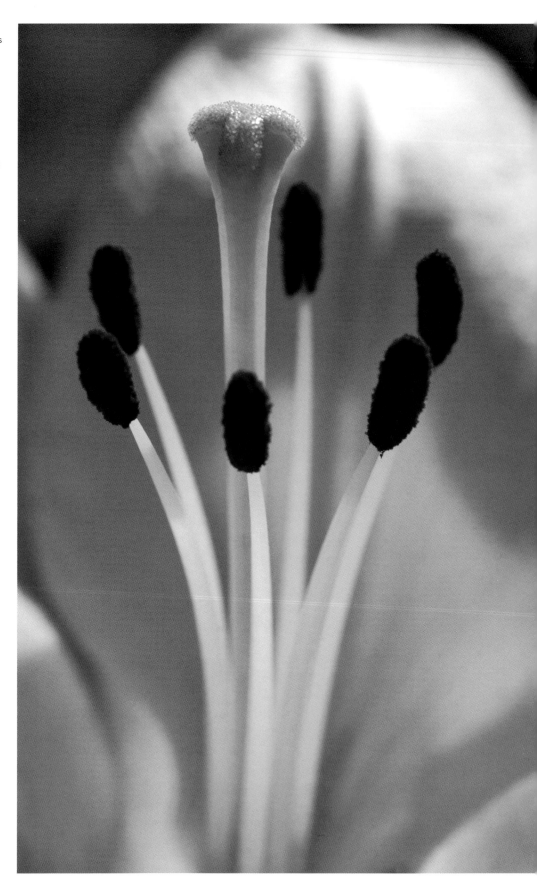

Choosing a Foreground

Closeups don't have to be flat scenes; they can be composed of many layers that add to the visual depth of the image. One way to incorporate depth in your images is to creatively use elements of the foreground as multiple levels to draw the viewer's eye into the frame.

Robin, Unionville, Pennsylvania. Nikon D1X
with Micro-Nikkor 105mm f/2.8D AF lens

Gawky nestlings flying the nest are simple to photograph. This young robin let me get a few dozen shots before it flew off a black walnut branch. My first instinct was to capture an unobstructed view of my subject. The photo technician in me said to use a high shutter speed to capture the open beak, to set the white balance to capture the correct color temperature, and to set the f-stop for the right exposure. It was only after stepping back a half-step that I was able to leave the technician behind and allow my creative side to take control. Moving back gave me the creative edge or inspiration I needed to frame the robin with elements of its environment. The blurry foliage in the foreground and the slice of blue sky in the background add a strong design component to the image.

Columbine, Mt. Rainier National Park, Washington. Nikon D1X with Micro-Nikkor 105mm f/2.8D AF lens

Choosing a Background

The background may seem secondary to the subject, but it is just as important to the aesthetic quality of an image. It's the negative space in the background that gives shape and form to your subject. One of the best ways to check if your negative space flows is to turn your image upside down and squint your eyes so that the image looks out of focus to you. Then observe how the subject and background interact. Is one competing with the other or are they complementary?

If you're shooting in a studio situation, you have total control over your background; your only concern is which background will look best with your subject. I use a variety of backgrounds that I've painted with flat (matte) finish paint on scraps of old drywall. I've found that a single color doesn't appear as natural as a combination of colors. Using a sponge to apply the paint to the backdrop material works well to suggest the slight tonal variations that you would find in natural settings. An abundance of backgrounds are also available for purchase (see Resources).

You may think choosing a background in the field is out of your control. Not so. Picking the right lens focal length and the direction in which you focus allows you to utilize the natural landscape for a variety of background choices. For example, if you want to hone in on one aspect of the landscape as a background, try using a longer focal length lens. Part of being a photographer is learning *how to see* and making quick adjustments in response to environmental conditions.

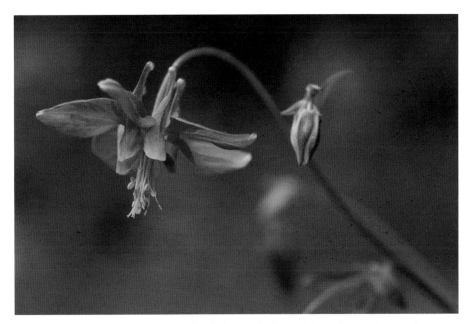

Sometimes, positioning your camera a few inches to the left or right and up or down makes or breaks an image. After crawling on my elbows for a few minutes, I thought the best composition was in sight. But the columbine framed against the green foliage wasn't as striking as I had anticipated. Dropping down a few inches closer to the ground enabled me to frame the columbine against the dark temperate rain forest. Composing the image using a slightly darker background made a significant difference, allowing the columbine to stand alone and not fade into the background as it did in the first shot.

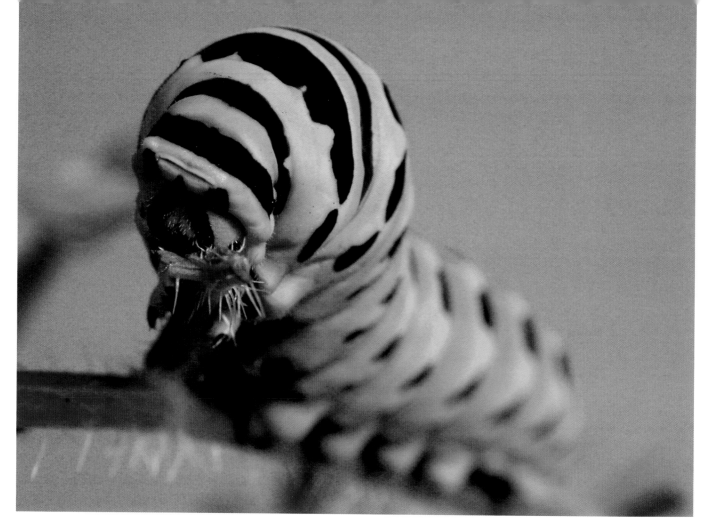

A section of my naturalized backyard is home to a thriving population of Queen Anne's lace. As a member of the parsley family, it's the primary food source for black swallowtail caterpillars. Knowing which plants are hosts to insects increases your chances of spotting these often-unseen creatures. Unhappy with the background and position of my subject in the field, I snipped off a little leaf and brought the larva into my studio. Using old pieces of drywall painted with matte finish paint (to minimize unwanted flash reflections), I positioned the subject as I wanted it. I handheld the camera with the external flash bracket attached, and to fill in shadows on the opposite side of the flash, I used a piece of drywall painted white. The caterpillar was still, and since it only took me two seconds to turn my background around, I was able to capture two almost identical shots of my subject with different backgrounds. I've said it once and I'll say it again: it's much easier to capture the shot you want in camera instead of trying to fix it later on the computer in an imaging program. The image with the blue background has more pizzazz; however, I could think of a few uses for one with the green background, so I kept both images. Once the photo shoot was complete, I returned the caterpillar to the same plant from which I had removed it.

Black swallowtail larva, Unionville, Pennsylvania (captive). Nikon Coolpix 4500 plus one external flash with bounce

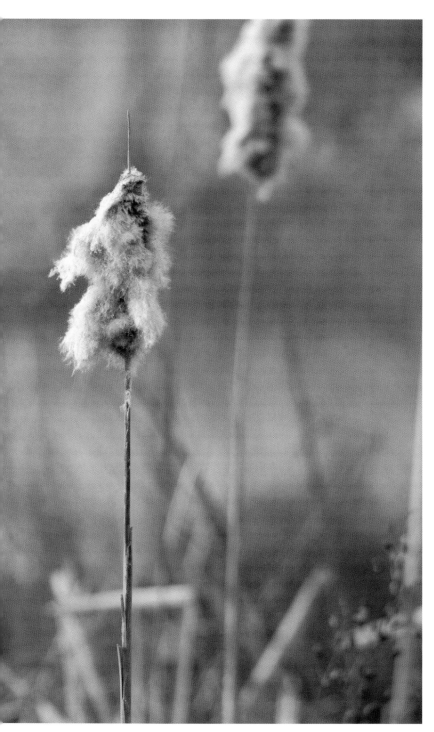

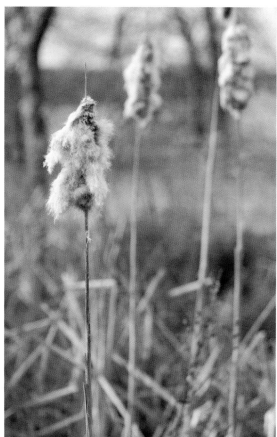

I made both these cattail images using my 80–400mm lens. For the first image (above), I used the 80mm focal length setting, which had an angle of view wide enough to include even a bit of the sky in the background. For the second shot (left), I set the zoom to 400mm and walked backward until the cattail on the left appeared the same size as it did in the first image. Notice that the sky is not in the frame; this is because the angle of view is smaller with a higher focal length. You can alter the background in your image by using different focal lengths.

Focusing for Closeups

Advanced lenses made especially for closeup photography are equipped with autofocusing features. However, while autofocus can come in handy, I prefer using the manual focus for most of my closeup needs. If you have problems with your eyesight think about getting a corrective lens for your camera's viewfinder.

When shooting closeups, focusing the camera can be challenging. You're often lying on the ground up to your elbows in mud or perched on top of an ant nest. Aside from the physical barriers to overcome, there is also a minimum margin of error for your plane of focus. In other words, the distance between areas that will be in sharp focus and areas that will be out of focus is very small. You must make precise adjustments to ensure that what you want to be sharp will be sharp.

If you find yourself holding a restaurant menu at full arm's length to read the daily specials, you have problems seeing close up and will benefit from purchasing an autofocus lens specifically designed for closeups, such as one made by Canon or Nikon. Depending on the camera make, you can select different areas in the frame where you want your focus to fall. If you're like me and you can see subjects within a few inches of your face, then a lens you focus manually is fine to start with. I should mention that my sharp vision stops at about ten feet. The rest of the world is a soft blur.

CHOOSING YOUR PLANE OF FOCUS

The plane of focus is the area in an image that appears sharp. This area in closeups is limited even when you're using a high *f*-stop, which gives you a high depth of field. Both 35mm and point-and-shoot digital cameras capture subjects with a flat plane of focus. This means that the plane of focus runs parallel to the front of the camera's lens. The only way for you to change the plane of focus is to move the position of the camera. This isn't the easiest thing to do, especially when you are in the field and your camera is on a tripod.

These two diagrams illustrate the limited depth of field when working with closeups. In each, the blue line represents the subject and the two red lines represent the plane of focus. As you move the camera, the plane of focus also moves. Whatever lies in between the two red lines will appear in sharp focus, and the other areas will not. As your subject moves farther away from the plane of focus, it becomes increasingly out of focus. When your camera is parallel to your subject and the blue line is directly in the center of the red lines, everything will appear sharp in focus, as shown at left. However, when you move the camera and your subject stays in the same place, the only area that will appear sharp is the area of the subject (the blue line) that is in the plane of focus (between the two red lines); the rest of the subject (the blue line) will be out of focus.

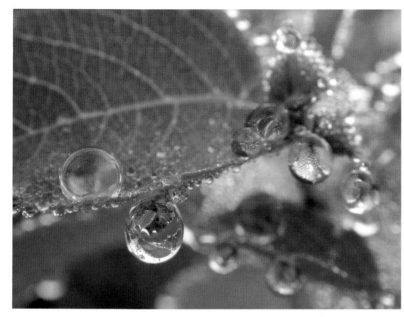

Spotted touch-me-not,
Unionville, Pennsylvania.
Nikon Coolpix 4500

My first shot of the dew-covered spotted touch-me-not was only partially in focus because the back of my camera was not parallel with my subject (left). This would have been fine if that was my objective, but I wanted all of the drops in focus. To fix my mistake, I moved the camera toward the back right-hand corner until both the right side and left side were in focus (below). Using a tripod will help you line up your focal plane to capture sharp shots.

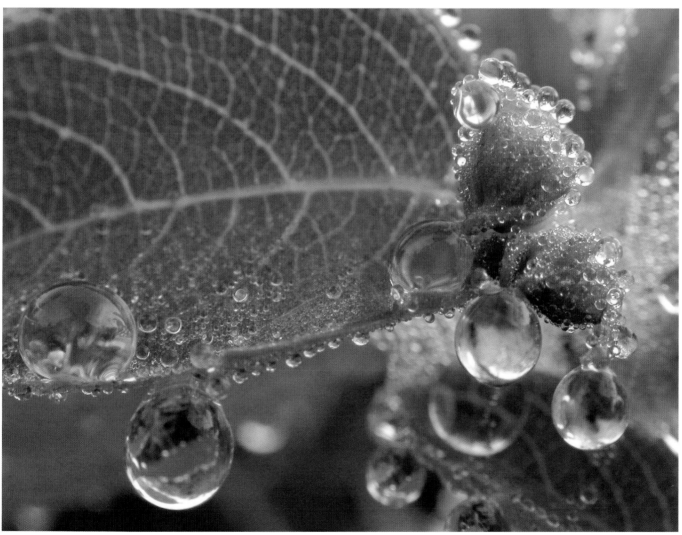

How Close Do You Go?

Choosing your magnification rate is one of the hardest challenges you'll face when shooting closeups. In the field, I try to carry equipment that will allow me to get as close as I desire; about two times life size is usually sufficient to cover my bases. If I want to get closer than two times life size, it's usually a subject that I can take into the studio, where a more controlled studio lighting setup is possible. And you should also keep in mind that just because you have the equipment to shoot especially close up, doesn't mean that it is always the best compositional choice.

You have all of the equipment to get really close up. How close do you actually want to go and still maintain an interesting composition? For this thistle, I realized that the first shot I had taken didn't capture the striking color (above left). I moved a few inches to the left, using the shadowed cliff as a dark background to get the purple color to "pop" (above right). While this shot did capture the striking color, it lacked an interesting composition. I realized I needed to back up a few inches to include more of the scene, being careful not to plummet a few hundred feet to the jagged granite lining of the canyon floor. Moving back a few inches enabled me to add elements and allows the viewer to travel through the frame without losing the dramatic appeal of the thistle plant (right). This is a prime example of when being really close up did not produce the best shot.

Thistle, High Sierra Trail, Sequoia National Park, California. Nikon D1X with Micro-Nikkor 105mm f/2.8D AF lens

Prickly pear cacti, Havasupai Indian Reservation, Arizona. Nikon D1X with Micro-Nikkor 105mm f/2.8D AF lens

After backpacking ten miles through the hot, dry canyon, I saw that Havasupai Falls is one fantastic sight—you're crazy if you leave without taking some shots of what *National Geographic Traveler* named "the best swimming hole in the world." And while the destination is well worth the effort, the journey is just as exciting. Lining the canyon walls are scores of cacti. At first glance, you're blown away with so many subjects that it's hard to decide what to shoot. The afternoon light hitting this cluster of cacti grabbed my attention, but I wasn't sure where to aim my lens. I kept shooting, getting closer with each shot, until I found the image with the strongest composition. Unlike the thistle image on the opposite page, this time the extreme closeup was the best choice.

The Rule of Thirds

I know the Rule of Thirds creeps up in just about every photography book, but only because it should. It's a wonderful way to begin learning how to compose an image. While in the beginning of your photography career, avoid placing your subject in the center of the frame. The center often lacks zest, and subjects should only be placed there when a conscious decision has been made to do so—and not because it's the easiest place to focus on your subject.

To use the Rule of Thirds, imagine a grid—made of two equally spaced horizontal and two equally spaced vertical lines—superimposed in your viewfinder that divides the image into nine equally sized rectangles. The four points at which the lines intersect are your Target Zones—the spots where your subjects will look best in the frame. Aim to have your subjects fall on these spots. Use the two horizontal lines as guides for horizon placement. Instead of placing the horizon in the middle of the frame, try positioning it on one of these two imaginary lines.

Using the Rule of Thirds is the easiest way to start composing an image. Place the main focus of your subject on one of the Target Zones. Use the horizontal guidelines to help position the foreground and background, and use the vertical lines to position elements that will guide the eye into the frame. Avoid the Foul Zone in the center of the frame at first; then, once you fully understand the Rule of Thirds, you can use the Foul Zone and let your imagination soar.

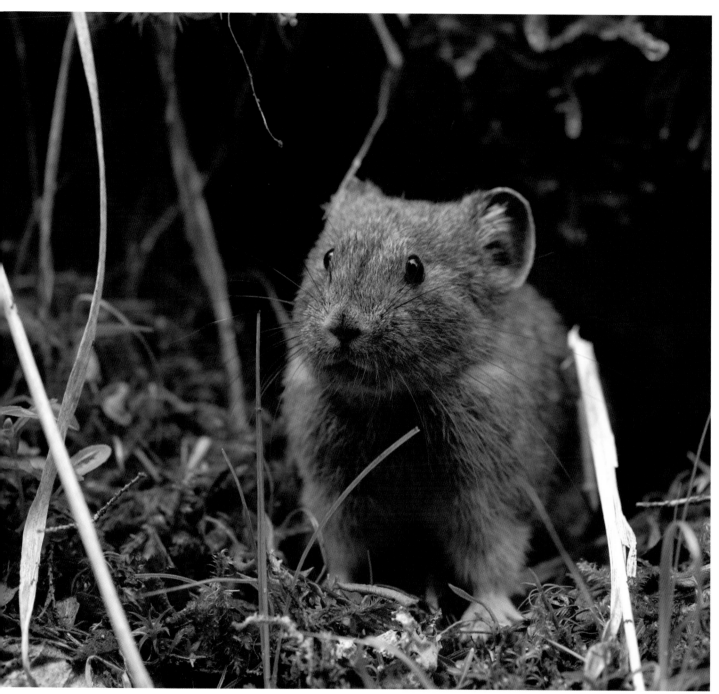

Pika, Mt. Rainier National Park,
Washington. Nikon D1X with
Micro-Nikkor 105mm f/2.8D AF lens

A streak of brown fur caught my eye while hiking through the temperate rain forest of Mt. Rainier National Park. Stopping to see if the elusive creature would reappear, I took a test shot to make sure the exposure of the scene was correct. Sure enough, a few minutes later, a pika popped out of a decaying tree stump. Slowly, I inched closer so as not to scare what I claim as the cutest northwest inhabitant. Composing the pika looking into the frame while emerging from the upper right Target Zone lets the eye travel through the image. What gives the subject life is the overexposed highlight in the pika's right eye. I captured this highlight by chance (I was just trying to get the shot, and after two, the pika dashed back into her abode), but being at the right place at the right time—and that crucial test shot—enabled me to capture this image. One of the best pieces of advice I can give to someone starting out in the world of closeup photography is to be patient and let your subject approach you instead of you chasing down your subject.

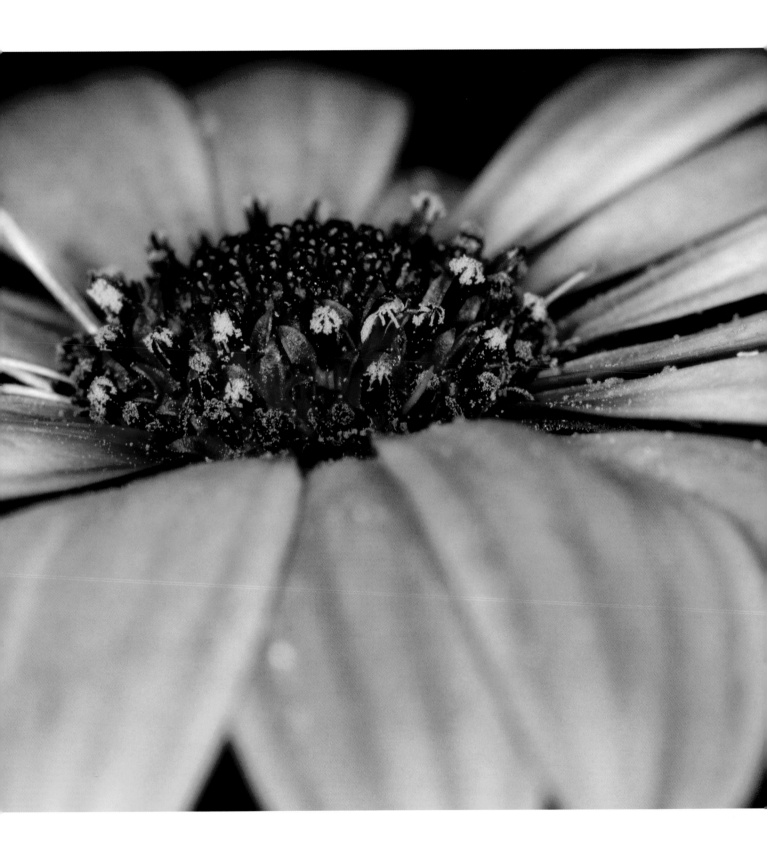

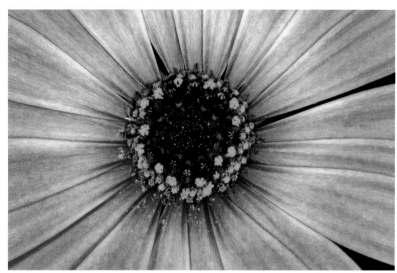

Sunsape Daisy, Unionville, Pennsylvania. Nikon D1X
with Micro-Nikkor 105mm f/2.8D AF lens and Nikon ring flash

There was no doubt this beautiful flower deserved a portrait, but I wasn't
quite sure how to compose it. Leaving my camera in the bag, I walked
around the daisy, standing up and bending over, before finding the exact
angle to capture it. Instead of placing the flower in the center of the frame,
I decided to crop in, showing only a few of the petals while placing the
center of the flower in the upper left Target Zone. To prove my point
about the Rule of Thirds, I immediately took another shot placing the
center of the daisy directly in the Foul Zone. You can see that when the
image follows the Rule of Thirds, the composition creatively leads the eye
through the frame.

Line

Horizontal lines tend to create a peaceful feeling in an image, whereas vertical lines often convey a sense of strength or power. In addition to using horizontal and vertical lines when composing an image, try incorporating some diagonal lines and acute angles into your frame. Diagonals and angles are dramatic and create tension in a scene, therefore pulling your viewer into the frame. Lines and angles become more apparent as you move in closer and remove your subject from context.

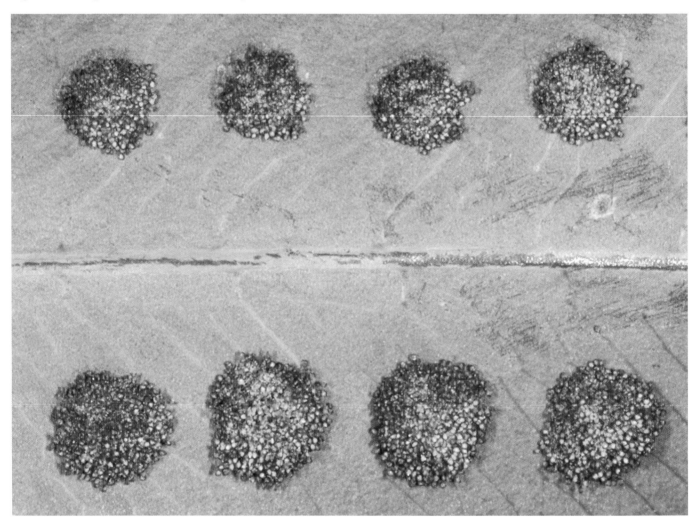

Staghorn fern spores, Longwood Gardens, Pennsylvania. Nikon D1X
with Micro-Nikkor 105mm f/2.8D AF lens, 20mm extension tube, and Nikon ring flash

Following the Rule of Thirds, we know that a composition in which the horizon (or main line in the case of a closeup) falls in the center of the frame is often dull. While this usually holds true, there are occasions when the middle of the frame is the most dramatic area to put a horizontal line. The spores straddling the center vein of this fern looked like a natural mirror to me, and the only place to position the vein to emphasize this symmetry was in the center of the frame. I surprised myself with this shot. It's good to always try new compositional techniques; if they don't work, who cares? Not trying new compositions is when a problem arises.

Snowmelt, Grand Teton National Park, Wyoming. Nikon D1X with Micro-Nikkor 105mm f/2.8D AF lens

I framed this subject using the natural diagonal line formed by the rushing water. The lines show the opposition between the water and the snow's reluctance to melt—compacted snow hangs on while the water carves its path.

Sand dune, Oregon Dunes National Recreational Area, Oregon. Nikon D1X with Micro-Nikkor 105mm f/2.8D AF lens

Of the many examples of repeating lines found in nature, sand waves have to be one of my favorites. The low angle of afternoon light was ideal to accentuate the windblown ripples. Sidelight cast dark shadows, showing each grove in the sand. Using a tripod enabled me to obtain maximum depth of field and make slight adjustments to capture a dramatic composition. I should also mention that at the end of this trip, my tripod had to be taken apart because grains of sand worked their way into all the moving parts. It's the nature of the beast; if you photograph along the coast, your equipment will need lots of maintenance.

Grasses, El Malpais National Conservation Area, New Mexico. Nikon D1X with Micro-Nikkor 105mm f/2.8D AF lens

Grasses are alluring subjects—it's baffling how many different colors appear in the stems and seeds of these overlooked plants. Moving in close enables you to capture the intricate details and colors in some of the most obscure places. If you always have your camera, you'll always have subjects to shoot.

Succulent, Longwood Gardens, Pennsylvania. Nikon D1X with Micro-Nikkor 105mm f/2.8D AF lens and Nikon ring flash

The variety of color in this plant is striking. To capture the beautiful color, I chose a ring flash, using both tubes to illuminate the scene and filling in most of the shadows. My first shot, emphasizing horizontal lines, was boring. To add an additional design element, I skewed the camera angle so that the succulent would create acute angles and diagonal lines. This compositional technique grabs the viewer's attention.

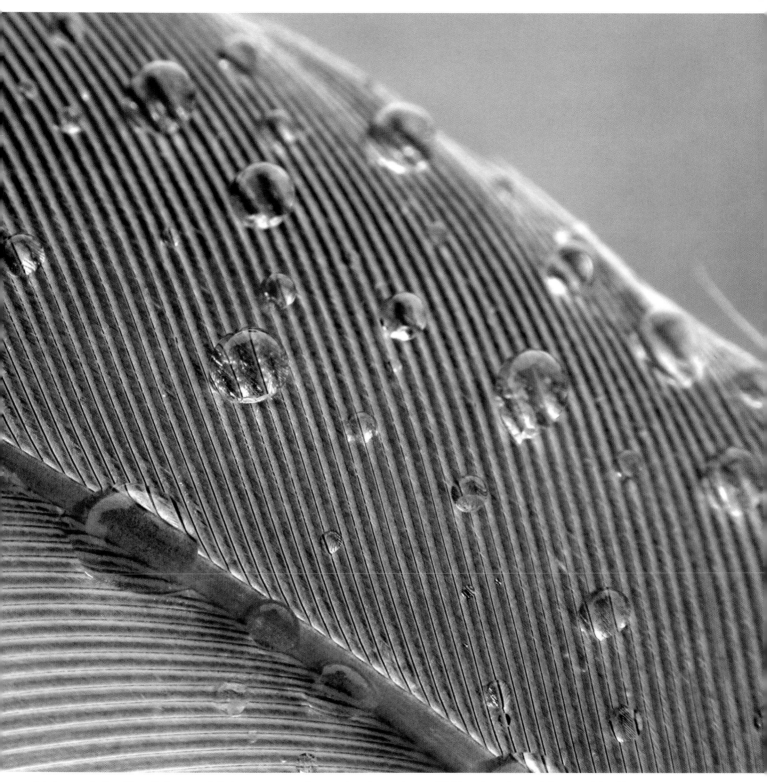

Raindrops on feather, Stone Harbor, New Jersey. Nikon Coolpix 4500

Raindrops are naturally occurring closeup lenses. Walking along the sand, I stopped dead in my tracks when I saw how the raindrops magnified the intricate design of this seagull feather. I did have my tripod with me, but it was much easier to use my shoe as a camera support at this low angle. Acute angles form throughout the feather, and even the negative space at the top right corner forms an acute angle with the feather's edge. Using these strong compositional aids, along with tiny raindrops, creates a dramatic image even with the monochromatic grey tone.

Pattern

The patterns of nature never cease to astound me. Cell by cell, plants and animals mold their structures into fully functioning organisms. The end result—a tree, a flower, a feather—is beautiful on its own, but move in closer and structures begin to take on a different appearance. Photographing the patterns of nature is a wonderful compositional tool, because you don't have any point of focus. You can ignore the Rule of Thirds, allowing the flow of the pattern to dictate the aim of your lens. If you haven't photographed patterns, try it. I guarantee this exercise will help your compositional skills.

Orchids, Longwood Gardens. Nikon D1X with Micro-Nikkor 105mm f/2.8D AF lens and Nikon ring flash

Public gardens are honeypots for closeup photographers. Every February, when a nasty case of cabin fever overwhelms me and all I need is a dose of spring to get through the rest of the winter, my closest treatment is found in the local public garden. Many gardens have regulations about bringing tripods—make sure you check before you go. Longwood Gardens is home to a beautiful orchid room where photographers can capture images of orchids from all over the world. I shot a series of extreme closeups, zooming in on the intricate patterns in the petals. By excluding the reproductive parts of the flower, I let the viewer enjoy the vibrant colors and obscure patterns of the structures. I used both flash tubes of the ring flash to eliminate shadows and highlight the color in the petal's design.

Shattered ice, Antarctica. Nikon D1X
with Nikkor AF VR 80–400mm lens

When the wind and time of year is
right, the Lemarie Channel fills with a
variety of ice shapes and sizes. Using a
long zoom lens enabled me to hone in
on the pattern created by shattered
ice. As I've stated before, I use the
term closeup loosely, but considering
the vastness of Antarctica, this shot fits
the term well for a closeup of the
Antarctic landscape.

Philodendron houseplant, Unionville, Pennsylvania. Nikon D1X
with Micro-Nikkor 105mm f/2.8D AF lens and Nikon ring flash

Using the ring flash enabled me to hone in on the intricate pattern of this leaf. I didn't
focus on any one particular region, making sure my focal plane rendered all aspects of
the image sharp. Letting the pattern dictate my camera angle created an image strikingly
different from the leaf's entire structure. To me, this scene is like a bird's-eye view of a
topiary garden. I think it would make a great puzzle!

Sticking with Your Subject

I can't overemphasize how important it is to stick with your subject. Rarely will you ever capture the shot you want with the first press of the shutter. Don't worry if you take twenty, thirty, even a hundred shots of your subject. Remember, you can erase or keep as many as you like. Many photographers (myself included) are impatient when starting out with closeup photography—they chase, they catch, they do almost anything to capture the shot. Many people suggest cooling subjects off in the refrigerator for a few minutes to slow them down; insects, amphibians, and reptiles will all move very slowly if you lower their body temperature, enabling photographers to easily get a shot. You can also use dead insects (pinned so that they look alive) to help you capture closeup images. Neither of these options ever look right, and they are terrible for your subjects. I will, on occasion, bring a subject into my studio, but only if I don't think this will harm it in any way. The best photographs are most often taken in your subject's natural setting. I've learned time and time again that the best method of capturing a closeup image is to be patient and move slowly. I'm constantly shocked by how close creatures allow me to approach before they flee. Many times I leave before they do.

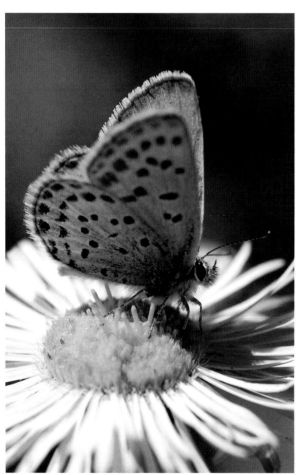

Copper butterfly, Grand Teton National Park, Wyoming.
Nikon D1X with Micro-Nikkor 105mm f/2.8D AF lens

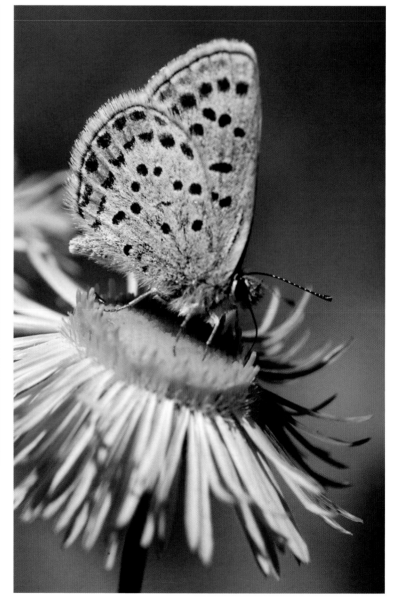

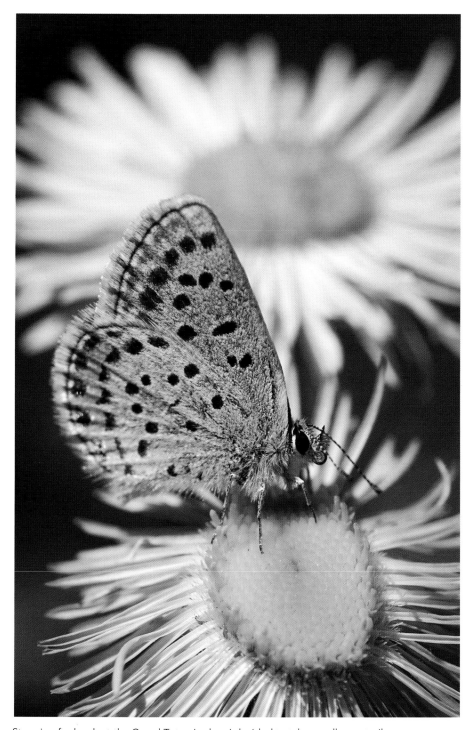

TIPS FOR GETTING UP CLOSE TO A LIVE SUBJECT

Don't let your shadow hit your subject—this almost always causes the subject to flee.

Stay close to the ground and move very slowly—only one or two inches at a time.

Don't make any sudden movements or sounds.

Try not to look at your LCD screen too often (because when you look up, your subject may be gone).

Try to think and see like your subject.

If your subject does flee, wait a few minutes and it may return—especially territorial subjects, such as dragonflies and lizards.

Stopping for lunch at the Grand Teton Lodge, I decided to take a walk on a trail overlooking a meadow leading up to the majestic Mt. Moran. Taking in the beautiful scenery, I photographed this copper butterfly to my heart's content. I inched to the left and right, up and down, rotating the camera vertically and horizontally and snapping off shots the entire time—not worrying how much I was shooting. It was one of those transcendental moments when there's nothing else you're thinking about—you're living in the moment. By sticking to my subject I was able to capture a variety of images, each with a slightly different appeal.

Getting on Your Subject's Level

The best way to have your viewers connect with your images is to shoot at your subject's level. Ask yourself how a turtle or toad sees the world. When you photograph from the subject's point of view, you're allowing the viewer to not only see the subject, but also to see how your subject perceives its environment.

Looking at closeup images taken from a human viewpoint is not aesthetically moving—show your viewers how your subject views the world and now you're getting somewhere! This may sound a bit weird, but the key is to know your subject and try to think like it—even if it's a plant or a rock.

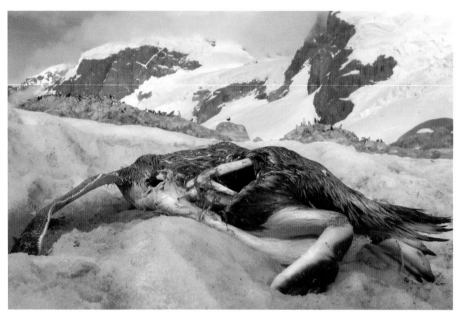

Deceased penguin, Antarctica. Nikon Coolpix 4500

A cacophony emanating from the distant penguin colony lured me in to take a closer look. Shocked by a lifeless penguin, I couldn't pass up the photo opportunity. Death is part of the cycle of life. I can't say I didn't feel bad, though, knowing firsthand how challenging it is to climb that snowy slope and that for some reason the bird didn't make it. I tried to put myself in the penguin's position and feel how the penguin was feeling when climbing. To emphasize the struggle, I positioned the camera as low to the ground as possible, making sure to capture the soles of the feet and the penguin colony behind. Some of the most powerful images aren't ones that make you feel good, but they are thought-provoking. For me, this image transcends the ordinary closeup into a scene people can relate to at a higher level.

Mushroom, Unionville, Pennsylvania.
Nikon Coolpix 4500

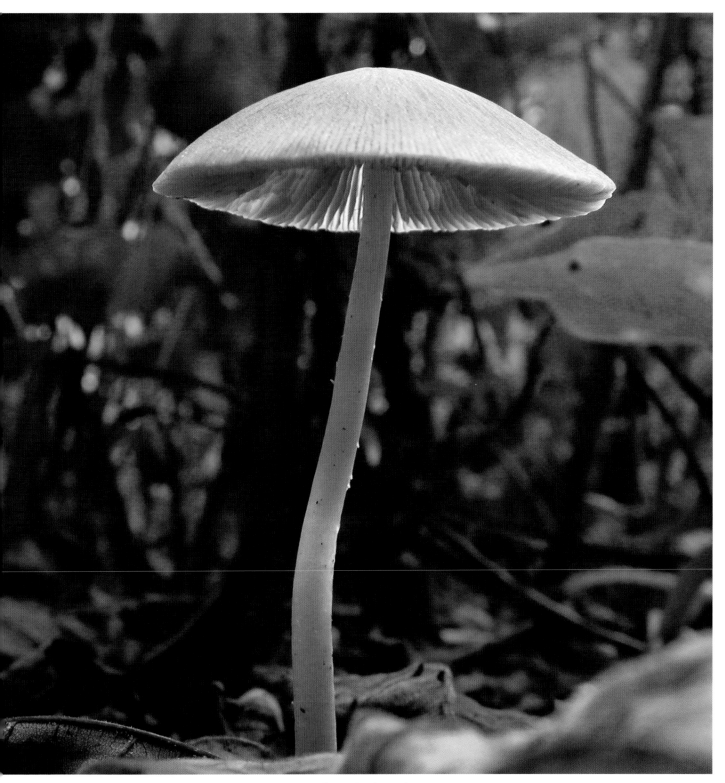

To capture the essence of your subject, try positioning yourself at its level. For this image, I placed my camera on the ground and used the timer to avoid camera shake. Forests are built up with layers, and each layer can resemble its own forest. The secret is knowing how to capture it. If a mushroom had eyes, I think this is how it would view its surroundings.

FLASH

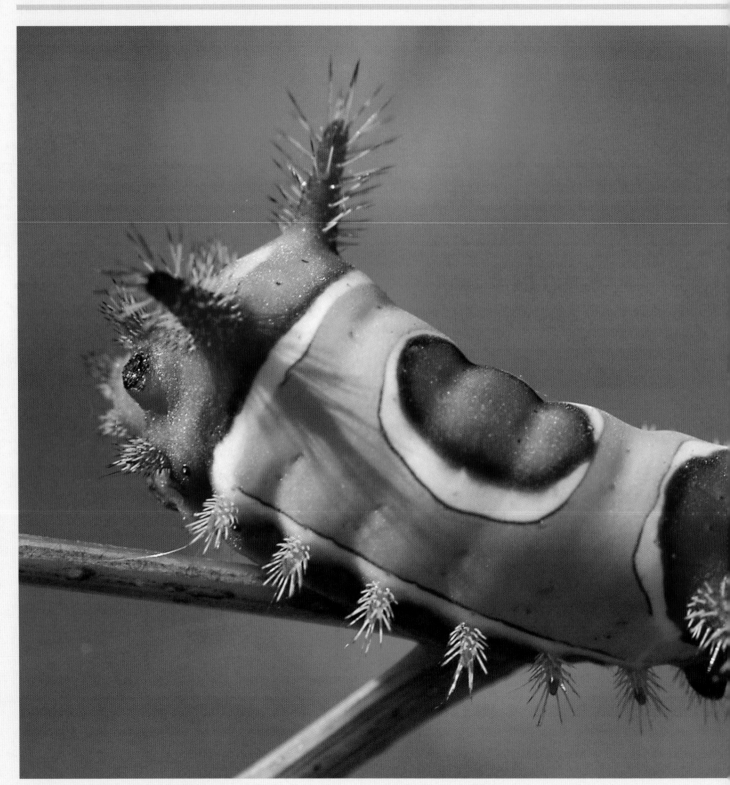

Saddleback caterpillar, Unionville, Pennsylvania.

Flash is one of the greatest inventions for closeup nature photography. When shooting miniature subjects, photographers often find themselves in a predicament—they don't have enough light.

The Basics

Adding a flash to your camera system can be an intimidating experience. With a little research, however, it's easy to start illuminating your subjects. Whether you're using a point-and-shoot or an SLR, you can take full advantage of the wonderful qualities flash offers.

The first step is determining how you want to use your flash. Are you going to use it exclusively for closeups, or are you going to use it for larger subjects as well? If you're just going to use it for closeups, look into a flash specifically designed for closeups. Canon has a specially designed closeup macro bracket that fits directly on the front of the camera. Nikon carries speedlights specifically designed for closeup photography. There are also third-party flash manufacturers who make a variety of flashes that may work with your camera system, although camera manufacturers don't recommend using third-party systems. If you do buy a third-party flash, make sure that it's compatible with your camera system.

If you already have a flash, does this mean it's not suitable for closeup photography? No. There are many ways to use your existing flash for closeups. I suggest using a flash when you can manually adjust the output of light, or a through-the-lens (TTL) flash. The TTL is almost a necessity for today's film photographers, and it's helpful for digital photographers, but not essential. In fact, I don't even use the TTL functions with my flash photographs. I prefer to adjust the flash manually and trust my camera's histogram for judging exposure after I capture the image. Using the manual functions allows me to make minute lighting adjustments.

When using film and manual flash, you need guide numbers of a specific flash relating to the flash's output of light. With this information you would then use mathematical formulas to determine how far you need to place your flash from the subject at a given magnification. I'm happy to say that this laborious process, consisting of test roll after test roll, is over. The guide number is still helpful when purchasing a flash, so that you know how powerful it is, but you don't really need to know this information when using a digital camera for taking closeups. If (after you check your LCD screen or the image's histogram) your exposure isn't how you imagined, change the output of your flash or adjust your aperture until you capture the shot you want.

When shooting closeups with film, I had fixed positions on my flash bracket for a few predetermined magnifications. These fixed positions limited my creativity as a photographer. With my digital camera, I am now free to shoot at any distance, at any magnification, and capture my desired exposure in a few frames. Checking the histogram immediately tells me whether I need to increase or decrease my light falling on the scene.

Before using a flash on all of your subjects, determine if a flash will really provide the best results. Whenever possible, I use natural light to photograph closeups. It's only when the natural light fails that I turn to flash.

This gerbera daisy was bathed in exquisite natural light. I took a shot, forgetting to turn off my ring flash, which I had used for a previous image. The result (opposite, top) was not at all what drew me to the subject. Turning the flash off enabled me to capture the flower as I envisioned it, using the available sunlight (opposite, bottom). Just because you have a flash doesn't mean you always have to use it. The only occasion you should use flash is when the natural light does not allow you to photograph your subject. I look at flash like I look at filters: if you don't need it don't use it.

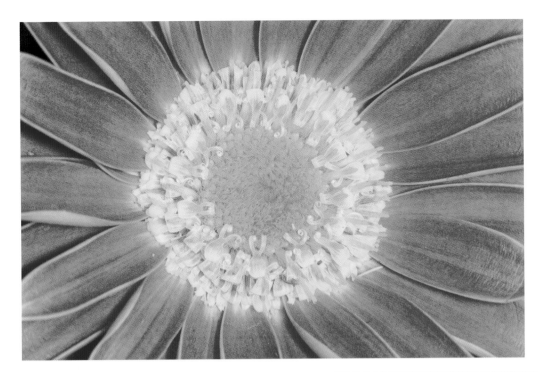

Gerbera daisy, Unionville, Pennsylvania. Nikon D1X with Micro-Nikkor 105mm f/2.8D AF lens

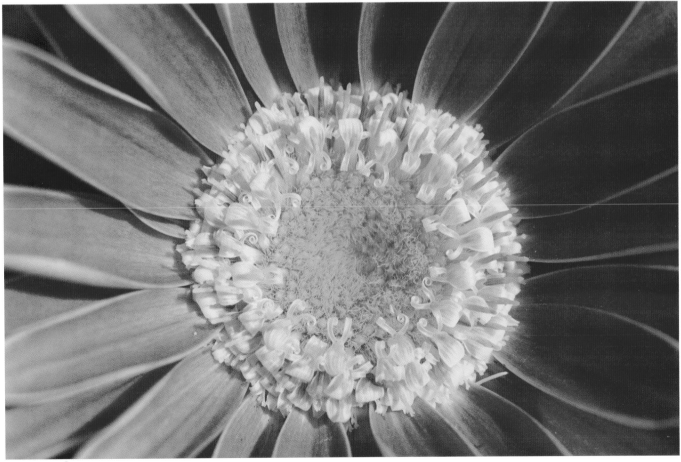

Ring Flash

There are many types of flash you can choose that are suitable for closeup digital photography. The most common and least effective is the internal flash common on many point-and-shoot models but also found on many digital SLR cameras. An internal flash is fine for straight frontal lighting, and you can capture some nice shots, but you're limited to a single lighting position. You should never be creatively bound by the limitations of your gear. Many beginning photographers become discouraged with close-ups in part because of the poor results they often get with their camera's internal flash.

Although much more expensive, a better choice is a ring flash, one of the most popular closeup accessories for 35mm digital SLR cameras. A ring flash attaches to the front of your camera's lens. You don't need an additional flash bracket to use it. The most common design includes a power source that fits to the top of your camera's hot shoe. The flash's output controls are located on the power source for easy access. A cord connects the power source to the flash tubes. Depending on the model, you may be able to attach the flash tubes directly to the power source, giving you what would be considered a "normal" external flash. If you can afford only one flash, I suggest a ring flash because it's a multipurpose unit. You can use a ring flash for animal

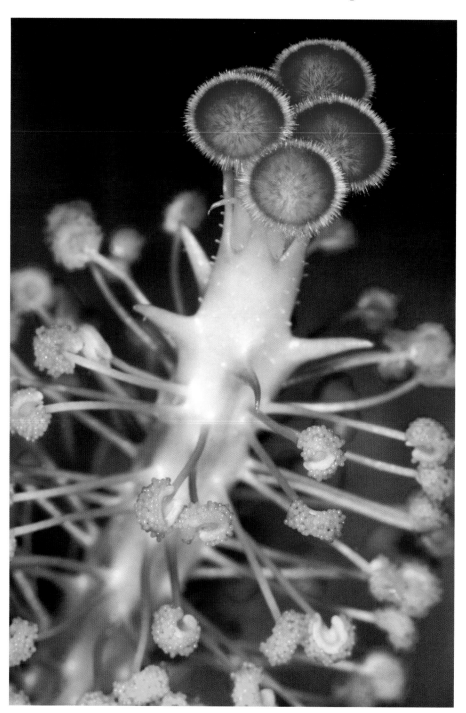

Here I am using a Nikon ring flash attached to the front of a Nikon D1X with a 105 Nikkor lens. Photo: Andy Bale

Hibiscus, Tanzania. Nikon D1X with Micro-Nikkor 105mm f/2.8D AF lens and ring flash

portraits, plant portraits, and, of course, closeups. You can also connect other flashes for better lighting control, which is especially useful for lighting tricky backgrounds.

On several occasions, I have heard and sometimes read that a ring flash is a poor way of capturing closeup subjects because it wipes out shadows, which are crucial for showing detail in an image. While this statement is true on older models of ring flash units, some new ring flash models allow photographers to either turn off one of the flash tubes for a directional light source or lower the illumination on one of the tubes to slightly fill in shadows for a more creative lighting effect. The flash unit can also be rotated on the front of your lens, giving you additional lighting angles from which to choose. A ring flash is also much easier to use than trying to attach two flashes to your camera.

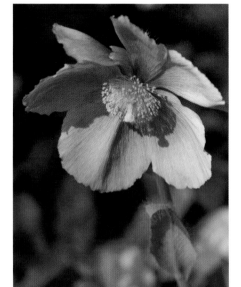

Blue poppy, Longwood Gardens, Pennsylvania. Nikon D1X with Micro-Nikkor 105mm f/2.8D AF lens

This series illustrates the different ways you can adjust flash tubes. I made my first shot using available light (far left). I wanted to move in closer, but there wasn't enough ambient light to capture the flower using the high depth of field I desired. I didn't have a tripod, so using a long shutter speed was out of the question, because I would have been breaking the handheld rule. This was a perfect situation for my ring flash. So, for the second image (near left, top), I turned the right flash tube off, which resulted in the shadows around the center section falling to the right as the light source came from the left. On the third shot (near left, middle), I switched the left flash tube off and turned the right flash tube on, which resulted in the shadows dropping to the left side. On the last shot (near left, bottom), I turned both flash tubes on so that light illuminated the poppy from both the left and right sides. The shadows appearing on both sides of the center section are softened by the firing of both flash tubes at the same time. I could have also lowered the illumination of one of the flash tubes to fill in some of the harsh shadows if desired. With today's ring flashes, you have various lighting options.

◄ There was a beautiful flower garden outside my window in the small backpacker's bed and breakfast where I stayed after a three-week safari in Tanzania. After a good night's sleep, I decided to take a few more shots before leaving for the airport. My large duffel bag was already packed, including my tripod. So, if I had any chance of getting this shot, flash was going to be my saving grace to light the shaded hibiscus. Using both tubes of the ring flash illuminated all the visible areas of the flower's reproductive parts. Even if you're on safari with amazing subjects in all directions, some good nature shots are still found in areas that you might pass up because they're not in a natural setting. By cropping in on your subjects, however, you remove them from their environment.

Flash Brackets

If you already own an external flash, you'll need a way to attach it to your camera because your camera's hot shoe is probably the worst location to use flash with closeups. You may think you can hold your flash with your left hand while you shoot with your right hand—try it once and that will be the last time. You could also ask someone to help you all the time, but assistants can be expensive, and you could end the relationship with the person trying to help you! Asking for help once in a while is fine, but don't always expect help. You must remember that not everyone is as excited about closeups as you are.

To avoid stress, use a flash bracket. A flash bracket frees up your hands for picture-taking. I've made my own flash brackets out of cast aluminum, but none compare to the versatility of the Wimberley macro flash bracket. This bracket permits full motion of the flash and enables you to position your flash to obtain any type of lighting angle. I liked the bracket so much I bought another one, which I can use at the same time and add a little fill light to eliminate harsh shadows in my photographs. You can synch the flashes with a cord, or you can use either your flash's built-in slave trigger or a manual slave trigger (see pages 122–123 for more on slaving your flash).

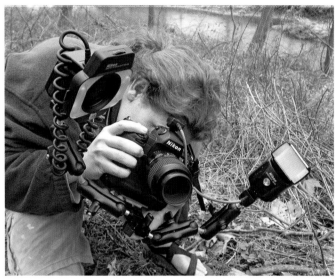

Here I had one flash synched to my camera and the other slaved so that both flashes would go off at the same time. The flashes were each on a Wimberley macro flash bracket attached to the bottom of my camera by a quick-release plate. This rig with two flashes is a bit cumbersome, but it enables me to shoot moving subjects in places where setting up a flash away from the camera would be impossible.

Bat pile, Unionville, Pennsylvania.
Nikon Coolpix 4500 with
one external flash

This group of bats lives under the eaves of my in-laws'
garage. One hot and muggy August afternoon was the
perfect time to capture the bats clumped together. I
stood watching them shift around and occasionally
yawn, and I waited. I pulled out a stepladder and
inched my way up the rungs until I was close enough
for a shot. If I had been using my digital SLR instead of
the Coolpix 4500, it would have been impossible for
me to capture this angle. With the camera wedged
between the rafters, I tilted the screen so that I could
see where I was aiming. I turned off the internal flash
and used the diffuser on the external flash to soften
the light hitting the bats. Considering the
circumstances, I'm pleased with the outcome.

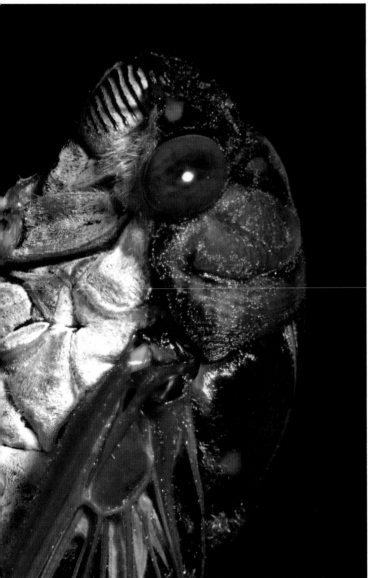

Dog day cicada, Unionville, Pennsylvania.
Nikon D1X with Micro-Nikkor 105mm
f/2.8D AF lens and one external flash

The steamy East Coast dog days of summer bring
out the cicada's song in full force. The high-pitched
buzz signals that the season is coming to an end, the
melons are ripe for the picking, the peaches are
sweet as candy, and it's time to sit back and enjoy
the few long days left before fall shows its face. If
you're trying to find and photograph creatures at
night, pick up a headlamp. It frees your hands and
produces enough light so that you can focus on your
subject. I used a headlamp to find this cicada as he
clung to the side of a black walnut tree. I used one
flash. You can tell by the single highlight in the
cicada's eye (crucial for giving life to your subject).
Positioning my flash to the side shows both the color
and the texture of my subject. The field in the
background was too far away to be affected by the
flash, so it was rendered black. This is okay because,
after all, it was nighttime.

Side-striped chameleon, Tanzania. Nikon D1X with Micro-Nikkor 105mm f/2.8D AF lens and one external Nikon flash with Wimberley flash bracket

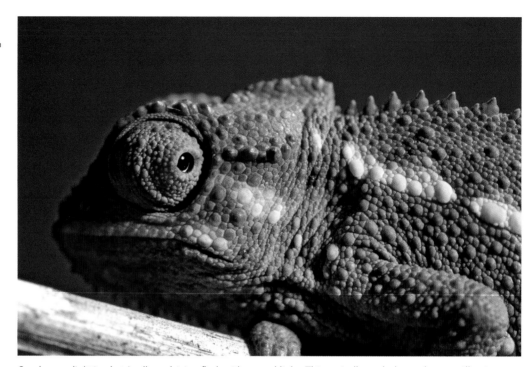

Synchro-sunlight is what I call combining flash with natural light. This typically works best when you illuminate a subject in the foreground and the sun illuminates the background. This chameleon, not much bigger than my pinky finger, was clinging to a stalk of grass. Looking down, you could barely see him amidst the yellow and brown dry foliage. Instead of showing how well this creature blended with its environment, I decided to make my subject stand out by contrasting the complementary orange hue of the chameleon's skin with the blue sky. I lay flat on the ground, angling my camera up toward the chameleon to include the sky in the background. If I had taken the shot with natural light, either my subject would have been black and my sky correctly exposed, or my sky would have been overexposed and my subject properly exposed. To combat the scene's extensive tonal range, which was out of my digital camera's reach, I used external flash to illuminate my subject, synching it with the sunlight. That is, I metered on the sky and manually adjusted my flash output to capture the correct exposure on the chameleon.

Owl butterfly (butterfly house captive), British Columbia, Canada. Nikon D1X with Micro-Nikkor 105mm f/2.8D AF lens and one external flash with one bounce reflector

Butterfly houses are rife with photo-ops. It's hard not to get a good shot with so many gems flying about. If the butterfly house breeds and raises insects, you can capture entire life cycles, adding to the wealth of your stock shots. With a little creative positioning and lighting, you can manipulate the scene to look like a natural shot of a butterfly in the wild. For this shot, I used a reflector to bounce light off of my external flash and to fill in the shadows cast by the subject. I had the luxury of someone helping me hold the reflector while I was able to concentrate on the shot. If you have the chance, bring someone with you on your photo shoots if you think you're going to need help. It's not like you're asking someone to help you move—all you need is an extra hand.

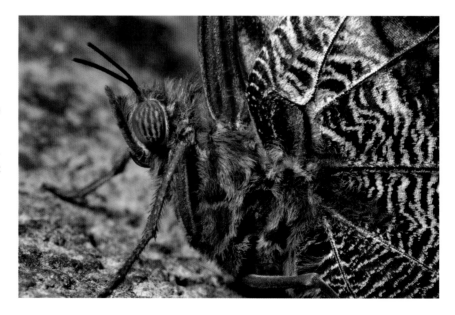

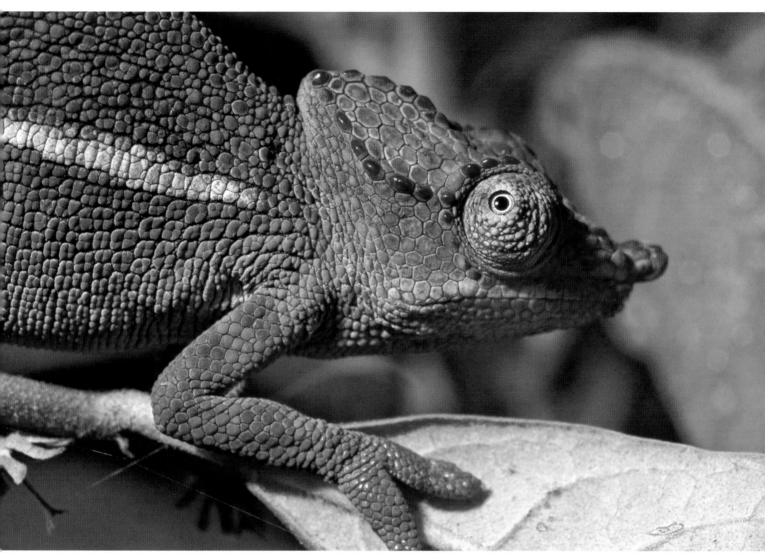

Hanang mountain chameleon, Nou Forest, Tanzania. Nikon D1X
with Micro-Nikkor 105mm f/2.8D AF lens and one external flash

I could photograph chameleons all day; their changing colors and slow movements
are intriguing. I used the same flash position for this chameleon as I used on the
cicada on page 119, only this time the foliage in the background is close to the
subject, and the flash was strong enough to illuminate it. It's okay for some of your
subjects to have a black background, but you don't want them all to look that way.

Slaving a Flash

Slaving a flash means you are causing an additional flash to fire when your first flash goes off. This happens so fast that there's basically no delay between the time the first flash goes off and the second flash fires. Some flashes have a slave mode built in so that all the photographer has to do is press the Slave button. If you have an older flash that doesn't fit your camera system, you can buy a slave trigger, which fits on the bottom of the flash. This is a small light sensor that causes the other flash to fire when the dedicated flash attached to your camera goes off. There's no limit to the number of flashes you can use in this type of scenario. The slave trigger I use is one I bought for about $10 eight years ago—and it still works!

This is a slave trigger. The hot shoe on top of the slave trigger looks a lot like the hot shoe on top of your camera. This small device really gives closeup photographers a lot of bang for their buck.

Purple mushroom, Unionville, Pennsylvania. Nikon D1X with Micro-Nikkor 105mm f/2.8D AF lens and two Nikon external flashes

One of the wettest summers on record (in 2003) produced some of the best crops of wild mushrooms. Any stroll through the forest would produce a bounty of colorful subjects to photograph. To light this purple beauty on a mattress of moss, I used two flashes, one wired directly to my camera and another using a slave trigger. This arrangement allowed me to soften harsh shadows and accentuate the purple and green tones. Using two external flashes is cumbersome; make sure you have a high level of patience when you attempt it.

Spider with outstretched legs, Unionville, Pennsylvania. Nikon Coolpix 4500 with one external flash and light bounce disk

What struck me about this closeup scene is the way the spider's legs mimic the positions of the leaves. The natural background was too far away for me to illuminate it with my flash, so I used a small handpainted background instead. I used the external flash to illuminate the scene from the left side, and then used a light-reflecting disk from Westcott on the right side to bounce light back into the scene, filling in harsh shadows. Instead of trying to hold the light disk, I used a plamp (a double-ended clamp from Wimberley that you can position) to hold the reflector. Setting the timer allowed me to press the shutter, and then hold the background in place. I could have really used an assistant that day, but with a few gadgets, I managed.

Assassin bug on thistle flower head (captive), Unionville, Pennsylvania. Nikon Coolpix 4500 with two external flashes

The wind was blowing and I couldn't seem to get a good shot of this assassin bug, so I cut off one of the thistle heads and brought the insect into my studio. (A studio for closeups can be as simple as a kitchen table, a glass, a background, and a light source.) For this shot, I wanted to highlight the flower and add a little rim light on the insect. To achieve the rim light, I placed the flash behind the subject. If I had only used this one flash, the front of the insect would have been black. To combat this, I added another flash toward the front of the subject, which also lit the background. Combining flashes allows infinite lighting possibilities.

Flash and Macro Aquarium Photography

Aquariums let us travel the far reaches of the world to the depths of the sea for a fraction of the cost, and they let photographers capture unique subjects for a fraction of the cost of buying underwater equipment. An aquarium, like a zoo, is somewhere between watching television and traveling to a creature's natural habitat. Zoos and aquariums are both better than television, but not as good as the real thing. While I would never trade the experience of actually being on site, aquariums and zoos are wonderful for people who can't travel for whatever reason.

In the dead of winter, when you've grown tired of photographing the brown, decrepit foliage and icy, white landscape, add a little color to your images and escape to another world. Aquariums are superb places to photograph during the winter months; crowds are small and subjects are plentiful. A recent visit to the Vancouver aquarium didn't let me down; I easily photographed the same hard-to-reach creatures that I saw in tidal pools while hiking the Pacific Crest Trail—without the worry of crashing waves destroying my equipment! If you don't live near a public aquarium, try shooting in a pet store; owners are usually happy to let you photograph some of their exotic species.

If you're going to shoot in a public aquarium, there are a few things you should first consider. Are you allowed to use a flash? If not, you'll be limited to what you can capture with available light. Are you allowed to take a tripod? You may only be able to on a certain day or at a certain time. Is it going to be crowded when you go? Check to see if any elementary school groups are going to be there; while they are often amusing, they can also put a real damper on your photography.

Whenever photographing in aquariums, I always carry extra batteries for my flash and an extra cleaning cloth to wipe off the glass of the aquarium before shooting. Aquarium glass is notorious for being caked with face smudges and fingerprints. These smudges may not show up in your image, but it's always best to start with the cleanest surface possible. I also carry a polarizer to help reduce unwanted glare. Remember, it's much easier to fix a shot on location than to manipulate it in Photoshop.

Flash and Glass

Shooting through glass has its hurdles to overcome. On my last trip to the Baltimore Aquarium, a nice older man was watching me photograph. He approached me and said that I would have much better luck if I moved my flash off the camera. What he didn't know was that I was using a ring flash with my camera pressed flat up against the glass. If I had been using a front-on flash (such as an internal flash) and had been holding my camera lens away from the aquarium glass, he would have been right—my shot would probably have contained an overexposed glare spot. But using a ring flash and holding the camera lens against the glass eliminates this problem.

Neon tetra, Baltimore Aquarium, Maryland. Nikon D1X with Micro-Nikkor 105mm f/2.8D AF lens and ring flash

I was careful to keep the front of my lens and ring flash pressed flat against the aquarium glass. It paid off, minimizing the distance between me and the subject, and eliminating the unwanted effect of glare spots in this image. Since I was using both tubes of my ring flash to light the fish, you see only a slight shadow from the subject on the background foliage.

This is not one of my typical compositions. The subject doesn't come close to filling the frame; its face is close to the edge of the image and facing out of the frame. What ties the image together compositionally is the upper right dark corner juxtaposed with the brightly colored fish in the lower left corner, held together with clear diagonal lines. This image is all about tension: tension of the fish leaving the frame, tension created by diagonal lines, tension in the fish's torn back fin, and tension in the dark upper right corner. Don't get stuck in a compositional rut—it's okay to break the rules.

Glare spot, Baltimore Aquarium, Maryland. Nikon D1X with Micro-Nikkor 105mm f/2.8D AF lens and ring flash

While following my subject, I accidentally moved my camera and it wasn't flat against the glass. When I snapped off the shot, brightly overexposed glare spots appeared in the image. This was not my intended result. Instead, the result was exactly what the man at the aquarium warned me about. I allowed too much room between the aquarium glass and the glass of my camera's lens. My ring flash, when attached to the front of my lens, illuminates with frontal lighting; when it hit the glass, it bounced back, causing glare in the image. Your angle of illumination is one of the most important aspects of shooting through glass.

Blue poison dart frog, Baltimore Aquarium, Maryland. Nikon D1X with Micro-Nikkor 105mm f/2.8D AF lens with Nikon ring flash

As mentioned in the chapter on light and color, frontlight accentuates color, which is what drew me to this frog. Emphasizing the brilliant blue skin was simple using both tubes of my ring flash to get good frontal lighting. The only downside to this setup was the effect it had on the wet rock; every water droplet reflected the light and was rendered as an overexposed highlight. However, I could easily remove the highlights in Photoshop with the Healing Brush tool if I desired.

Sunflower starfish, Vancouver Aquarium, British Columbia, Canada. Nikon D1X with Micro-Nikkor 105mm f/2.8D AF lens and one external flash

I was happy with this image when viewing it on my LCD screen; when I downloaded it to my computer, however, the screen revealed harsh shadows, and I changed my mind. I did want some shadows to highlight the texture of the starfish, but these are a bit too dark for my taste. If I were able to reshoot this image, I would either add another flash or use a bounce card (which reflects light back toward the light source) to fill in some of the shadows.

Plumose anemone, Vancouver Aquarium, British Columbia, Canada. Nikon D1X with Micro-Nikkor 105mm f/2.8D AF lens and external flash plus Wimberley macro flash bracket and Nikon flash

Sea anemones are as different as wildflowers in a meadow. A single flash was the only light source needed to capture the flowing tentacles that draw the eye through the frame. Using a single light source produced shadows, emphasizing the texture and three-dimensionality of the subject.

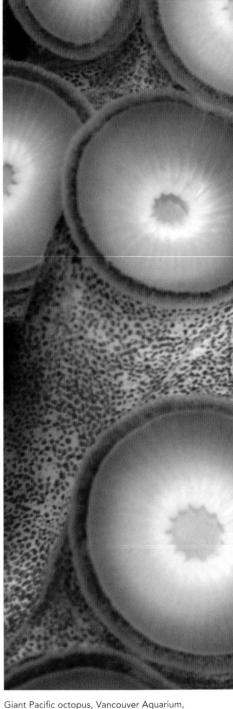

Giant Pacific octopus, Vancouver Aquarium, British Columbia, Canada. Nikon D1X with Micro-Nikkor 105mm f/2.8D AF lens and Nikon polarizer plus Wimberley macro flash bracket with Nikon flash

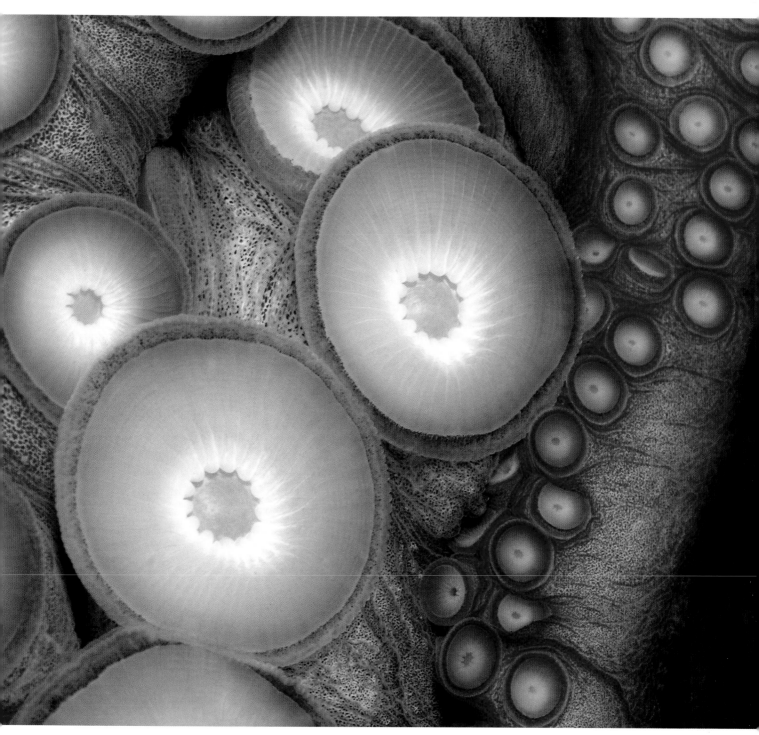

Mesmerized by the changing colors, I watched this octopus for at least twenty minutes with its arms drifting back and forth as it moved slowly about the tank. It finally settled directly in front of me, attaching its suckers to the aquarium glass. I knew this was going to be a tricky shot; I couldn't position my lens directly against the glass if I wanted to include multiple suckers in the frame. But moving the lens away from the glass would result in glare caused by the camera's external flash. To reduce the glare, I added a polarizer to the front of my lens. I then used my flash on my Wimberley macro flash bracket, positioned at about 45 degrees from my subject and lens. The polarizer worked—it eliminated glare, allowing the viewer to see the intricate colors of the suckers.

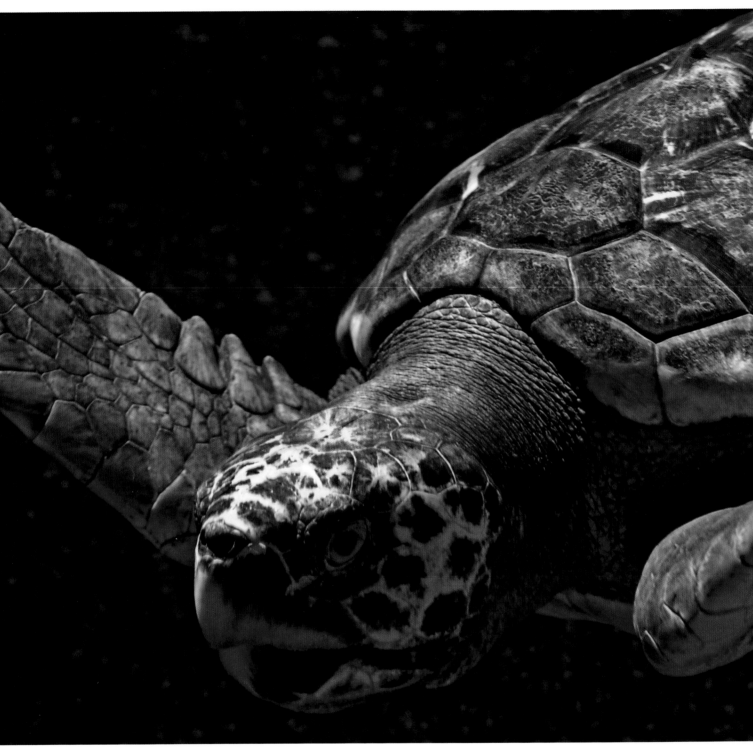

Sea turtle, Vancouver Aquarium, British Columbia, Canada. Nikon D1X with Micro-Nikkor 105mm f/2.8D AF lens

Capturing a moving subject with natural light in an aquarium may sound impossible without a tripod. I was able to do this because the aquarium is outside, where natural light strikes the surface of the water. The sides of the aquarium are underground with a glass tunnel for visitors to walk through. I used autofocus, waiting for the turtle to swim toward my lens. It doesn't get any easier than this; however, that doesn't mean the shots aren't useable. You can hike a hundred miles into the backcountry for a great shot, or you can walk out your back door and capture a great shot—it's how you capitalize on the light that's important.

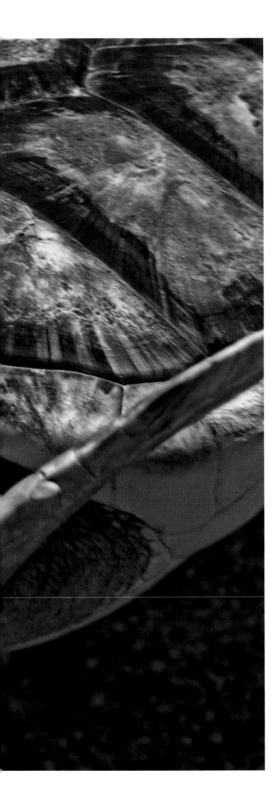

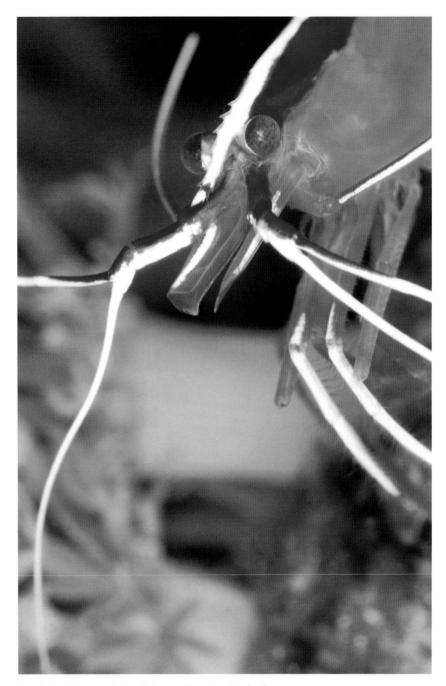

Red-backed cleaning shrimp, Baltimore Aquarium, Maryland.
Nikon D1X with Micro-Nikkor 105mm f/2.8D AF lens and two
Wimberley macro flash brackets with two Nikon external flashes

Using two external flashes for this particular image produced similar results to using a
ring flash—in fact, I don't think I would be able to tell that it wasn't a ring flash. I chose
not to use a ring flash because the shrimp was too close to the front of the glass, so I
couldn't position the front of my lens against the aquarium glass.

WORKING WITH HISTOGRAMS & RAW FILES

Salmon berry, Mt. Rainier National Park, Washington. Nikon D1X with 28–70mm 1:4.5 macro lens

Both histograms and RAW files will help you get the most from your digital photography. You may not always want or need to use them, but knowing what they can do for you will give you more resources at your disposal.

Understanding Histograms

If you've spent any time shooting with a digital camera, you know the picture on the LCD screen doesn't always give an accurate representation of how the image will appear when downloaded onto a computer. Digital photographers shoot and look down, shoot and look down, and so on. At first, we look down at the LCD screen to make sure the image we just shot is the same as the scene before us, but eventually, and even more importantly, we look down to see our camera's histogram.

Histograms are used throughout the entire process of digital photography; from camera to print they show how digital data are represented in your image. Your camera's histogram might not match exactly with the image's histogram displayed in Photoshop, but it's probably very close. Most digital cameras sold today have the ability to show histograms either separately or superimposed over the image in the LCD screen. Histograms can either be displayed immediately after the image is shot or during the camera's playback mode.

So, what does this graph have to do with photography? A histogram shows the arrangement and balance of pixels throughout an image. It indicates if an image contains areas that are over- or underexposed. An image that's overexposed contains highlights that lack detail, whereas an image that's underexposed contains shadows that lack detail. There are no right or wrong histograms; they are what they are. You decide how you want to use the data in your histogram to analyze your images.

How do you use a histogram in the field? No matter what type of file you are shooting (JPEG, RAW, or TIFF), the histogram will prove an invaluable tool. For a film photographer, the light meter is the most valuable tool for capturing the correct exposure. It is still useful for a digital photographer, yet it's only a starting point to capturing the exposure you want. Once you select your ISO setting, *f*-stop, and shutter speed, your camera's meter indicates whether your image will be under- or overexposed. You make adjustments to these settings until the light meter reveals that the scene is properly exposed. With film, this is the final step; then, you take the shot and move on to the next frame. With a digital camera, this *can* be your final step; however, your images will benefit if, after you take the shot, you look at the histogram to see where your tones actually fall. If your shadows or highlights lack detail, your histogram will show you this, allowing you to

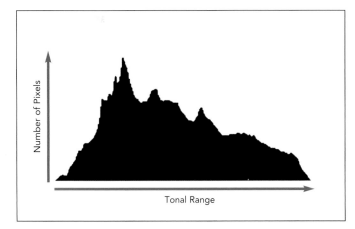

This is a basic histogram. It's easy to interpret, as long as you know what you're looking for. The left horizontal axis is used for determining the balance of dark pixels in an image; the right horizontal axis is used to determine the balance of light pixels in an image. A histogram illustrates the tonal range of an image. The vertical axis shows how many pixels occur in each individual tone. A higher vertical axis in a given area reveals that there are more pixels occurring in that particular tone. Fortunately for digital photographers, a histogram has the same meaning in both a digital camera and in Photoshop.

Under my camera settings, I selected the histogram to be displayed superimposed over my image, which in this case is a shot of butterfly wing scales. By looking at the histogram, I could check that detail was preserved in all parts of the image, giving me confidence that I had captured my intended exposure. Since the histogram didn't reach the left or right edges of the graph, I knew that detail was preserved in all parts of the image—both in the dark and the light areas.

make adjustments and capture the exact exposure you desire.

Now let's break the graph down a bit more. The human eye is able to differentiate between 256 different levels of the grayscale. This is why there are 256 vertical lines appearing on the horizontal axis making up the histogram. Starting at the far left is 0, or pure black, and moving to 255 on the far right is pure white. Each vertical line represents a level of the gray scale that our eye can distinguish. In actuality, the first 10 and last 10 vertical lines of the histogram are so hard to distinguish in detail that you should consider, for all intents and purposes, 0–10 to be pure black and 246–255 to be pure white, as well. Level 128, halfway between 0 and 255 on the graph, is considered

Lichen, too dark

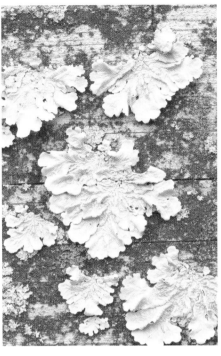

Lichen, too light

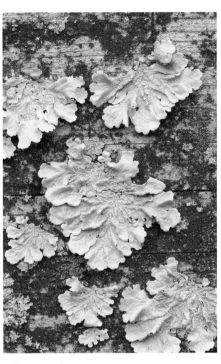

Lichen, just right

Notice that the histogram touches the left side of the graph, indicating that the image does not contain any detail in the black areas—any areas in shadow will be completely dark. This is fine if you're shooting a silhouette with shapes and no detail. If you want a rich black with detail, this image simply won't work for you no matter how much time you spend in Photoshop trying to fix your mistakes.

In this version, the histogram touches the right side of the graph, indicating that the image does not contain any detail in the light areas—any areas in the lightest parts of the image will be completely white. This is fine if you don't want detail. However, if you want a rich white with details throughout the image, it simply won't work for you no matter how much time you spend in Photoshop.

In the histogram for this image, the vertical lines stop before reaching both the left and right sides of the graph. This is an ideal histogram, containing details in both the light and dark areas of the image. A histogram such as this will enable you to make a variety of adjustments in Photoshop to achieve your desired result—without compromising the image's detail.

gray or a mid-tone. If you've ever used a gray card to meter a scene, you'll know that it's a perfect 18% reflected-light mid-tone and would have numeric value on a histogram of 128.

When using Photoshop, you can view different histograms depending on which mode you're using. Most digital photographers are working in the RGB color space, which is what I will use in my explanations. The RGB histogram combines the Red, Green, and Blue histograms to give you an overall view of the tonal values in your image. For a more precise look at where the colors and tones fall, you can view individual histograms for the Red, Green, and Blue channels.

Colors and tones in an RGB image are determined by assigning each pixel a tonal value ranging from 0 to 255 from each of the three channels (Red, Green, and Blue). When viewing histograms, you can set the cursor in Photoshop on individual pixels to see the numeric tonal value. For example, setting the cursor on a pure black pixel would show a numeric value of R0+G0+B0. However, setting the cursor on a pure white pixel would show a value of R255+G255+B255. A mid-tone gray results from combining equal parts of R127+G127+B127.

For this grasshopper image, you can see that the individual histograms of Red, Green, and Blue look different from one another. If you want to tweak specific areas in one of these channels, this is where you want to work, in whichever area needs adjusting. If you want more of a basic, overall adjustment, work in the RGB histogram, which shows an average of where the tones fall.

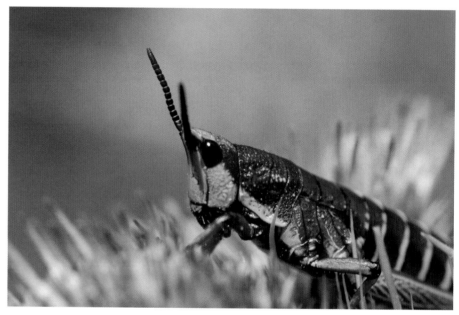

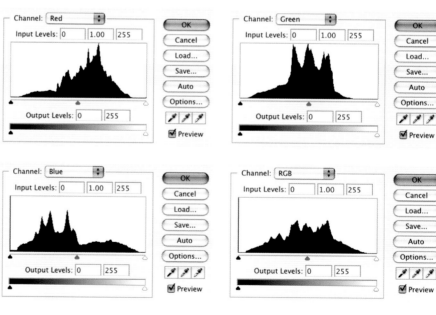

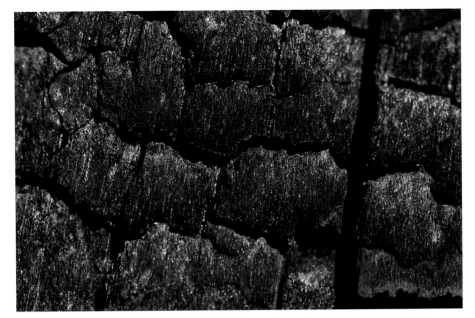
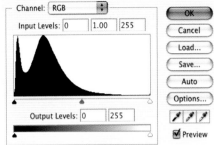

This photograph of acacia tree charcoal is an example of a low-key image: one in which the detail is condensed in the dark areas of the image. It's a perfect representation of an image for which most of the information occurs in the dark regions of the histogram graph. Notice the high spikes toward the left side of the histogram. This shows that most of the image's pixels occur in the dark region of the frame.

This picture of a fungus-covered leaf is an example of an average-key image: one in which the detail is condensed in the mid-tones. Even though there were many colors present on the leaf, I knew that the tonal value of this scene was basically a mid-tone. Most of the tones fall about halfway between 0 and 255 on the histogram.

This image of a Persian buttercup is an example of a high-key image: one in which detail is condensed in the light areas of the image. Notice that even though the pixels are concentrated on the right side of the graph, they don't go past the 255 mark, showing that detail is preserved in all areas of the image.

Adjusting Histograms

To adjust a histogram in Photoshop, you must use the Levels command. For maximum quality, you should first change your image from 8 bits/channel to 16 bits/channel. Working in 16-bit mode will take up more memory, but you won't lose as much data when making adjustments as you would if making adjustments in 8-bit mode.

Your second step is to decide whether you want to adjust the RGB levels all at once or separately. I suggest initially adjusting them all at once to see if this gives you the result you desire. If it doesn't, then go in and tweak the individual Red, Green, and Blue channels.

The best place to start is to move the left triangle, which controls your blacks, to the point where the left side of the graph begins. Next, move the right triangle to where the graph begins. How does that look? Finally, move the center triangle, which controls your mid-tones, to the point where the image appears just how you would like it to appear. There's no real right or wrong area to place the triangles—it's how you, the photographer, envision your image.

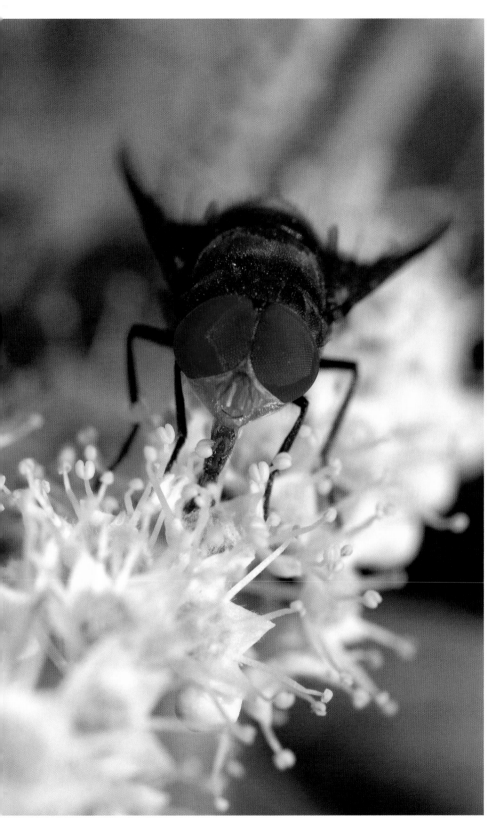

I adjusted the Levels exactly the same, using the 8-bit mode (top) and then using the 16-bit mode (bottom). Note how, in the 16-bit mode, the gaps (the white lines) are evenly spaced and there are fewer of them. This means there was very little data loss in the image level adjustment. On the other hand, look at the gaps in the 8-bit mode; there are many, and the degree of change in the vertical axis is great. While it may be difficult to see a difference in a printed version, more data are preserved in the 16-bit mode. To obtain the best results for your image, make sure you switch to 16-bit mode before adjusting the Levels.

Working with RAW Files

A diamond cutter studies a lump of stone, decides where to make each cut, and captures the beauty of the crystal rock. The cutter's skills, along with the quality and clarity of the stone, determine how striking the cut diamond appears. Like diamonds in the rough, RAW files allow digital photographers to prove their expertise. How the photographer interprets the data decides the allure of the image.

The Photoshop RAW plug-in is like a special, photographer's software package bundled within a larger imaging program. In my opinion, this is the best method to render your digital images. As mentioned earlier, a RAW file is a "lossless" compressed file containing minimal camera processing. It seems counter-intuitive to spend thousands of dollars on a digital camera equipped with sophisticated settings, such as white balance and sharpening, and use a file format that doesn't take full advantage of these advanced settings. However, this is exactly what you do when you shoot using the RAW file format.

For years, nature photographers have primarily taken color slides. When developing a slide into a print, there's little leeway to make changes to exposure in the darkroom. Black-and-white film allows countless adjustments in the darkroom, enabling photographers to pull out details that are difficult to see on the negative. You can compare a JPEG file to a color slide in that you have less leeway in the darkroom to make changes, so your shooting technique must be accurate. My mindset has changed since shooting RAW files, becoming more like it was when I shot black-and-white film. Today, when shooting RAW files, collecting data is my primary goal; and, this data is then imported into the digital darkroom for final editing. I shoot and look at the histogram to make sure my exposure contains details in the whites and blacks.

To use the RAW file, you must start by making sure your camera has the ability to shoot using the RAW-file format. Under your camera's shooting menu you will have different format options from which to choose. Your camera's manufacturer may have given its RAW-file format a different name than "RAW"; however, RAW should be indicated. Once you select the RAW file, see how many images you can store on your card. Then switch back into JPEG-file format and see the difference. The number of pictures you can store will have drastically increased under the JPEG format. Now switch into an uncompressed-file format, such as TIFF. You will be able to store even fewer images on your card than in the RAW mode. For example, a Nikon D1X and a 160 MB can capture forty-seven high-quality format JPEG images, twenty RAW file images, and only ten TIFF images.

The image to the left is exactly how it appeared on my camera's LCD screen, seemingly underexposed with very little detail. If I had been judging my exposure based only on the image in the LCD screen, I definitely would have reshot this. However, I was looking at the camera's histogram, which showed there was detail in every part of the image, including in the highlights and shadow. This is why I kept the shot. Weeks later when I downloaded the image onto my computer, it still looked much too dark. My camera's histogram didn't lie, however: a few steps in Photoshop's RAW dialog box and the scene appeared just as I remembered it (above).

Managing your RAW files is a whole other beast. As you can see, your digital memory storage capability will either have to increase or you will have to shoot fewer images if you're going to use the RAW format instead of the JPEG format. Taking your time and shooting less is a good option, but passing up good subjects to save on digital media storage is not. I suggest using at least a 512 MB digital media device and even larger if you can afford it. At least one digital media manufacturer is making compact flash cards able to store 8 gigabytes of information.

To aid in your storage dilemmas in the field, you can also use laptops, portable hard drives, and battery-operated CD burners to keep your large files. I use a variety of storage devices depending on my needs and location. The key is to find one to suit your needs. (See pages 44–45 for more on the different types of storage devices.)

Even though minimal camera processing occurs to the image when using the RAW format, there are a few camera adjustments of which you need to be aware. You still need to select an ISO setting. The ISO will still have the same effect as it would if you were shooting any one of the other file formats. Next, you can select a white balance that will show up as the camera default when you open up your RAW file. Try the automatic white balance setting as a place to start. If your camera allows, select a color space. Adobe RBG 1998 is the one I choose because it's the largest color space my camera offers. The other camera settings that you must use are shutter speed and aperture, as the RAW file will not affect these.

Once you've taken a few images, download them onto your computer. Adobe Photoshop CS has the built-in ability to open RAW files taken from

This illustration shows the RAW file dialog box in Adobe Photoshop CS. When reading this section, it's beneficial to open up Photoshop and follow along with the RAW file dialog box. There are two modes available in the camera RAW dialog box: Basic and Advanced. When you click on the Advanced mode, two more menus appear: Lens and Calibrate.

many digital cameras. I will use this program for all further discussion. RAW files take longer to process than JPEG or TIFF files, but using them has become much easier with the Adobe Photoshop plug-in. You might have to adjust your workflow a bit when dealing with RAW files: you can only open more than one file at a time if you create an action to open all the files at once with a particular setting applied to all images. This lets you see a quality preview of all images before opening them individually. As you scroll through the previews, select an image you want to view in more detail. It's in this window where the power of the RAW file lies.

The first area I work with is the bit depth. You have two choices in the lower left menu: 8 bits or 16 bits per channel. I always choose 16 bits per channel because there is more information in an image containing 16 bits per channel than in one with 8 bits. The downside to working with

16 bits per channel is that the image is now twice as large, and some options in Photoshop will be inaccessible. What you can do is apply all of the available adjustments in 16-bit mode, and then switch to the 8-bit mode for a final tweaking if needed. This will ensure that you retain as much of your digital data as possible.

The Space menu refers to the color space of an image. You have four options to pick from: Adobe 1998 (RGB), available as a color setting on high-end digital cameras; Color Match RGB; sRGB IEC61966-1; and ProPhoto RGB. If you want to pick your own color space, choose ProPhoto RGB, and choose your color space after the image opens. Adobe 1998 (RGB) is usually my chosen color space to keep consistent with the color space selected on my digital camera and my chosen Photoshop default color space.

You can also adjust your size and resolution before the RAW file opens up in Photoshop, or you can use

adjustments in Photoshop to resize your image. I keep the file size the same as it was taken in the camera and make adjustments in Photoshop, or I use Genuine Fractals, depending how large I want to make the final image. Once you make these few minor adjustments, it's time to take advantage of the RAW file options.

Start with white balance adjustments. As explained on page 78, the white balance is the color temperature. When you shoot RAW files, you can easily change the white balance using a few different methods. For example, you can use the Eyedropper tool to select a mid-tone. Move the Eyedropper to select your desired mid-tone and watch the color temperature change. This is, in my opinion, the least effective way to adjust the color temperature.

You can also select preset color temperatures described as Cloudy, Daylight, and Shade. These are basically the same names your digital camera may give you for the white balance selections.

My preferred method, however, is to use the slider to select a custom color temperature. You'll notice that the color temperature gets cooler as you move to a lower temperature. This

2,000 K

4,000 K

6,000 K

When I downloaded this image of sugar cane, I chose five different color temperatures from the RAW dialog box to show the outcome. At 2,000 degrees Kelvin, the color appears cool. At 10,000 degrees Kelvin, the color appears warm. I remember the scene as being about 6,000 degrees Kelvin. You decide how to best use the color temperature setting.

8,000 K

10,000 K

I was drawn to this closeup of a hibiscus petal because it looked like pink rolling hills. The original was a bit muted for my taste (left), so I increased the exposure, increased the shadows, and increased the saturation (right). The final image has the "pop" I remembered when I shot the scene. In the field I checked my histogram and was confident my file contained the needed information to adjust it in the digital darkroom.

doesn't seem to make any sense at first glance because a lower color temperature as seen in the Kelvin scale on page 78 produces warm colors. The color becomes cooler (bluer) at lower temperatures in the RAW Photoshop plug-in because you're actually correcting for an image taken under a warm color temperature. The same holds true for an image taken in a cool color temperature. You're actually adding a warm temperature to combat the cool color. You can immediately view how your selections change the appearance of the image.

The last adjustment I make is Tint, used for adjusting the image cast from green to magenta. Moving the Tint slider to the left will add green to your image, while moving it to the right will add magenta.

The next adjustment I use is the Exposure slider. For Mac users, hold the Option key. For Windows users, hold the Alt key. You can see at what value the whites in your image will lose detail. The image will be "clipped" and appear overexposed. White on the screen shows that detail

is preserved, while color on the screen indicates that detail is being lost in one of the channels.

The best way to adjust the exposure value is to move the slider until the whites are losing detail, and then move the slider back a bit so that your whites retain detail. When you move the slider, a value will appear in the window that relates to the amount of f-stops that you have changed in your image. For example, -1 shows that your image is one f-stop darker than how you shot it, and +1 shows that your image is one f-stop brighter than how you shot it.

The Shadows slider works in much the same way as the Exposure slider. If you want to increase the blacks in your image, move the slider to the right. Mac users hold the Option key, and Windows users hold the Alt key, to view the point at which the blacks begin losing detail. White on the screen shows that detail is preserved, while color indicates that detail is being lost in one of the channels.

The Brightness slider may not seem any different from the Exposure

slider. Use this adjustment only after you have adjusted Exposure and Shadows in your image. When moved left, the Brightness slider will darken the image; when moved right, it will lighten the image. The main difference here is that you won't lose any detail in your blacks or whites when you adjust your image using the Brightness slider. You can only lose detail when using the Exposure or Shadows sliders.

The Contrast slider is best utilized after you adjust Exposure, Shadows, and Brightness. The mid-tones in your image will be affected most when using the Contrast slider. If you want to add more contrast to your image, move the slider to the right; if you want to reduce contrast, move it to the left.

The Saturation slider adjusts the saturation of color in your image. Moving the slider to the right increases the color saturation to the point where it can appear overblown and sick. Moving the slider to the left decreases color saturation. If you move it to a value of -100, you have an image that looks like grayscale.

These are details of an image of a passion plum tree flower. Despite the shady conditions, photographing this wouldn't have been a problem if my tripod had reached high enough. Since it didn't, I was forced to handhold the camera and use a shutter speed of at least 1/160 sec. Using my lowest f-stop still didn't allow me enough light to capture a good exposure. This left me with only one option: increase my ISO setting to make my imaging sensor more sensitive to the light. The side effect of using a high ISO was digital noise in the image (left). Using the RAW file advanced settings enabled me to decrease the digital noise (right), making it appear as if I had used a lower ISO. I don't think it looks as good as if I had used a lower ISO, but it's difficult to tell the difference.

In the field, my camera's histogram showed that there was detail in the dark and light areas of my image. Using the basic RAW settings didn't give me enough control over the color balance, so to render the scene the way I remember it, I used the Advanced Calibrate setting. I first adjusted the shadow tint and then made adjustments to the different hues and saturation.

Advanced Settings

If you want even more control over your digital images, you can turn the Advanced setting on to take advantage of some additional settings. Since the conception of the digital camera, "noise" has been a problem. This nasty side effect shows its face in two forms: grayscale, referred to as *luminous*; and color, referred to as *chroma*.

The best way to combat noise is to use a low ISO setting when you are shooting in the field. Using a low ISO setting may not always be possible, however, due to low-light situations. By shooting a RAW file, you have the ability to lessen the noise in your image in Photoshop CS by choosing Detail in the RAW dialog box. Move the Color Noise Reduction slider to the right to reduce color noise to an acceptable level. Move the Luminance Smoothing slider to the right to reduce grayscale noise.

The chromatic aberration setting lets you adjust for color fringing—a side effect when a lens focuses on colors differently. Color fringing is when an outline of a different color appears around a certain element in your frame. You can adjust the amount of blue and yellow or red and cyan fringing by moving the two Chromatic Aberration sliders to the left or right.

For vignetting issues, there is the Vignetting Amount slider. My first suggestion if your images are vignetting is to buy a different lens. If this isn't feasible, you can reduce the vignette by shooting RAW files. If you want to lighten a vignette in an image, move the Vignetting Amount slider to the right; to darken the vignette, move it to the left. You can also use this feature as a creative tool, causing the vignette to be either black or white.

In addition, advanced color adjustments are sometimes necessary when

the basic white balance and tint settings fail to render an image's color satisfactorily. Using the Calibrate setting enables you to remove shadow colorcasts and correct the hue and saturation of Red, Green, and Blue. Like other RAW file settings, you move the slider to the right or left to make adjustments to your images. Even though these adjustments are categorized as "advanced," they're easy to use. The hardest part is to visually decide how you want your image's color to appear.

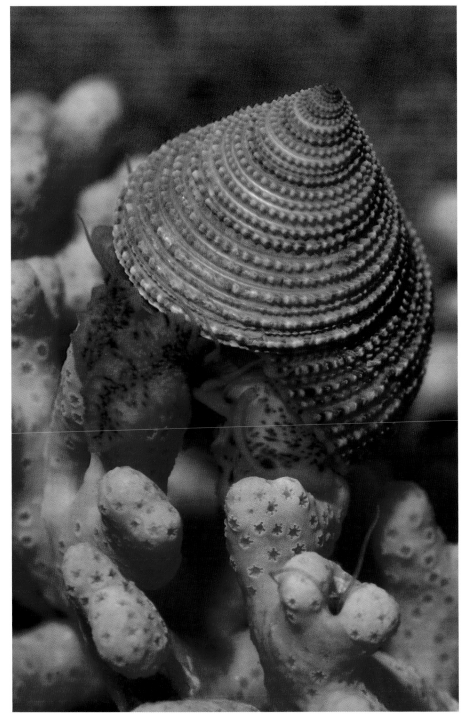

This image of a blue top snail that I made in the Vancouver Aquarium offers an example of color fringing. Unfortunately, I wasn't shooting RAW files, so I couldn't easily remove the purple fringe (detail, above). This is one more reason to shoot RAW files whenever possible. Not using RAW files doesn't mean I can't remove this fringe in Photoshop, but it does mean that it will take me more time—and take time away from shooting.

THE DIGITAL DARKROOM

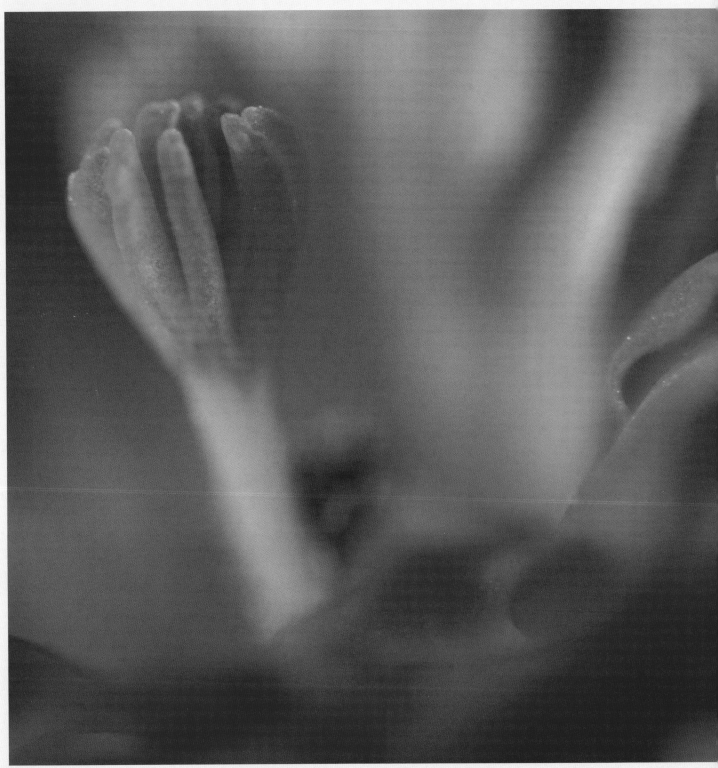

Claret cup cactus flower, El Malpais National Conservation Area, New Mexico. Nikon D1X with Micro-Nikkor 105mm f/2.8D AF lens

Shooting closeups in the field is exhilarating, but it's in the digital darkroom where your images come to life. Having the right equipment and software is crucial, and knowing how to use them is essential to ensure the quality of your images. This chapter is designed to help you get the most out of your prints. This is not a Photoshop lesson. There are plenty of books devoted entirely to Photoshop technique. I will give tips on what I think are the most common problems in digital photography and how to correct them.

Managing Color

All digital photographers want their prints to match what they see on their monitors. The first step is to capture the correct color using your digital camera. If you're shooting RAW files, this is no problem. Choose a color temperature when you download your images. If you're shooting JPEG files, make sure you select the right color space (my preference: Adobe RGB1998) and white balance setting to capture the correct color. When you select a color temperature, you are actually selecting a *color profile*. A color profile describes the color behavior of your digital camera, your monitor, or your printer. These profiles are used by software to keep color consistent throughout the process of digital capture to final photographic print.

Monitor calibration is one of those areas in digital photography that people tend to ignore. Yet it is one of the most crucial elements of being a digital photographer. I admit, it took me a while to come around and buy third-party calibration software. Why? I guess it's hard to spend money on something you think you can do without.

So, for a few years, I used the calibration setup provided by my computer manufacturer. I was quite happy with the results and sold many prints using this system. But eventually, there came a time when I was no longer satisfied with my results; I wanted more from my prints, so I switched over to third-party monitor calibration software. Initially, it will cost you more; how-

ever, you may save money because you won't have to tweak prints as much when your monitor and print match closely. This will save you time and the cost of ink and paper.

Monitor calibration is like plumbing in your house: you don't see it, and when it's working, you don't really care about it. However, when you spring a leak, it's the most important part of your house. Calibration is much in the same. When your prints don't match your monitor, it can drive you crazy! Your computer probably includes a calibration setup, but most likely, it's not nearly as good as one you can purchase.

So, why don't your prints match your monitor? You're dealing with two different types of light. Your monitor emits transmissive light, and a

Once software is loaded, this device is attached to the computer monitor. It takes readings of different tonal values of colors and creates a profile for your specific computer. The calibrated monitor profile is then stored as the name you specify. This specific model can even be used to calibrate LCD screens.

Spyder monitor calibration device

print transmits reflected light. The two, by nature, couldn't be more opposite. Your goal as a digital photographer is to match the image on the screen as closely to the print as possible. While it's impossible to get an exact match because of the different types of light, you can come very close if you go through the correct steps. Note that you should wait at least thirty minutes for your monitor to warm up before calibration, and you should pull down shades or blinds and keep direct light off the screen when calibrating your monitor.

At press time, third-party calibration systems start at about $100 and can cost well into the thousands. I'm happy to report, however, that calibration software is now much easier to use than it was in the past. The process of monitor calibration isn't as scary as it may seem; a typical calibration will take just about thirty minutes. For best results, you should calibrate your monitor every two weeks or at least once a month. Monitors tend to shift color, so if you see a shift in your prints, check to make sure your monitor is calibrated correctly. If you aren't comfortable doing it yourself, you can hire individuals to make monitor calibration house calls. My best advice for monitor calibration is to do it! You won't be sorry you spent a few extra dollars.

A NOTE ABOUT DIGITAL MANIPULATION AND HONESTY

We all know that photography, both film and digital, can be masterfully manipulated to make a viewer believe that a false situation is true. To keep the ethical debate simple, if you manipulate a subject either in camera, out of camera, or in the digital darkroom, caption it as such. Be true to your subject and to your viewers. If you bring a wild subject into your studio, it's now a captive subject just as any subject residing in a zoo or aquarium. There's no point in trying to fool your viewer; a good photograph is a good photograph, no matter where it's taken.

Digitally rendering your images is different from digitally manipulating your images. A RAW file might look completely underexposed on the camera, but in the digital darkroom, you can bring out the subtle details and render the essence of your subject. This isn't manipulation; you haven't changed the meaning of the scene, having stayed true to your subject. However, if you cut and paste, adding or taking away elements that alter the meaning of the image, you must caption it as such. Honesty is the best policy!

Workflow

What you do in the digital darkroom is important, but how you do it—and the order in which you do it—is also important to digital photography. Workflow is an individual process. What works for me might not work for you. That being said, I'll tell you the order in which I go about handling my digital images.

After each photo shoot, I copy all of my files directly to a CD or DVD. I think this is the most vital aspect of digital photography. People often download the shot, manipulate it, and then resave the new image, having lost their original file. As a beginner in digital photography, I was also guilty of doing this. The biggest problem you will encounter is that you have lost the purest version of your image. The original file holds the most accurate information about the image that you will ever have. Once you change it and save it, you can't go back to the original image.

Photoshop keeps getting better, and hopefully, your skills in the digital darkroom will consistently improve. Images you worked on a few years or even a few months ago may have been rendered poorly. They may have been fantastic images, but you didn't have the skills to bring the subject to life or your software couldn't take full advantage of the image. If you saved the adjusted image and not the original, you may not be able to take full advantage of your new skills or any new enhancements to Photoshop to render your images in the light they deserve. I could just kick myself for a few images for which I've lost the original file. This is why you should always make a copy of the original image—exactly how you captured it. On those storage DVDs or CDs, I write the date, place, and names of my subjects, using a permanent Sharpie marker, and I place them in archival CD storage binders.

I suggest opening all of the images and deciding which ones to store on your hard drive. You don't have to store them all—only the ones you're going to work on—because you now have a copy of the original files on DVD or CD. Once you've rendered your images the way you envision, save them under a new name and enter them into a database, if you have one, and also make a hard copy onto a DVD or CD. Constantly backing up your files may seem laborious, but it's nothing compared with trying to reshoot images you've lost.

Resolution and Printing

Before printing an image, you must understand the difference between camera, image, and printer resolution. If you don't, the quality of your prints may suffer.

To measure the resolution of a digital camera, we use pixel dimensions, which show how much detail is recorded by the camera's imaging sensor. The camera resolution is determined by multiplying the number of horizontal pixels by the number of vertical pixels. The vertical pixels × horizontal pixels = megapixel rating of a digital camera. For example, a digital camera with 2,000 vertical pixels and 3,000 horizontal pixels would have a megapixel rating of 6,000,000 pixels or 6 megapixels.

A printer's resolution is measured in dots-per-inch (dpi), which indicates how many ink dots are sprayed down for each square inch of the print. A print made using a higher dpi setting with all other aspects being equal will have more detail than a print made using a lower dpi setting. For example, a print using a resolution of 720 dpi will not look as clear as a print using 1440 dpi.

Printing seems to be an enigma to many digital photographers. Simply pressing the print button probably won't produce an image as vibrant as the one you see on your monitor. With a few steps, you can turn your desktop into a fine-art output station. If you don't want to print out your images, try digital printing labs. Most camera stores can turn your digital files into prints. You can also have custom labs print your digital files.

Digital photo printers are wonderful tools because they give you control over the final output of your images. I've used Epson photo printers since I started shooting digital. However, there are plenty of other manufacturers on the market. (See Resources.) For images 13 x 19 inches or smaller, I use the desktop Epson 2200. If I want to print out an image at 24 x 36 inches, the Epson 7600 is my chosen printer. For any image between 24 and 44 inches wide, I choose the Epson 9600.

Paper

The quality of a print is judged by its look and feel and is highly subjective to personal tastes. That being said, you need to decide on your preferences. Some people are happy with a glossy coated image, while others prefer a textured matte finish. In the past few years, as many choices of digital photographic papers as there are breakfast cereals have become available. Just as you don't have to eat plain cereal flakes, you don't have to stick to one particular plain paper. You can use everything, from high glossy papers to deep textured matte papers to transparent film. If you're unsure of

This is the Image Size dialog box in Photoshop. This is where you find and adjust information about picture resolution. The image resolution—measure in pixels-per-inch (ppi)—shows how the detail will be spread out in a print. For example, if your image resolution is set to 100 ppi, your image's final print size may be 20 x 30 inches. When you change only the ppi to 300, your image's final print size is now 6.66 x 10 inches, three times smaller than when the ppi was set to 100. It comes down to the actual size of the file in terms of megabytes. It's up to you to decide how to use the megabytes in your file for printing. If you want a larger print, you'll have to use a lower ppi, which will produce a lower quality print. On the other hand, if you want a smaller print, you can use a higher ppi for a higher quality print.

VIRUS PROTECTION

Like calibration software, antivirus software may seem like an expense you just don't need. You're right; you don't need it—unless your computer catches a virus, and then it's on the top of your list of things to take care of. Mac users often think they won't catch a virus because most viruses are written for PCs. Notice I said *most*; there are still plenty of viruses written to destroy Macs. My best advice: bite the bullet and buy an antivirus program, such as Norton. Make sure you update regularly to keep on top of new viruses as they arise. If your digital media is corrupted, you can also scan it using your antivirus program. If that doesn't work, you can mail your corrupted card back to the manufacturer (or to Drivesavers, see Resources) for recovery.

The best way to avoid using a recovery service is to reformat your digital media after every download, and store media at a temperature comfortable to you. This means don't leave your digital media on the dashboard of your car in the middle of summer. Back up all of your images onto CDs, DVDs, or external hard drives. I always make sure I have two copies. I even have a little fireproof safe to store my irreplaceable DVDs. These are available at many home improvement stores. When you make a copy of an image, it's the exact same as the original, meaning you can have multiple original copies in case something were to happen.

what paper to use, buy a few sample packs from different companies and see what works best for you.

Before you try printing on a new type of paper, make sure you download the paper's profile for your specific printer. Each paper handles color in a different fashion. If you don't use the paper-specific profile, you'll probably be unhappy with the results—and it won't be the paper's fault.

Ink

Like other aspects of digital photography, inks are improving at an alarming rate. In the past few years, we've witnessed a transition from inks that start to fade in six months to inks that are said to last over a hundred years—now that's progress! Using your printer's specified inks should give you the best results. That being said, you can refurbish an old printer to accept inks from third-party sources, such as Piezography (specially made for printing black-and-white and toned images). These produce spectacular print results.

Resizing

Resizing your image may seem like a simple process, but there are a few factors that will determine the quality of the image when altering its size. When you make a file smaller or larger, you have *interpolated* your image. Reducing an image causes little or no side effects, while enlarging an image can cause it to appear pixilated and blurry. Your computer either adds pixels to the file to make it bigger or removes pixels to make the file smaller. Photoshop does a good job at resizing; however, if you want to turn your prints into big posters or large fine-art prints, you may want to reassess the quality of the Photoshop resized print.

For maximum results when using Photoshop to make big prints, try resizing your image by 10 percent increments instead of all at once. The first step is to create a Photoshop action to increase your image to 110 percent of its original size. This will save you loads of time. To create an action, open an image in Photoshop. Choose Create New Actions in the window option, name your action and choose a function key to assign the action, and then hit Record. Assigning a function key allows you to use this key to resize any image anytime. Under Document Size, choose Percent and type in 110, making sure to check the Constrain Proportions and Resample Image boxes. Select Bicubic Smoother as the method of interpolation, and pick your desired resolution. Hit the Stop Playing/Record button in the Actions dialog box once you've made your selections. Now you can use the function key you chose to keep resizing the image 110 percent at a time until you reach your desired size.

Compare a print you resized in a single step with a print resized using the 110 percent method, and see if you can tell a difference. If you're unhappy with the results, try Genuine Fractals (www.lizardtech.com), a Photoshop plug-in. I use this for all my resizing needs. Simply put, the images look better when interpolated with Genuine Fractals than when interpolated with Photoshop. It's an added cost, but the benefits are well worth it, especially when I'm creating large 24 x 36-inch fine-art prints.

When you use Genuine Fractals, you must first save your image as an stn. file and then reopen it in Photoshop. A new dialog box appears asking you at what size and resolution you want the image to open. With this program you don't need to increase your image size in increments; you can do it all in one step. It may just take your computer a few minutes.

Once you've calibrated your monitor and chosen your printer, paper, and image size/resolution, you must follow the right steps to get your printer and monitor to match. I use Photoshop to color manage my images. This means I turn off my printer's color management. I choose the color space of my image, and then select my paper's profile. My final step is to pick a printer resolution. You can make a test strip by cutting and pasting a section of your image onto another file. This comes in handy when making large prints. You may need to make adjustments to obtain the desired results, and making a test strip will allow that process to advance much more quickly.

PRINTER CONSIDERATIONS

Before purchasing a printer, you should ask yourself the following:

How big do you want to make your prints?

Do you want to use a variety of papers?

Do you want the option of using roll paper?

What type of ink do you want to use?

How long do you want your print to last before it fades?

How high do you want the printer resolution to be?

Troubleshooting

The following are the problems I frequently encounter in the digital darkroom with Photoshop and solutions for fixing them. The most common problem I see is people overcompensating when rendering their images. If an image doesn't need adjusting, don't adjust it. Show your images to other photographers and get their opinion.

Before you do anything in Photoshop, make sure you have chosen your desired color space for your image, most likely RGB or CMYK. Your next step is to select Image>Mode>16 Bits/Channel to ensure you retain the most amount of data when rendering your images. Now you are ready to begin.

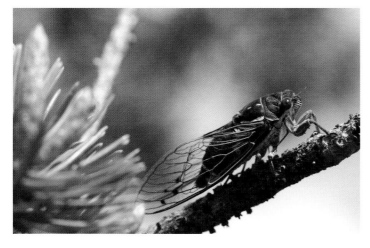

Problem: Shadows are too dark and highlights are too bright

Solution: Photoshop CS includes my new favorite setting, the Shadow/Highlight command, found under Image> Adjust>Shadow/Highlight. This tool enables you to adjust the highlights and the shadows independently of each other and the mid-tones in your image. Open a high-contrast image, and try the different options under the Shadow/Highlight command. You'll be amazed at how well it works. For this cicada image, I liked the overall tonality of the scene, but the shadows were too dark for my liking. I could have gone through some complex dodging methods, but a much easier and faster way was to use the Shadow/Highlight command. I increased the exposure in only the dark regions, leaving my highlights and mid-tones as they were.

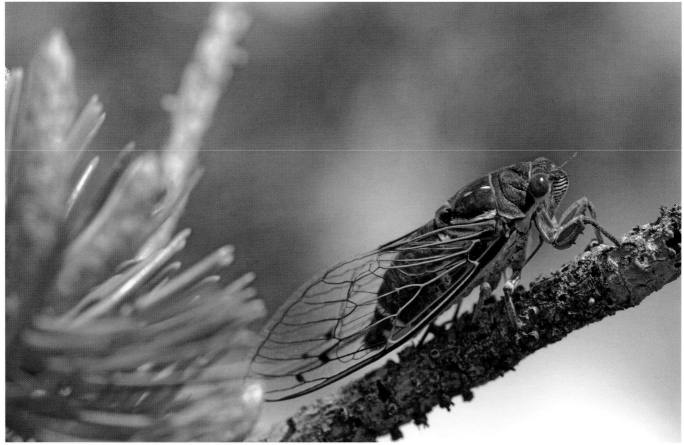

Problem: Image's color cast is unsatisfactory

Solution: Use the Photo Filter command found under Image>Adjust>Photo Filter to make adjustments to the entire scene, like you would do if you were adding filters to the end of your lens. I don't use filters to correct for color. So, this new setting offers precise control, adjusting overall color in a scene. This is not the tool to use if you want to adjust individual colors. Once you choose a filter, you can adjust the density and decide whether or not to preserve the luminosity. When I photographed this fly, I remembered the scene as having a blue tint. When downloaded, however, the image appeared much warmer than I had anticipated. To correct for the warm tone, I used the blue filter to adjust the intensity until I reached the desired overall color.

Problem: Certain colors don't appear the way you predicted

Solution: A photo filter is good for adjusting the overall color of scene, but there are many other methods for adjusting the colors in your image. I treat each image differently and employ different techniques to achieve the results I desire. I don't think one method is any better than the next. To work on this image, I used Color Balance, Color Match, Selective Color, and Curves, which are all located under Image>Adjust and are my favorite color-adjusting tools. Use the tools you're comfortable with, and play around with new tools to see how they affect your images. The very best way to learn about these settings is to try them out.

In my early days of photography, I probably wouldn't have bothered working on this image. The shadows were too dark, and the overall color of the original image had a muted yellow cast. First, I used the Shadow/Highlight command to lighten up the dark areas. I then used Image>Adjust>Match Color to adjust the luminance and color intensity of the scene. Lastly, I used Image>Adjust>Color Balance to individually tweak the colors of the highlights, mid-tones, and shadows. What's great about Photoshop is that you decide how you want to adjust an image because you have so many options.

Problem: Banding (lines in areas of solid color)

Solution: Lines in areas that should be solid color in your print, such as the sky or a flower petal, are called banding. The printer cannot distinguish where to change slight color differences, so it creates a distinct line. Adding a little noise to the image will enable the printer to make a smooth transition between slight tonal variations. To add a few pixels of noise, use Tools>Filter>Noise>Add Noise in Adobe Photoshop.

The monochromatic sky in this photo of a weaver bird makes this image a perfect candidate for potential banding. To ensure that this didn't happen, I selected the sky using the Magic Wand tool, and then used Select>Feather with a radius of 4 pixels to soften the selection. Then I used Filter>Noise>Add Noise to increase the noise by 1.5 percent. When adding noise, make sure you view the selection at 100 percent.

Visible banding effect.

No banding.

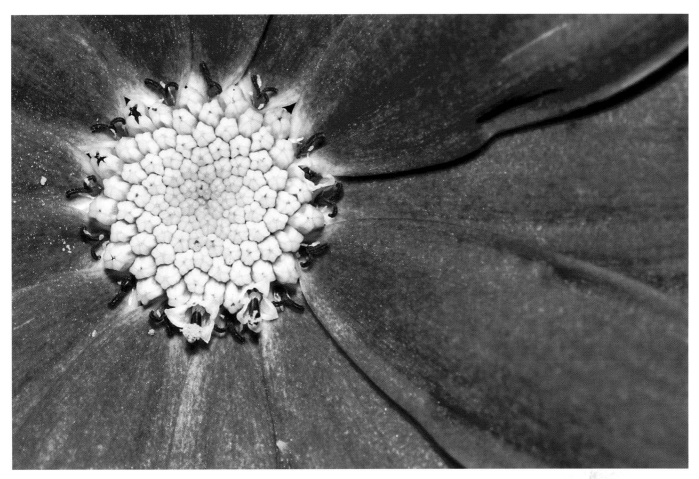

Problem: Print isn't as sharp as it appeared on camera LCD screen

Solution: Remember that there's a difference between sharp focus and image sharpness. Shooting with a digital camera will require you to sharpen almost every image before printing. At different sizes images need different amounts of sharpening. I don't apply any sharpening to images until I'm ready to print them. A 6 x 9-inch image may need less sharpening than a 24 x 36-inch image. There are many ways to sharpen an image, but the method I use most often is the Unsharp Mask filter. I choose Filter>Sharpen>Unsharp Mask, and set the amount to 100 percent and the threshold to 8. I then move the radius to a point a bit farther than I think is necessary, but never more than 4 pixels. I then go to Edit>Fade Unsharp Mask, and under the Mode, I scroll all the way to the bottom and select Luminosity. Selecting Luminosity will reduce the noise that's a common side effect of sharpening images. My final step is to lower the opacity until the sharpening looks right. Make sure you don't oversharpen your image;

Softer

I think an oversharpened image looks much worse than a slightly soft image.

I used this sharpening technique for this blue flower, which I wanted to print at 8 x 12

Sharper

inches. When shown at that size, the center of the flower was too soft for my liking, so I sharpened it to define the edges, thus giving the image depth.

Problem: Changing color to black and white/Changing black and white to duotone

Solution: Changing an image from color to black and white sounds simple, and it can be if you aren't concerned with the results. You can simply change the mode to grayscale, but you probably won't be happy with the results. My preferred method of converting a color scene into a black-and-white one is to use Image>Adjust>Channel Mixer. Channel Mixer allows you to adjust the specific colors of Red, Green, and Blue in your images. By choosing Monochrome, you can turn the scene into a grayscale image and tweak individual channels. However, the final step is changing the mode from RGB to Image>Mode>Grayscale.

When changing black and white into a duotone, you must change your image to grayscale or you will not be able to use duotones. You'll also have to change from 16-bit mode to 8-bit mode. (Remember that some options in Photoshop are not available when using 16-bit mode.) Select Image>Mode>8 Bits/Channel. You can then load specific duotone, tritone, and quadtone samples and alter them to your liking, or choose your own. Once you've selected the tone you want, you can save it and apply it to other images. (Note that these instructions are just meant to get you started; there are so many other options and variations that I could go on forever.)

When shooting this scene, I knew I was going to convert it to black and white, but I shot in color anyway. Shooting in color allows for minute tonal adjustments, and you will always have the color image if you ever need it. The top left image is the original file, bland and boring. I view it as a negative not yet rendered. I shot it as a RAW file, so I made most of the exposure and contrast adjustments in the RAW dialog box. Once I opened the image in Photoshop, I used the Channel Mixer to make slight changes and then changed the image to grayscale and 8-Bits/Channel (top right). This let me work with duotones, tritones, and quadtones. The final image is a tritone that I loaded from the Photoshop samples and to which I then made my own adjustments (bottom right).

Glossary

aperture An adjustable hole in the lens, referred to as an *f*-stop, that allows light to be captured by the camera.

aperture priority A camera mode in which the photographer chooses an *f*-stop to attain a desired depth of field. The camera then chooses a shutter speed to obtain a correct exposure.

artifact A side effect of compressing an image, usually seen as overexposed pixels throughout an image. Common when using the JPEG file format.

autofocus The camera function in which the camera focuses automatically on the subject at which the photographer is aiming, usually when the shutter release is depressed halfway. Many cameras allow the photographer to select the area within the frame that the sensor will focus on.

aspherical lens A high-quality lens that prevents a spherical image by adding multiple radiuses of curvature. If you're photographing a horizon that includes the ocean, this is the type of lens you'll want, otherwise there will be a curve in the horizon line.

banding Occurs during image printing when an area of smooth color gradation breaks up into blocks with defined tonal lines.

bit Derived from the words *binary* and *digit*, this is the smallest unit of memory.

bracketing Taking a series of images of the same scene or subject in which you change the shutter speed or *f*-stop, usually in half- or one-stop increments, to capture various exposures.

bulb A camera setting that allows the photographer to take as long an exposure as desired by keeping the shutter fully depressed.

cable release A device that eliminates photographer shake; used when taking long exposures or when the photographer needs to be separated from the camera.

calibration The adjusting of equipment so that the color balance is consistent from one device to the next. You would calibrate your computer monitor and printer so that colors match.

CCD (charge-coupled device) A type of digital image sensor used by many digital cameras. The number of sensors, which form the imaging surface, determines how high the resolution will be. The more sensors, the higher the resolution.

chromatic aberration The effect sometimes seen of a purple fringe separating the light and dark areas in an image. This occurs most often when photographing subjects that have high-contrast areas. If you're shooting RAW files, you can reduce this effect in the advanced RAW dialog box in Photoshop.

CMOS (complementary metal oxide semiconductor) A type of imaging sensor that uses

less power than a charge-coupled device (CCD) but is not as widely used as the CCD.

CMYK An abbreviation for the four basic colors used in ink cartridges: cyan, magenta, yellow, and black. (Epson's line of Ultrachrome inks also uses a light cyan, light magenta, and light black.)

color space An abstract three-dimensional color model with a specific range of colors. Digital cameras capture color using these set profiles, and these profiles are used by printers and imaging programs as a color reference. The most common digital camera color spaces are Apple RGB, sRGB and AdobeRGB, which has a larger color space. A color space gives a starting place for printers and programs to interpret the color in your digital images.

color temperature Calibrated in degrees Kelvin, photographers use this when describing a scene as cool or warm. A sunny day at noon would have a color temperature of about 5500K. A lower temperature scene (say, about 3000K) would be described as having a warm light, whereas as high temperature scene (about 7000K) would be described as having a cool light.

complementary colors Pairs of colors that fall directly opposite each other on the color wheel (red and green, blue and orange, yellow and violet). Complements result in maximum color contrast when used together in an image.

compact flash card, types I and II Digital media used in many digital cameras to store images.

compression The reduction in size of an image to save digital media memory. The most common type of compression is JPEG (or Joint Photographic Experts Group).

depth of field The plane (or area from front to back) in an image that appears to be in focus; it is controlled by the size of the aperture, known as the *f*-stop. A large aperture (an *f*-stop of *f*/2, for example) will result in a limited (or shallow) plane that's in focus, whereas a smaller aperture (*f*/32, for example) will result in a large (deep) plane that's in focus.

diffuser Anything, from a cloud of mist to a piece of waxed paper, that can disperse light to reduce contrast in an image. Most commercial diffusers are made from fabric.

digital zoom By contrast to an optical zoom, this is a simulated zoom feature found on some digital cameras that involves zooming in on an image by electronically cropping in on the subject. The quality of an image captured with a digital zoom is much lower than the quality of an image taken with an optical zoom.

electronic flash A device used to artificially light a subject that may be used directly with a camera's TTL (through-the-lens) metering system.

exposure The final tonal quality of an image created by the combination of shutter speed, *f*-stop, and ISO setting.

extension tube A hollow metal tube placed between the lens and the camera body to magnify a subject's size, allowing a photographer to obtain closeup images.

eyespot An overexposed highlight in an animal's eye that gives a subject "life."

filter A piece of glass added to the end of a lens to create or intensify a lighting effect.

FireWire High-speed data interface used on high-end digital cameras to download images onto a computer.

focal length equivalency Photographers are accustomed to 35mm lenses, so manufacturers often describe digital cameras using these specifications. For example, a 35mm camera lens with a focal length of a 70mm lens may have a focal length equivalency of 105mm when used on a digital SLR camera.

gigabyte A unit of measurement to describe an amount of digital memory. A thousand megabytes equal one gigabyte.

graininess A grainy textured look that images taken with a high ISO can have. The higher the ISO setting, the grainier an image will appear.

histogram A graph feature of digital cameras and imaging programs that shows the contrast and tonal range of an image.

hot shoe A device used to connect a flash to the top of a camera, enabling it to synch with the shutter. You can also attach an extension cord to the hot shoe for external flash.

ICC profile The ICC (International Color Consortium) is an organization that sets color management standards. These standard profiles are used by hardware and software to communicate with other devices to interpret color.

image resolution Usually measured in pixels per inch (ppi), this refers to the amount of pixels per inch in an image. The higher the resolution, the higher the quality of the image.

info-lithium A rechargeable battery that indicates how much time remains before it runs out of power.

inkjet A type of printer that creates an image by spraying dots of ink onto paper. A printer that sprays on a high number of dots per square inch has a high resolution; an example of this would be a printer spraying 2880 dots per square inch.

interpolation The process of increasing or decreasing the size of an image by adding or subtracting pixels in an imaging program. Used when you want to print an image larger or smaller than your current resolution allows.

ISO (International Standards Organization) Equivalency Based on 35mm film ratings, this gives a value for setting the digital camera's sensitivity to light. Digital cameras currently range from ISO 6 up to ISO 3200, depending on the camera make and model.

jaggies This is a slang term for a pixilated image—one in which you can visually see individual pixels.

JPEG (Joint Photographic Experts Group) An image file format that compresses an image to enable the storing of more images on a camera's digital media. The amount of compression can be adjusted depending on the make and model of the camera.

LCD (liquid crystal display) A screen on a digital camera that displays what the viewfinder sees; used for composing and viewing your images.

lens distortion An inward or outward bending effect in an image caused by the quality of the lens. A plug-in can be purchased to combat this effect.

lens hood A tube placed on the end of a lens to reduce flare caused by light directly hitting the glass of the lens.

macro lens A lens that can focus within inches of a subject, obtaining closeup images that are life size or even greater.

manual focus A camera function that allows the photographer to adjust the focus rather than requiring the photographer to rely on the camera to set the focus. This is very useful for closeups, night shots, and action shots for which the camera's focusing device (autofocus) may not work the way you want.

megapixel One million pixels. A 2-megapixel camera will have a resolution of 2,000,000 pixels.

memory card reader A device that accepts digital media and is used to rapidly download images onto a computer.

monitor resolution Usually measured in dots per inch (dpi), this refers to the amount of pixels per inch on a monitor screen.

NiMH (nickel metal hydride) A type of rechargeable battery with a constant voltage.

noise Graininess in an image caused by using a high ISO number.

optical zoom Altering the focal length of a lens, thereby altering the angle of view of the image. Resolution remains constant when you use an optical zoom. (Compare with *digital zoom*.)

overexposure When an image or part of an image appears brighter than intended. A camera's histogram will show if an image is overexposed.

pixel Derived from a combination of the words *picture* and *element*, a pixel is a dot and is the smallest element that makes up an image. When all other aspects of two cameras are equal, the camera with more pixels will produce a higher-quality image.

pixelation This occurs when the resolution in an image is too low for the size at which you are viewing it. You will see actual pixels of color in the image.

plug-in An additional piece of software added to a program. For example, you can buy a plug-in to combat lens distortion or to interpolate an image.

polarizer A filter placed on the end of a lens to reduce or eliminate glare and to saturate colors. Circular polarizers are the best for digital cameras.

ppi (pixels per inch) A measurement of pixel density that describes the final printed image. For example, an image with a high ppi of 300 will have better quality than an image with 150 ppi.

pre-flash A camera feature used to reduce red-eye in a subject by closing the pupil down with a preliminary flash that goes off before the flash that is used to illuminate the subject.

printer resolution Usually measured in dots per inch (dpi), this refers to the amount of ink dots a printer sprays per square inch in an image. All other aspects being equal, a printer with higher dpi will produce a higher-quality image than one with lower dpi.

profile A file that includes information about how a device will reproduce color. It allows your printer to know how to reproduce the color of your image based on your ink and paper settings.

RAW An image file format. RAW files undergo minimal camera processing and a lossless form of compression. These are the best files to shoot if you want the most freedom in the digital darkroom.

recycle time The amount time it takes for a flash to charge to full power after it has fired.

red-eye A red effect in a subject's eye that can be reduced or eliminated with a pre-flash.

retouching Changing the appearance of an image after shooting to increase the quality of the image.

resizing Changing the size of an image either by upsampling, which increases the size, or downsampling, which decreases the size.

RGB The color system used in most digital cameras. The camera separately captures red, green, and blue light and then combines the three colors to create a full-color image.

shutter The device in the camera that opens to allow light to be recorded by the camera's sensors (in the case of digital cameras) or by film (in the case of traditional film cameras).

shutter speed The amount of time the shutter stays open, letting light into the camera. A longer shutter speed will allow more light to be recorded, whereas a fast shutter speed will allow less light to be recorded.

shutter priority A camera mode in which the photographer selects the shutter speed and the camera selects the aperture to capture the suggested exposure.

slave unit A device that will cause another flash to fire at the same time as the camera's flash. This allows a photographer to use more than one flash without linking them together with cords.

slow synch A camera mode in which the flash fires for only part of the exposure. This allows the photographer to have control over the exposure of the background.

stopping down The increasing of the *f*-stop so that the size of the aperture is smaller, allowing less light to be recorded. The result is an increase of depth of field.

synchro-sunlight Using both flash and natural light to expose an image.

TIFF (tagged image file format) An image file format. Images are usually shot as TIFFs, and then the camera converts them to JPEGs to save on digital media memory. You can open a TIFF file, change the image, and then resave it as a TIFF file without losing any quality due to compression, unlike with a JPEG file in which there will be quality loss if the image has been altered.

tone The darkness or brightness of an image, caused by the intensity of the light source.

TTL An abbreviation of the term *through-the-lens*, which refers to a system of metering a subject through the lens of the camera, regardless of additional attachments.

underexposure When an image or part of an image appears darker than intended.

USB An abbreviation for a *universal serial bus* computer port, which allows for rapid transfer of data.

vignetting Dark areas around the edges of an image. This effect is caused by either stacking lenses and filters, or by using the wrong type of lens for the camera.

white balance A setting on a digital camera that prompts the camera to measure the color temperature of a scene, and then adjusts it so that white areas in the image do not take on extreme color casts. The white balance setting is set by the camera but can also be set by the photographer, depending on the make and model of the camera.

wide-angle lens A lens used to capture a broad view of the subject or scene.

working distance The distance between the lens and the subject.

zoom lens A lens with a variable focal length that is very useful in nature photography.

Resources

Backgrounds
www.amvona.com
www.belgerphotography.com
www.signaturebackgrounds.com

Battery Chargers
www.radioshack.com

Camera Bags/Carrying Cases
www.pelican.com
www.promaster.com
www.roadwired.com

Camera Manufacturers
www.fugifilm.com
www.kodak.com
www.konicaminolta.com
www.nikon.com
www.olympusamerica.com
www.pentax.com
www.sony.com
www.usa.canon.com

Camera "Raincoats"
www.kata-bags.com
www.tenbagear.com

Computers
www.apple.com
www.dell.com
www.hp.com

Data Recovery
www.drivesavers.com

Digital Media
www.lexarmedia.com
www.sandisk.com

Framing Supplies
www.dickblick.com
www.lightimpressionsdirect.com

Imaging Sensor Cleaning Supplies
www.photosol.com

Light Diffusers
www.fjwestcott.com
www.ftl-gmbh.de
www.lastolite.com

Microscope Adaptors
www.scopetronix.com

Nature Photography Organizations
www.nanpa.org

Online Digital Photography Equipment Reviews
www.dcresource.com
www.dpreview.com
www.imaging-resource.com
www.megapixel.net
www.pcphotoreview.com
www.steves-digicams.com

Online Digital Photography Magazines
www.digicamera.com
www.ephotozine.com
www.outdoorphotographer.com
www.pcphotomag.com
www.pdnonline.com
www.popularphotography.com
www.shutterbug.net
www.vividlight.com

Online Digital Photography Stores
www.abesofmaine.com
www.amphotoworld.com
www.bhphotovideo.com
www.bwayphoto.com
www.cameraworld.com
www.focuscamera.com
www.ritzcamera.com

Online Digital Printing
www.bonusprint.com
www.imagestation.com
www.shutterfly.com
www.winkflash.com
www.YorkPhoto.com

Papers
www.argraph.com
www.crane.com
www.epson.com
www.hawkmtnartpapers.com
www.ilford.com
www.kodak.com
www.legionpaper.com
www.usa.canon.com

Portable CD Burners
www.micro-solutions.com

Portable Hard Drives
www.apple.com
www.delkin.com
www.image-tank.com
www.jobodigital.com
www.smartdisk.com
www.vosonic.co.uk

Printers
www.epson.com
www.fugifilm.com
www.hp.com
www.kodak.com
www.lexmark.com
www.piezography.com
www.polaroid.com
www.rolanddga.com
www.usa.canon.com

Tripods/Tripod Heads
www.gitzo.com
www.manfrotto.com
www.tripodhead.com

Index

AC adapter, 42
advanced settings, 142–143
anti-mirror-shock, 59
aquarium photography, flash and macro, 124–129
automatic closeup lenses, 36–37
average-key image, 135

background, 90–93
backlight, 66, 68–69
bags, camera, 42
banding, 154
batteries, 42
bellows, 33–35
black and white, changing to/from, 156
brackets, flash, 15, 118–121

calibration, 142–143
 monitor, 146–147
camera bags, 42
camera care, 39
camera features and techniques, 46–59
camera mechanics and settings, 48–54, 58–59, 78–83, 142–143
camera rain gear, 42–43
camera resolution, 48, 148
cameras
 digital point-and-shoot, 14–17
 digital SLR, 18–21
camera shake, 48–49
card formatting, 59
care, camera, 39
CD burner, 44
center-weighted metering, 55
changing lenses, 18
charging, 42
chroma noise, 142
chromatic aberration, 142
cleaning camera, 39
closeness
 degree of, 96–97
 to live subject, 109
closeup(s), 10
 focusing for, 94–95
closeup lenses, 28
 automatic, 36–37
color, 60–61, 74–77
 to black and white, 156
 managing of, 146–147
 troubleshooting of, 152, 153
color fringing, 142, 143
color profile, 146
color temperature, 78–83'
color wheel, 74

compensation, tone, 59
complementary colors, 74, 75, 77
composition, 84–111
 importance of, 86–88
cool colors, 74, 76

darkroom, digital, 144–156
diffusers, 72, 73
digital darkroom, 144–156
digital factor resources, 18
digital files. *See* files
digital manipulation, and honesty, 147
digital point-and-shoot cameras, 14–17
digital SLR cameras, 18–21
diopters, 28–29
direction, of light, 66–71
downloading digital files, 44
duotone, black and white to, 156

equipment, 12–45
extension tubes, 26–27

features, camera, 46–59
file format, 56–57
files, downloading and storing of, 44–45
filters, 30–31
flash, 112–129
 and aquarium, 124–129
 ring, 116–117
 slaving of, 122–123
flash brackets, 15, 118–121
focus
 plane of, 94
 sharp, 59
focusing, for closeups, 94–95
foreground, 89–90
format
 file, 56–57
 horizontal vs. vertical, 86, 87, 88
formatting, card, 59
frontlight, 66–67
f-stop, 52–53

glass, flash and, 124

Handheld Rule, 48–49
heads, tripod, 38
high-key image, 136
highlights, troubleshooting of, 151
histograms, 130–131, 132–137
honesty, digital manipulation and, 147
horizontal format, 86–87

image resolution, 48, 148, 149
image sharpening, 59
imaging sensor, cleaning of, 39
ink, 150
insurance, equipment, 45
ISO, 54, 55

JPEG file, 56, 57

lenses
 automatic closeup, 36–37
 choosing and changing, 18
 cleaning of, 39
 long zoom, 22–25
 plus/closeup, 28, 36–37
 stacked, 32
 wide-angle, 19–21
level, of subject, 110–111
light, 60–61
 direction of, 66–71
 types of, 62–65
line, 102–105
live subject, closeness to, 109
long zoom lenses, 22–25
lossy/lossless files, 56
low-key image, 135
luminous noise, 142

macro aquarium photography, 124–129
managing color, 146–147
manipulation, digital, and honesty, 147
matrix metering, 55
mechanics, camera, 48–54
metering, 55
microscopes, 40–41
mirror shock, 59
monitor calibration, 146–147

NANPA (North American Nature Photography Association), 45
neutral-density filters, 31
noise reduction, 58

paper, 148, 150
pattern, 106–107
photographer shake, 48–49
plane of focus, 94
plus lens, 28
pocket-sized point-and-shoot digital cameras, 14–17
point-and-shoot cameras, digital, 14–17
polarizing filters, 30–31
primary colors, 74
print, troubleshooting of, 155

printer considerations, 150
print resolution, 48, 148, 149
protection, virus, 149

rain gear, camera, 42–43
RAW files, 56, 130–131, 138–143
reflectors, 72
resizing, 150
resolution, 48, 148, 149
resources, 159
 digital factor, 18
ring flash, 116–117
Rule of Thirds, 98–101

secondary colors, 74
self-timer, 58
settings, camera, 48–54, 58–59, 78–83, 142–143
shadows, troubleshooting of, 151
shake, camera/photographer, 48–49
sharpening, of image, 59
sharp focus, 59
shutter speed, 48–49
sidelight, 66, 70–71
slave trigger, 122
slaving flash, 122–123
SLR cameras, digital, 18–21
speed, shutter, 48–59
spot metering, 55
stacked lenses, 32
storing digital files, 45
subject
 getting on level of, 110–111
 sticking with, 108–109
succession, 34
synchro-sunlight, 120

Target Zones, 98–101
techniques, camera, 46–59
teleconverters, 38
temperature, color, 79–83
timer, self-, 58–59
tone compensation, 59
tripods, and tripod heads, 38
troubleshooting, 151–156

UV filter, 30

vertical format, 86, 88
vignetting, 142
virus protection, 149'

warm colors, 74
white balance setting, 78–83
wide-angle lens, 19–21
workflow, 148–150